FIFTEEN PATHS

How to Tune Out Noise, Turn On
Imagination and Find Wisdom

DAVID WEITZNER

Published by ECW Press
665 Gerrard Street East
Toronto, Ontario, Canada M4M 1Y2
416-694-3348 / info@ecwpress.com

Editor for the press: Michael Holmes/
a misFit Book
Cover design: Paul Hodgson
MISFIT Cover illustration: © Jackie Saik
Author photo: © Stephanie Mill

LIBRARY AND ARCHIVES CANADA
CATALOGUING IN PUBLICATION

Weitzner, David, 1974–, author
 Fifteen paths : how to tune out noise, turn on imagination and find wisdom /
David Weitzner.

Issued in print and electronic formats.
ISBN 978-1-77041-474-7 (softcover).
ISBN 978-1-77305-333-2 (PDF).
ISBN 978-1-77305-332-5 (ePub)

1. Self-realization. 2. Social interaction.
3. Imagination. 4. Wisdom. I. Title.

BF637.S4W47 2019 158.1
C2018-905333-X C2018-905334-8

The publication of *Fifteen Paths* has been generously supported by the Canada Council for the Arts which last year invested $153 million to bring the arts to Canadians throughout the country and is funded in part by the Government of Canada. *Nous remercions le Conseil des arts du Canada de son soutien. L'an dernier, le Conseil a investi 153 millions de dollars pour mettre de l'art dans la vie des Canadiennes et des Canadiens de tout le pays. Ce livre est financé en partie par le gouvernement du Canada.* We acknowledge the support of the Ontario Arts Council (OAC), an agency of the Government of Ontario, which last year funded 1,737 individual artists and 1,095 organizations in 223 communities across Ontario for a total of $52.1 million. We also acknowledge the contribution of the Government of Ontario through the Ontario Book Publishing Tax Credit, and through Ontario Creates for the marketing of this book.

PRINTED AND BOUND IN CANADA PRINTING: NORECOB 5 4 3 2 1

MIX
Paper from
responsible sources
FSC
www.fsc.org FSC® C103560

To the memory of my grandfather Moshe Yechiel Rosen,
who saw the worst of humanity but emerged from the
dissonance as an exemplar of dignity and love.

CONTENTS

Introduction

At least one thing is becoming clearer as we round out the second decade of the third millennium: well-meaning societies have allowed the wrong people to lay claim to substantial amounts of power. You want proof? In the last few political cycles, how many populist and nationalist leaders comfortable using strategies that exploit bigotry and prejudice to advance themselves have been elected? How many entertainment industry stewards have finally been exposed by the #MeToo campaign, after decades of engaging in horrific abuse? How many senior executives at tech companies that dominate both the stock market and much of our lives harbor unabashedly monopolistic ambitions and a complete disregard for privacy rights? And let's not even start counting the molestation scandals at religious institutions or abuses of power at the hands of police. The fact that these bad behaviors are coming to light with greater frequency offers a beacon of hope that things will get better. But the more immediate takeaway is that even in an age of information, good people who should know better have been complicit in ceding excessive amounts of social, political and economic power to bad ones.

I've spent a lot of time wondering how this happened. I'm less curious about why those who acquire power tend to be horrible (research in psychology has found that at a certain point, the acquisition of power leads to empirically verifiable brain damage[1]), and more curious about the good folks who fail to resist. Is it because people are struggling to make sense of the contemporary world, perhaps more so than in decades past? Is it because so many of us just don't understand how societies and cultures with so much promise have come to such a demoralizing social place? Isn't it weird that "citizen" has become a dirty word in some segments of society, and that while our social networks may be vast, our circles of trust are ever shrinking?

I believe that the antidote to crippling uncertainty and confusion is wisdom. One important source of wisdom is the ability to keep a conversation going, but conversation is in a state of decline, supplanted by online diatribes. When honest folks lose the ability to understand and respect intellectual differences, they are unlikely to be able to make sense of a complicated world. So how can we tune out the noise that prevents us from staying in dialogue with each other, particularly when we have opposing world-views? The short answer is to turn on our imaginative faculties and turn off, or at least temporarily mute, our argumentative ones. Moral progress is driven by imagination — hearing and telling stories that increase our sensitivity not winning rational arguments. As a culture, we have historically put our trust in the imaginative expressions of artists to offer leadership in the task of extending societal sympathies. Art offers paths of transcendence and hope, a filling of the gaps in moral progress that allows our political class to follow.

1 Useem, J. (2017, July/August). Power causes brain damage: How leaders lose mental capacities — most notably for reading other people — that were essential to their rise. *The Atlantic.* https://www.theatlantic.com/magazine/archive/2017/07/power-causes-brain-damage/528711/

The long answer to the question is the point of this book. I wanted to talk directly with the people who give me hope. I set out to spend a full year seeking the counsel of my heroes, appreciating their art, engaging them in conversation and working with them to chart some useful paths forward. The fruits of our exchanges are shared here so that others can pick up our conversations and move them forward. Tackling such an important topic with any degree of competence could not possibly be a solo journey — it requires the thinking of a wide and diverse assortment of imaginative participants. I needed the artists to start the conversations, and I need the readers to keep it going.

A few major themes emerge from this year of conversation: As dialogue across political, social, economic, religious or ideological divides become mired in identity politics and fake news, we need to rethink what it means to listen. As corporate scandal after scandal goes unanswered, with fewer people benefiting from our economic system, we need to reevaluate the predatory form of capitalism that dominates our markets. As monopolistic tech companies try to position themselves as the new gatekeepers to social meaning, and screens become our mystical pathways, even those without mystical inclinations need to rethink spirituality. The artists that I was lucky enough to sit down with have much to offer on these topics, and many of these conversations challenged my own worldviews and assumptions. Even if you are not familiar with any individual artist or their work, even if you are not interested in the genres they create in, even if you don't care for rock or rap or comics, I am confident that you can still learn a lot from their words. Let them help you tune out the noise that is preventing you from turning on the full potential of your imagination.

Most of us, most of the time, do our best to use our physical, mental and emotional tools to craft purposeful lives. When things go right, we confidently find harmony between what we

think and hope should be and what actually is. We observe, we imagine, we aspire and, most importantly, we carry on.

Until something cracks. In the aftershocks of those moments, the "is" of our observations and the "ought" of our imagination no longer coalesce. We stumble to make sense of our lived experiences. We are thrown off by the sudden disappearance of the stability, born of a coherent sense of self and a seeming alignment in our internal assessment of the relationship between purpose and possibility, which had enabled us to find meaning up until the rupture. When we encounter a disruptive experience in our emerging narrative of sense-making, many of us withdraw from the uncertain outside world into the familiar confines of our inner mental space, where we can control our own reality. And in the technological age, we have tools of social media that allow us to withdraw from the reality of a social world without even realizing that we have done so.

Disruption does not need to be catastrophic for us to justify a social withdrawal. Even when we imagine a future that looks welcomingly bright, conflict can arise in our mental models, causing a halt in our forward progress. When we find a disagreement between the mind and the heart, for example, we may feel unbalanced and immobilized. Eventually, though, we make a choice. Living means taking action — even when we need more time to think, or wish we had more options. Living means finding a way to accept the bumps of conflict and move on.

Far more unsettling, however, and difficult to overcome, are those history-making events that leave a wake of disruptive instability in the social narratives of a diverse group of folks. As 2016 drew to a close, I happened to be in New York City on election night, having made a pilgrimage with other nerds eager to witness the local live debut of the somewhat mythical alternative rock band Temple of the Dog. This night would tragically take on even more significance in light of lead singer Chris Cornell's untimely passing a few months later. There will have been only

4

eight live shows in the history of this tremendous band. While their music brought so much light to their audiences, Cornell sadly could not shake off the darkness.

Many of the fans gathered that night at Madison Square Garden came of age during the grunge era of the early 1990s. We had traveled from all over to come together and honor a time when popular culture was dominated by alternative rock, Hilary Clinton was living in the White House and Donald Trump was the Howard Stern regular who never seemed to be in on the joke. Despite being older, grayer and preferring the comfort of seats over the tumult of a mosh pit, the observers were aging better than the culture itself. Nostalgia had never seemed so understandable . . .

Our hotel, as chance would have it, was directly next door to Trump HQ, and we found ourselves trapped in the security perimeter, making the familiar streets of NYC seem a strange fortress of exclusion. It was an appropriate place to take in the unfolding political reality. Illiberal citizens will talk of alternative facts (on the right) or intersectional power (on the left) in closed echo chambers. Opposing sides no longer make sense to the other. One side demands intellect and expertise be rejected as products of fake news, while the other insists that personal privilege be checked at the altar of identity politics. In the face of such impossible rules of engagement, curiosity is stunted. Formerly open spaces are now made "safe," but at what cost?

Can we still hope for the free expression necessary for learning, intellectual growth and human enlightenment when both the right and the left seek to censor and silence voices that make them uncomfortable? Not unless we rethink listening and how we engage in the political realm. Can we still defend an inclusive type of capitalism when greed and narcissism are rewarded with the highest office? Not unless we rethink why a predatory form of capitalism has come to dominance and how we engage in the economic realm. Can we still believe in a non-fundamentalist,

welcoming approach to religion as having a part to play in civic discourse when sacred texts are used to limit the rights of those who choose to live differently than these texts prescribe? Not unless we rethink spirituality and how we engage in the philosophical realm.

Recent polls suggest that only a little over half of American millennials hold a favorable view of capitalism.[2] The young see things with fresh eyes, allowing for insights that perhaps those of us who have been socialized within the system for so long can no longer discern. If our preferred economic system can only be salvaged by re-engineering the mindsets of nearly half of the next generation, is something not terribly wrong with our plan? If Donald Trump, a boorish child of privilege and caricature of the capitalist pig, is elected President of the United States by a constituency that regrets nothing in their choice, is it not time for radical change?

Forty percent of American millennials believe in restricting speech.[3] That's an astonishing number. The common sense of the masses is no longer aligning with the wisdom of old. To a certain extent, this a good thing. The noted economist Joseph Schumpeter wrote about the importance of "creative destruction."[4] A healthy business enterprise is not trying to retain existing structures, it is trying to be the first to destroy them and bring on whatever is to be next. In this thinking, companies that do not seek to continually re-invent the business landscape will find themselves powerless in the face of the innovators. Try as

2 Smith, N. (2018, July 12). If you love capitalism, worry about small business. *Bloomberg.* https://www.bloomberg.com/view/articles/2018-07-12/small-businesses-and-startups-lose-to-market-dominating-giants

3 Rampell, C. (2017, September 18). A chilling study shows how hostile college students are toward free speech. *The Washington Post.* https://www.washingtonpost.com/opinions/a-chilling-study-shows-how-hostile-college-students-are-toward-free-speech/2017/09/18/cbb1a234-9ca8-11e7-9083-fbfddf6804c2_story.html

4 Schumpeter, J. A. (1975). *Capitalism, socialism and democracy.* New York: Harper.

they might to keep up through imitation, merely copying the industry leaders as a form of adaptation will result in a very short corporate life-span. Digital photography could not rise without destroying the film industry. Streaming companies necessarily had to seek to destroy video rental stores. Ride-sharing services are trying to destroy the taxi industry.

Creative destruction in the marketplace of ideas should be as welcomed as creative destruction in the marketplace of things. In light of the repeated cycles of global financial crises, capitalism as we know it is finally being questioned by those on the inside. This is progress. But rethinking the social good of free speech is regressive. Anti-fascists using the tools of fascism is regressive. And for those who celebrate regressive behavior as an antidote to the perceived ills of progressivism, like supporting Trump in a haste to make America "great again," there is a pressing need to reflect on the values that we in Western society have deliberately left behind and why we did so.

I admit that as a citizen of the West I am inclined to focus on the Western experience, but much of the pain I am describing is being felt across the globe. While we focus, for example, on Russia's alleged political interference in the American presidential elections, Russian acquaintances remind me of the hopelessness they feel as Putin silences his opponents and slows their prospects for a freer society. Colleagues from Hong Kong remind me of the 2014 Umbrella Revolution, and the hopelessness they feel about their efforts to attain a democratic identity in the face of integration into Greater China. Friends from the Middle East remind me of how the promise of the Arab Spring has turned into more war in their home countries and not less. There is a global wave of discontent with the direction of the social conversation as it is currently being laid out by diverse classes of governing elites.

I was fortunate enough to converse with Richard Rorty, the actually great American pragmatist, on the beautiful Hawaiian island of Oahu two years before he died. He once wrote that

despite his certain skepticism, going through the therapeutic process can be useful. Rorty believed that through therapeutic reflection, along with maturity, we could comfortably seek out redescriptions of our past and selves that better serve the living present. He believed that therapy might help us realize the danger in being committed to the idea of a "true self," as the self is provisional, made up of changing values and beliefs acquired through social interactions. This benefit is also without a doubt the most unsettling part of therapy — giving up on the notion of a permanent self. In a later chapter, Dany Lyne will call the temporary parts of our selves the "architects of survival." They are to be respected, but ultimately sent off as we partake in the surprising and ever-changing journey of life. The difficult question is, how much of who we used to be can be cast aside while still retaining a coherent, or at least useful, sense of self?

There is compelling evidence that conversation — as an art, a skill, a teaching tool, a pastime, a worthwhile undertaking — is in a state of rapid decline. MIT sociologist Sherry Turkle regretfully reports that millennials and younger people who grew up deprived of their parents' conversational attention are finding comfort in social media.[5] This early retreat from a shared familial conversation means youngsters don't learn emotional intelligence in the manner of generations past, or perhaps don't learn it at all. And there is evidence that this cognitive deviation is not limited to certain age groups. Amongst his other surprising successes, Donald Trump became the first person to harness the power of Twitter in his ascent to the highest public office — a format that limits the breadth of expression but expands its reach to millions of receivers. Trump unleashed a great call to those whose emotional growth may be stunted, and whose rage can be electronically connected to and incited.

5 Turkle, S. (2015). *Reclaiming conversation: The power of talk in a digital age.* New York: Penguin Press.

Turkle discovered in the early 1990s that as folks started living more of their lives on screens, there was an initial feeling of empowerment: for the first time in history, ordinary people could widely project narratives of their own creation. The mediation by computer screens brought new ways for people to think about relationships, sexuality, politics and identity. Turkle wrote that "a decentered self that exists in many worlds, plays many roles at the same time."[6] Real life becomes just one window amongst the many mediated by our screens. Could she have even imagined the windows offered by Logan Paul, a YouTube sensation who, for the entertainment of Western teens, went to the Aokigahara Forest in Japan to film and mock the lost souls who committed suicide there?

Turkle cautions us to slow the pace of these radical changes in behavior. The more she found youngsters using screens to make sense of their lives, the more she felt the viability of a manageable social future might be in doubt. Looking at current realities, we've become excellent at broadcasting, but receiving has perhaps become a lost skill. In the digital age, information is abundant, but wisdom is in short supply.

When I imagine a child growing up in an environment where the reclusive act of texting has come to replace the boisterous din of parental banter, I think of the fetus/star child from Stanley Kubrick's hauntingly prophetic masterpiece 2001. Written with Arthur C. Clarke, 2001 is still widely regarded as one of the most important films of all time. In his book on the making of the film, Piers Bizony expounds[7] on the insight that one of the main reasons why so much of 2001 accurately predicted how we are in fact living with technology today is

6 Turkle, S. (1995). *Life on the screen: Identity in the age of the internet.* New York: Simon & Schuster.

7 Bizony, P. (2014). *The making of Stanley Kubrick's 2001: A Space Odyssey.* Frankfurt: Taschen.

because the filmmakers were in a race with NASA — the film had to significantly outpace the emerging technology or else Kubrick's vision would appear outdated. So they needed to understand which technological tools were coming to market and how their usage might evolve. The prophecy was born of a reasonable hypothesis of the next steps NASA and private enterprise partnerships were likely to take.

Yet it is not their predictions of the technology itself that holds my imagination. It is their predictions of what happens to humanity as a consequence of these newly acquired tools. I think of the star child, floating absolutely alone through the vastness of space, untethered to any maternal cord, eyes wide open, staring not at the viewer of the film, but through and beyond them. Maybe the star child represents the next evolutionary stage for humanity? Soon after he saw the film in 1968, the late Pulitzer Prize–winning film critic Roger Ebert discussed the brilliance in Kubrick's vision with a message that resounds and invites pause a half century later:

> [Kubrick] shows us becoming a toolmaker in order to control our natural environment, and he shows us finally using our tools to venture out into space. At the end, he shows man drawn beyond his tools so that we exist in the universe itself with the same natural ease we once enjoyed on Earth . . . man undergoes a transformation as important as when he became a tool-user. He becomes a natural being again, having used his tools for hundreds of thousands of years to pull himself up by the bootstraps. Now he no longer needs them. He has transcended his own nature, as that original ape did, and now he is no longer a "man."[8]

8 Ebert, R. (1968, April 21). *2001 — The monolith and the message*. *Roger Ebert's Journal*. http://www.rogerebert.com/rogers-journal/2001-the-monolith-and-the-message

Does this accurately describe the current digital explorations of modern cybernauts? Will the digital tool-makers be reborn in cyberspace, as the techno-boosters hope, into something greater than mere humans? There is no doubt that the unfolding digital present is proving to be quite evolutionary in regard to how we construct our social reality. Texting is replacing talking. Teams and workspaces are more often than not virtual. And most curious to those of a certain age, a social invitation now requires a dimensional qualifier. The urbane denizens setting the trends of contemporary civilization are radically differentiating themselves from all other organic life via a somewhat frantic and unthinking mass transference into digital space. Where Kubrick's prophetic vision falls short is in his presumption that humanity would use their advanced digital tools in the exploration of the natural world. Instead, we're retreating from the organic world altogether.

What still strikes me about the closing image of 2001 is the loneliness in the eyes of the star child. Yes, there was a knowing peace in the star child's glimmer as he turned to face the audience, but to the younger me it was a chilling gaze. Our techno tools are addictive — not by accident, but by design. How can we not be horrified that leading social media companies have behavioral neuroscientists and psychologists on staff, not to cure the mental diseases of addiction, anxiety and depression, but to encourage their manifestation?[9]

It is not the vastness of an ever-expanding universe that interests the majority of our leading creative minds, but the potential of a shrinking retreat. Closed borders. Closed conversations. Closed systems. It is not the discussions of those who have lived bigger lives, physically traversed a greater span of our planet's terrain or seen more firsthand that interests a good chunk of our

9 Dillard-Wright, D. (2018, January 4). Technology designed for addiction. *Psychology Today.* https://www.psychologytoday.com/ca/blog/boundless/201801/technology-designed-addiction

fellow citizens, but the retreat to a narrow world that they can both create and control. Perhaps they will view *me* as the lonely star child, floating through a physical space detached from the digital tether of hive connectedness. The very human act of looking upwards into the vastness of space can both remind us of the loneliness in the human condition and inspire a motivating sense of awe, wonder and the limitless possibilities of human endeavor. It is perhaps fitting that in the early months of 2017 scientists discovered a number of previously unknown planets potentially able to support life and within a distance from Earth that is theoretically possible to traverse over a lifetime — and few people cared.

Those of us who still believe in the enduring value of unfettered free expression, an inclusive type of capitalism, a non-fundamentalist, welcoming approach to religion or other ideas that were once taken seriously by thought leaders need to rethink their paradigms and reclaim social power. We need to find hope amidst the dissonance, a word of Latin origin that means "not agreeing in sound." Psychologist Leon Festinger's theory of cognitive dissonance suggests dissonance leads to psychological discomfort, motivating sane and rational beings to try to reduce it.[10] Most often, these efforts lead to consciously avoiding information that would likely increase dissonance. But that won't work in times of social upheaval. We need to encounter the dissonance head-on and unafraid, with the intention of transforming that which makes us uncomfortable into something hopeful.

New ideas that make us uncomfortable are an opportunity to question assumptions. Even those who prefer cold rationality over emotional heat should not turn away or reject these feelings . . . Strengthening the mind requires spending some time sitting in these awkward feelings, soaking in the sensations and trying to gain a clearer understanding of that discomfort's powers.

10 Festinger, L. (1962). *A theory of cognitive dissonance*. Stanford: Stanford University Press.

A safe way to embrace dissonance is through conversation. In this book, you will be exposed to an impressive variety of imaginative, iconoclastic and prophetic artists and conversations that explore the many difficult but empowering paths to wisdom in the information age. Richard Rorty defines wisdom as the ability to keep a conversation going.[11] Is there wisdom to be found in listening to people we disagree with or whose opinion makes us uncomfortable that is more life-affirming than crafting the safe space of an echo chamber? Is wisdom, as opposed to identity, still a virtue that can help heal the contemporary malaise?

We are surrounded by information and cynical of efforts to transfer wisdom of the past to our always buzzing contemporary hive mind. But are we generating new paths to wisdom, or are we simply collecting information? Author and artist Douglas Coupland worries that when we know that all the information that exists in the world can be accessed instantly by the tiny devices in our pockets, world-weariness creates a disincentive for doing so.[12] Our lackadaisical attitude towards seeking wisdom is made more worrisome by corporations increasingly infringing on personal space. As author and technology critic Franklin Foer eloquently warns, companies like Google, Facebook and Apple "aspire to encompass all of existence . . . More than any previous coterie of corporations, the tech monopolies aspire to mold humanity into their desired image of it."[13] Is this what we as a society want? To have every aspect of our individual life dominated by corporations? Do we even remember what it means to trade fairly? Love of innovation means finding new ways to engage in business, politics and culture, and where innovators seek to not only further

11 Rorty, R. (2009). *Philosophy and the mirror of nature*. Princeton: Princeton University Press.

12 Coupland, D. (2010). *Player one: What is to become of us*. Toronto: House of Anansi.

13 Foer, F. (2017). *World without mind*. New York: Penguin.

enrich themselves but to improve the society in which they are active. Innovation should be tied to a sense of moral agency and a vision for social change. Innovation should be a value-creation process dedicated to finding new ways to meet social needs. And innovators need to convince the public that their vision for society is just.

The conversations that form the core of this book present fifteen ways forward. This book sets out to test ideas with the imaginative, romantic, iconoclastic visionaries who can reshape our thinking. What links these seemingly disparate individuals is their sense of wonder that powers imaginative expressions — whether it be through dissonant rock, punk shamanism, ecstatic dance, poetic rap, fantastical comics, magical clowning or mystical channeling — that can help us tune out noise, turn on our imaginations and discover new paths to the heart of wisdom.

CHAPTER 1

Be Brave and Romantic

Nearly fifty years ago, sociologist Peter Berger asked[1] whether Western society could still find transcendence in a modern secularized world. And while[2] he did not single out experiencing art as a secular path to transcendence, he did list hope, play and humor as possible paths — all elements of artistic expressions. Some of the artists we will meet rage, while others laugh. Some will offer order, while others deconstruct. All of them have spent a lifetime refining their imagination by engaging in experimental creative activity and immersing themselves in creative environments. It is their voices, often speaking from the margins, that we must listen to and learn from so that we can improve our own imaginative faculties.

In our pre-secular past, the path to transcendence was heralded by prophets. Has America known prophets? I think

1 Berger, P. I. (1970). *A rumor of angels*. New York: Anchor Books.

2 Christoffersen, S. A., Hellemo, G. T., Onarheim, L., Petersen, N. H., & Sandall, M. (2015). *Transcendence and sensoriness: Perceptions, revelation, and the arts*. Boston: Brill.

Abraham Joshua Heschel and Martin Luther King Jr. may qualify, rabbi and preacher, white and Black, marching together in Selma over fifty years ago. Do we still have prophets of that caliber? Let's ask a different question first: what are the qualities we should expect to find in a contemporary American prophet? Before we can know if worthy prophets still exist, we need to know what characteristics we should be looking for. In seeking to answer that question, Richard Rorty[3] decided that today's prophets would be patriotic, religious and romantic . . . and therefore very unlikely to find a welcoming audience in modern America!

Our first path to wisdom is inspired by the last of these prophetic characteristics: the often-maligned romantic spirit. The romantic instinct is missing in the mainstream political and intellectual voices that dominate our contemporary cultural landscape. This is a shame, because romanticism was the essential calling card of the ancient prophets and poets . . . but it has been devalued. As the public conversation fills with arguments rooted in alternative facts and lacking in sense, individuals seeking wisdom need to embrace their romantic instincts.

Let me share a personal story. As a know-it-all undergraduate student in philosophy, I would spend hours arguing with a professor who was also a rabbi and member of a fundamentalist Hasidic sect. I could understand the backwards appeal of fundamentalist cultural isolationism to those who didn't know better, but how could this esteemed scholar live a life that was so antithetical to rational inquiry? Our back-and-forth on identity and purpose went on for years. Until one day, we were sitting at his dining room table, having consumed copious amounts of vodka, and he stared straight into my eyes and said, "You will never know the incredible joy I feel in being a Hasid of my rebbe. Your intellect

3 Rorty, R. (1991). The professor and the prophet. *Transition* (52), 70–78.

will never allow you to feel what I feel." And with that he poured us another shot, and we never debated the issue again. Because he was right. My drive to overanalyze and hyper-rationalize prevented me from seeing the positive possibilities in his choice to make himself completely vulnerable to his teacher. He had chosen a romantic path to wisdom, and while I recognized the wisdom in him, which is why he was my teacher, until that moment I simply could not see the necessary connection between what he was and how he came to be.

To pull back from spectacle and baseness and present deep emotion requires vulnerability, which is the major risk of committing to a romantic pursuit. Too many of us are scared of allowing ourselves to be vulnerable, often with good reason. People are cruel; people judge; people exploit. We protect ourselves with our own judgments and rationalizations. We think our paths to knowledge are the only ones worth taking. So the opening path to get beyond knowledge and information and actually seek wisdom is twofold: Be brave to be romantic.

Courage is the emotional strength that allows us to accomplish our goals in the face of opposition,[4] including traits like integrity, authenticity and perseverance. Being real means being brave. Being brave means being vulnerable. Being vulnerable lets us build more durable relationships. This may shock a generation who has matured on social media, but authenticity involves the long and hard work of developing an honest reputation, and not simply worrying about our "brand." Perseverance means rejecting the shortcuts offered by public relations deceptions, and instead working hard to show the world the distinctive character that we have developed.

A romantic spirit can bolster our focus during tumultuous times. It spurs the quest for ideas, which encourages commitment

4 Peterson, C. & Seligman, M. E. (2004). *Character strengths and virtues: A handbook and classification.* Oxford: Oxford University Press.

to a project even when there is uncertainty around the outcome. The romantic instinct creates a shared sense of trust that allows for radical exploration and the hope of creating something transformational. A romantic spirit can be the foundation of trust and hope in times of discord and fear. Romanticism can be the driver of innovation in uncertain environments.

In fleshing out what it might mean to be romantic, Heschel describes[5] prophets as poetic, iconoclastic and unwilling to tolerate human mediocrity. It's also how I would describe my heroes. Lee Ranaldo emerged from the no wave scene of 1970s New York City, honing his voice and craft over decades while maturing into the elder statesman of alternative culture that he is today. In our radically disruptive age, the ability to be comfortable with dissonance is a valuable currency. Lee was the guitarist and cofounder of the seminal alternative rock band Sonic Youth, but his creative vibrancy has only increased over the past few decades as he continues to express himself as a musician, poet, writer and visual artist.

Though far too modest to ever self-identify as such, Lee has all the hallmarks of a contemporary prophet: a true artist, using words, music and performance to stimulate the emotional and imaginative faculties of his audience; a post-punk iconoclast and elder statesman of alternative rock challenging the revered; and one of the kindest and most humble individuals one is ever likely to encounter. The goal of talking with Lee is to learn what we can from someone who has spent a lifetime immersed in sonic dissonance. A society in flux can still thrive, as long as we can listen to each other, and on occasion, listen to those who are outside our community. Dissonance need not be a conversation stopper, provided that a few safeguards are securely in place.

In my mind, the most important of these safeguards are innovative subcultures. A healthy society must include constellations

5 Heschel, A. J. (1962). *The prophets.* New York: Harper & Row.

of small subcultures that carry on distinct conversations that empower its members. Lee Ranaldo, both with and without Sonic Youth, has been at the forefront of creative subcultures, as an inspiring leader and active participant, for over four decades. For those unfamiliar with his former band, I defer to his compatriot Lydia Lunch — another personal hero whom we will encounter in our closing chapter — and her description of Sonic Youth as "the aural equivalent of an interplanetary detonation, which reconfigures sound into a blistering emotional maelstrom." Sonic Youth were a group whose musical explorations defied categorization, veterans of the post-punk scene of '80s New York and the alternative-rock breakthrough of the '90s. They directly inspired and introduced to the world bands who would more explicitly shape pop culture, like Nirvana.

The first Sonic Youth album (cassette, actually) I ever bought changed how I think about the world, and as a piece of art is no less impactful today. We all have songs or stories that inexplicably stick with us over the course of our lives, offering emotional resonance that does not wane even as the context of our enjoying the songs or stories may change radically. For nearly twenty-five years, the Lee-penned Sonic Youth song "Wish Fulfillment" has elicited the most powerful emotions in me not tied to a particular place, time or associative experience as pop songs may, but through the immersion in its three and a half minutes of dissonant envelopment.

Heschel had a thought on the topic of musical expressions versus argumentative expressions worth bringing up here. He realized that "listening to great music is a shattering experience, throwing the soul into an encounter with an aspect of reality to which the mind can never relate itself adequately . . . the shattering experience of music has been the challenge to my thinking on ultimate issues. I spend my life working with thoughts. And

one problem that gives me no rest is: do these thoughts ever rise to the heights reached by authentic music?"[6]

"Wish Fulfillment" offers the soul-shattering experience that defies analytical explanation. The song opens with twin guitars: one playing a gorgeous melody, each note methodically picked and clear; the other offering a howling screech of feedback and distortion. The feedback stops for a moment, leaving just the melody, and Lee sings plaintively, "I see your wishes on the wall," when again there is a burst of sustained distortion, "and that's all right with me." As a listener, you don't know where to focus your attention, the melody in the foreground or the sonic blasts in the background. The song's narrator sees the "wishes" of the person he is addressing, her innermost fantasies of being in a magazine, being validated as a celebrity of sorts.

The strength of a musical expression is that an audience, in this case a listener, gets drawn in to the narrative of the desire to be famous more completely than if, say, the audience were a reader of an argumentative article exploring the same topic. The song was written in an era that preceded social media and selfies and is timelessly framed as an observation of a typical human emotion, a frailty that has the power to endure through changes in media, format and reach. Whether published on glossy paper, or lit up on screens through social media, the core of the wish to be seen, to be admired, remains the same. And so the message at the core of the track still resonates powerfully today. This type of wish is now easier to fulfill and as a consequence represents a more dangerously seductive frailty.

The narrator of the song assures the dreamer of approval and safety. As each lyrical phrase is punctuated by a double hit

6 Heschel, A. J. (1966). *The vocation of the cantor.* American Conference of
 Cantors.

from the rhythm section, there's a haunting calmness that is barely contained in Lee's voice as he sings, "Your life and my life they don't touch at all, and that's no way to be / We've never seemed so far." The feedback begins to sound more pained and wounded. Perhaps the safety is not there, perhaps her fantasies negate the possibilities of a meaningful relationship. Then, the true ferocity of the band is unleashed as he screams, "What's real? / What is true? / I ain't turning my back on you!" and all the power of their distorted, alternatively tuned instruments are brought to the fore, and the narrator, as a powerful figure, is drawing the intended recipient of his words back in to a safe and assured space, no longer as soft-spoken poet but as passionate defender.

Lee: There are a couple of particular people I had in mind when I was writing "Wish Fulfillment." That song is a very important song to me — I don't really feel like the recorded version that Sonic Youth made really fully captured it. There are actually a couple of demo versions which are a little more gentle — which is more to me the way the song is. But yeah, it did go back and forth between this dissonant thing and these romantic, heartfelt images. It was partly about getting caught up in the world of magazines and glossy culture — and it was kind of addressing someone who seemed to think that culture was THE culture. And was aspiring towards that reflection — the reflection you get when other people see you on a glossy magazine. And I guess just being aware of the fact that aspiration is not what is really going to be fulfilling in the end. Just trying to look at that — without being particularly critical as much as being observant.

There, in essence, is the power of art today: offering a perspective that is not explicitly critical, but reflects the observations

of someone who may be a bit wiser than us. For those of us peering into a social world that seems far more confusing than ever before, exposure to the imagination of artists like Lee can be therapeutic. Listening to songs like "Wish Fulfillment" has the potential to expand the moral senses of an audience, and not just due to the story being told. The music itself has a unique soul-shattering power.

Lee and I met up before he was to perform a solo acoustic show at the appropriately named Great Hall, originally constructed as a state-of-the-art YMCA in 1890, and now a regal venue whose stage he would first grace exactly 100 years after its construction during Sonic Youth's second appearance in Toronto. My fondest memories of Sonic Youth are when they brought their dissonant sounds to majestic concert halls like the Masonic Temple and the legendary Massey Hall, venues whose historic importance would lend an added weight of significance to the proceedings. And even without a band or the wall of distortion, seeing Lee perform onstage with nothing more than a rug beneath his feet, a guitar in hand and some chimes within reach is no less powerful. If anything, the ferocity of his stage presence seems even more all-consuming in the company of acoustic instrumentation and a cavernous hall that naturally amplifies his sounds.

Dissonance can lead to a state of psychological discomfort. So sane and rational people are likely to try to reduce the dissonance, or so the dominant thinking goes. Lee continues to explore dissonance in a myriad of artistic endeavors. What can he share with those of us who have not been as brave and find ourselves disoriented? In our conversation, I asked him to talk about his lived experience as an artist. In the current political climate, trying to perceive what it means to be part of meaningful social conversation has become a near impossible exercise. We don't really know how to listen anymore, or how to tune out the noise. Maybe Lee can help show us how to turn on our imagination.

Lee: I guess the easiest way to explain that is that I don't make a huge distinction between consonance and dissonance. I think a lot of people use dissonance in a negative context, and to me it's all part of music. For instance, when Sonic Youth was first starting out people were like, "Oh these guys are noise merchants," or whatever, and to us, it was never about making noise. It was about using the dissonant qualities of some sounds in opposition to beautiful sounds or consonant sounds. You're trying to play something that's either beautiful or on the reverse side that's supposed to be a little aggressive or a little bit discordant. I think if I was thinking about the fact, in the way you phrased it — "you've been dealing your whole life with dissonance" — it sounds a little depressing in a way.

But the dissonance that Lee and Sonic Youth were exploring was not depressing. Lee has written that Sonic Youth were interested in integrating pop structures with noise. That is a very different imaginative endeavor than the projects of, say, French philosopher Jacques Derrida or American Beat writer William S. Burroughs, who also were experimenting with dissonance in their artistic media. Rather than deconstruction, which is what Derrida, Burroughs and others were doing, Sonic Youth were looking for integration. And that is an especially compelling message for those navigating the contemporary socio-political landscape. On the right, we find the desire to tear down the institutions that have supported American democracy since its founding a very un-conservative undertaking justified by the view that these institutions — academia, the free press, an independent judiciary . . . even the FBI and CIA (because of the so-called Deep State) — are irreparably corrupted. On the left, there is an equally passionate desire to dismantle the institutions behind the established social order, which they view as corrupt from the start, like the so-called military-industrial complex, although the

vision of what to replace it with is not yet clear. Both sides are privileging deconstruction at the expense of integration, which is why our political culture is in crisis. The message I get from Lee is that, as an artist, integration is the far more fruitful path.

Lee: I think, in part, that we were children of the time when it was all part of the sonic palette. When Stravinsky premiered *Rite of Spring* in the teens — 1913 or whatever it was — it wasn't part of the vocabulary and people reacted very badly. I think these days it's much more accepted. When Sonic Youth started out it wasn't like that, and we were considered "noise-icians." We happily wear that tag, but ever since then society has been a lot more accepting, and now people are using stuff that sounds beautiful alongside stuff that sounds a little discordant or dissonant. This integration makes the dissonance less offensive, less distinctive . . . it's just another color on the painter's palette.

Stravinsky is a wonderful reference. Riots broke out in May 1913 when the composer put on the premiere performance of his *Rite of Spring* ballet. The audience was appalled by the level of dissonance in the piece, with a reviewer who was present at the ballet complaining that "the music always goes to the note next to the one you expect."[7] This infuriated the crowd, leading to the surprisingly violent reactions. Why did hearing the note next to the one expected have such a strong impact? Cognitive researcher Daniel Levitin explains the effects of tonal dissonance this way: two notes can sound dissonant together if the sequence doesn't conform to what we expect or are used to hearing.[8] So

7 Hewett, I. (2013, May 16). *The Rite of Spring* 1913: Why did it provoke a riot? *The Telegraph.*

8 Levitin, D. J. (2006). *This is your brain on music: The science of a human obsession.* New York: Dutton.

for example, babies prefer the predictably soothing sounds of the consonant melodies heard in lullabies. The ability to appreciate noisy dissonance — like the music of Sonic Youth or Stravinsky — comes later in life. Of course, the thought of a contemporary audience covering their ears and losing their minds should Stravinsky be played is laughable. As a society, we evidently have the ability to evolve our thresholds of tolerance for tonal dissonance. So why not cognitive dissonance?

Dissonance can be integrated so that it is simply another color on the palette of sense-making. We need to refine our listening skills in the same way that many of us have refined our visual perception. We are not thrown off-balance when encountering a surprising color. We laugh at Stravinsky's first audience, who violently reacted to unexpected sounds. But why are we so much more sensitive to unexpected words or ideas? It is not uncommon on university campuses today to find controversial speakers being violently shut down by self-identified progressive students. In many ways, we have not evolved that much from Stravinsky's crowd, but the potential is certainly there. We as a society need to figure out how to facilitate the development of better listening, because it is not yet a natural or comfortable state for most people.

In Lee's artistic endeavors, there is a deep desire to keep a particular type of conversation going. In addition to creating dissonant sounds as a "noise-ician," he writes poetry, publishing some of these as gorgeous, hand-bound volumes, treating the book itself as a piece of art, as books once were. He plays stripped-down acoustic concerts, like on the night we spoke, hearkening back to a once-vibrant coffeehouse culture and the powerful protest songs that shaped a revolution. There is a distinct romanticism in the conversation he leads as an artist, which one does not hear in the elites. I wonder if this why we are at this current cultural crossroads. We're not hearing enough bravely

vulnerable romantic voices. Our elites may tweet, but they don't write poetry.

On the surface, it may seem a cheesy observation, but maybe what our society really needs is more poetry. And, by the way, I am making this suggestion at a troubling time in our culture, as editors at a century-old American progressive weekly are in fact *apologizing* in real-time for the radical poetry they published hours earlier![9] When the public conversation is filled with senseless arguments of alternative facts, a call to return to the poets is actually radical and disruptive. But can the contemporary artist/ poet step up to the social megaphone and lead our conversation? It seems that both the left and the right have no interest in creating a space for experimental poetry, and even progressive gatekeepers have lost the will to fight for an authentically disruptive disruption. Writing for the *New York Times*, a former poetry editor of the *Nation* points out that over her thirty-five year tenure they never once apologized for a poem they published. She believes that that "the proper thing to do would have been to reprint the poem together with readers' opinions. That would have been in keeping with the expectations of a free press."[10]

Lee: Mainstream culture is so bent on the lowest common denominator. I guess I can't see the stuff I'm doing or the stuff Sonic Youth has done as in any way being welcomed into that world — it's such a different place. What's interesting about romanticism, because there's an awful lot of cheesy romanticism on TV or in movies, is that it is not true romanticism . . . I find that a healthy dose of

9 Schuessler, J. (2018, August 1). A poem in *The Nation* spurs a backlash and an apology. *The New York Times*. https://www.nytimes.com/2018/08/01/arts/poem-nation-apology.html

10 Schulman, G. (2018, August 6). *The Nation* betrays a poet — and itself. *The New York Times*. https://www.nytimes.com/2018/08/06/opinion/nation-poem-anders-carlson-wee.html

romanticism is a good way to keep on track. I think for some people they would say that's a bit of a dirty word — like it sounds "too cutesy" or "too Hallmark-y" or something like that — but I have no problem with the idea of romanticism. In a way, if you are trying to live an artistic life you are on some level involved in a romantic pursuit from the word go — you don't have a straight job, and you do this other stuff, and you hope that people will respond to it and allow you to keep doing it. So I'm not afraid of the romantic tendency. Some of our greatest artists are romantics . . . If you look at Patti Smith, there's a huge romantic tendency in what she does, and she uses it to access certain feelings or certain intentions that you need to access in that regard. I almost wonder if the breaking down [in her December 10, 2016, performance at Bob Dylan's Nobel Prize ceremony] was almost a little conscious — to do a little bit less of a straight rendition of the song and really remind people where they were at that moment. I thought it was really beautiful.

The romantic instinct is missing in the political voices of today. As we discussed earlier, the philosopher Richard Rorty noted that romanticism coupled with patriotism were hallmarks of the ancient prophets. Prophets were those who loved their country, and their countrymen, but were so sensitive to evil that nothing pertaining to questions of the good was ever considered to be corny or uninteresting. Abraham Joshua Heschel viewed prophets as poets who used emotional and imaginative language to challenge the revered, unwilling to tolerate human mediocrity. Prophets coupled a romantic view of the future with a demanding attitude towards the present. If the artist won't be given a platform in mainstream culture from which to be heard, or have that platform pulled away if the market doesn't like what is produced, their art can certainly seep into the social conversation in less explicit ways. We need exposure to Heschel's shattering

experience, listening to the sounds that rouse our souls when the critical faculties of our mind are confused, to open us up to authentic inclusivity.

As Lee explains, there is a romantic instinct in the commitment to living an artistic life, and this instinct allows the artist to access feelings that are beyond the reach of calculative logic. There is bravery in the commitment to creating meaningful art in a culture that values spectacle. Social media and reality TV seem to celebrate our baser animalistic instincts, but not the sort of imaginative expressions that can lead an audience to a greater sense of inclusivity. The type of art being discussed here celebrates the deep possibilities of our humanness. That sense of wonder has long been evident in Lee's work. I cannot help but think of Douglas Coupland's observation, briefly discussed in the introduction, which explains that the problem with information in our digital age goes beyond an unwarranted faith in data analytics and the increasing aptitude for error. His "omniscience fatigue" hypothesis explains why we as a people do not seem to be getting smarter despite living in the information age: When we know that all the information that exists in the world can be accessed instantly by the tiny device in our pocket . . . why bother accessing it? Wonder disappears when the romantic instinct is crushed by the practical reality that everything we could possibly want to know can be attained by the simple push of a button.

Lee: It's an interesting thought — I know what he means. It's the same thing we used to say in the old days, you would get a record album, and it would be this mysterious object, and it might take you months to get more information. You know, like who is this guy Jack Nitzsche that produced Neil's record? And now, you can just pull a thing out of your pocket . . . it takes a lot of the mystery away. But I don't think you can let that stop you. I think the thing about people who have long careers — in any field, really, but

certainly in artistic fields — is that they remain interested. Not only in what they're doing, but in being part of a larger conversation. A lot of people have a flashpoint where they are either doing really good work, or they are really popular — and then they lose the interest as soon as their popularity wanes. A true artist is just going to put their head down and say, "This is what I'm here for, this is what I'm doing," and just continue doing it sort of no matter what because that's what they do to breathe or however you want to characterize it.

The artist, through determination and commitment, facilitates empowering conversations. The advancing of a social conversation, by definition, cannot happen in solitude. One can meditate to intellectualize a greater inner sense of inclusivity, but the inner experience must then be given a voice. Nor can the social conversation be any further advanced through confrontation and argument, at least not now. There is a unique power to artistic expressions, and we need to refine ourselves to be able to listen to them. This conversation with Lee affirms support for one of the major conclusions I want to push, which is that we need more artistic and less argumentative expressions. In Lee's artistic output, there aren't many arguments — in contrast to, say, Neil Young. Neil, genius that he is, still has a tendency to put out arguments, while Lee restricts himself to imaginative expressions. In this way, Lee acts as a facilitator of a conversation, rather than the conductor of a monologue. It is an important difference. With an imaginative facilitator, the romantic wonder of conversation can be sustained.

Lee: Who wants to spend their life arguing? I think the objective is to add what you can to the conversation and to further dialogue through inclusion. That was one thing from Sonic Youth that surprised a lot of people in

the early days — we were really interested in punk music and the American hardcore scene and all that, but we were also really interested in Prince and Madonna and people thought that we were taking the piss, as they say in England. And it wasn't that at all — to us, we didn't see any problem with being more inclusive and bringing more people to the party and putting more ideas and bits of information into play, is the way I would put it. I think that is a lot more important than arguing or jockeying for a position at this point.

Bring more people to the party. Be more inclusive. But inclusivity is not an invitation to all viewpoints. A healthy liberal society still needs to place limits on inclusivity. Society still needs something to distinguish between what Rorty terms the sort of "individual conscience we respect from the sort we condemn as 'fanatical.'"[11] How do we determine this? Not through theory, but through imaginative works that redescribe our world. Through art. So it is art, not celebrity, that can facilitate the primary noble endeavor of the liberal enterprise. What differentiates an artist from a celebrity? I'll start with modesty. Lee engages in a myriad of collaborative efforts, and what stands out is how he always gives space to the other. The listener hears his voice, but also the others.

Lee: I feel like — especially if you're involved in a group activity — you have to give yourself over to the group. There's very little place for ego in that situation. In a way, the modest thing to do is to be a part of a group and to allow all the voices to be heard, and not be trying to ball hog,

11 Rorty, R. (1991). The priority of democracy to philosophy. *Objectivity, relativism, and truth: Philosophical papers.* Cambridge: Cambridge University Press, 175–196.

as Mike Watt would say. And that's the whole nature of it. If I'm doing music where it's collective improv . . . you want to be part of the group — so it's just as important to be listening as it is to be dominating. Group dynamics are certainly interesting. If someone has a brilliant idea, or a brilliant riff, you don't want them to stress it, but you don't want to be a ball hog either. It's got to be a give and take. It's a conversation. With that kind of work, it's different — I'm playing solo acoustic tonight, so it's all my decision-making, and it's a different process. But as soon as you start involving other people, what you're asking for is a collaboration, and there's no point in trying to have a collaboration where you're trying to dominate the situation.

Lee talks about being influenced by two-guitar bands like the Grateful Dead. Ostensibly the soul of the band, Jerry Garcia always created space for collective exploration. While still retaining a unique and identifiable sound, Jerry was widely hailed as being a generous musician. Giving space to others need not detract from the power of an individual voice. At a recent gala in Toronto for Hebrew University, I heard the Dead's Bobby Weir address this topic directly, talking about the necessary combination of humility and effort to make creative collaborations work.

Lee: He's pretty wise about that stuff, and those two — those are good. Nobody needs an egoist, or someone who walks around thinking they are God's gift to the planet or something. It's much nicer to be humble. I think the idea is that you put your work out and people either respond to it or they do not. You can't really influence that. You certainly can't influence it by puffing up your chest or anything like that. So the idea is that you put in the effort. My painting teacher used to say that talent is one thing, but you have got to show up every day. If you don't show up, no matter

how much talent you have, you are not going to get anywhere. The people that do show up every day, they are the ones that succeed, because they are working at it. So those are two good words [humility and effort] that were brought up.

Humility and effort are critical to the success of experimental artistic endeavors. Yet, while big media can certainly promote the latter, it is less supportive of the former. Research has shown that egoists and narcissists thrive even when helming innovative corporate environments.[12] This is confirmed in the experience of not only Lee, but many of the artists across different media and platforms featured in this book, who suggest that experimental efforts will only take place underground. The most interesting conversations may never be heard in the mainstream. Which is troubling. If it is the unselfconscious artist that can best facilitate conversation, and if it is listening to art that expands our sense of inclusivity and tolerance, then it is critical for these experiments to be taking place in the open, or at least with the tacit endorsement of broader society, through tax-payer support of cultural institutions committed to experimentation.

Lee: I think there is a reason why it's "counterculture." I don't think most of the mainstream has time or interest in it. Most people don't have time for art in their lives. They work a nine-to-five job, they come home exhausted, they have a beer, they play with their kids and they go to sleep or whatever it is — whatever their particular form of oblivion-seeking is. Again, I don't think it matters if it's mainstream culture or counterculture — I find that

12 Gerstner, W. C., König, A., Enders, A., & Hambrick, D. C. (2013). CEO narcissism, audience engagement, and organizational adoption of technological discontinuities. *Administrative Science Quarterly, 58*, 257–291.

counterculture usually has more of an interest in it. And those ideas filter into the mainstream culture. Take a band like the Velvet Underground. Brian Eno's famous quote — hardly anybody bought their records, but everybody who did formed a band, and it just went snowballing from there. And even with Sonic Youth, we saw much more mainstream acts — from Nirvana on down — that were mining aspects of things that we brought to light, and doing them in a more palatable way and becoming mainstream.

For some people that just happens — like with a band like Nirvana, it just happened, they didn't imagine that that was going to happen to them — but there are also people who go out and deliberately try to design their work to be super popular in a mainstream way. You know, all those songwriter collectives that are analyzing riffs and locking in things like there needs to be a new hook every thirty seconds or whatever it is. Usually counterculture people are much more on the quest for an idea. They've got an idea in their head or a vision of something and they are just trying to do it — and they're not even always sure what's going to come out, but they are explorers. They are explorers in that heroic kind of way, where it's not about getting the gold at the end but it's about finding the new knowledge or uncovering a new idea or a new image or a new sound.

This too is a theme that will repeatedly come up. There are celebrities who became such because they are excellent technicians. These are people in the comic book world who know how to draw a perfect figure, people in the music world who can produce a perfect auto-tuned melody or people in the film world who can direct the perfect effects-laden spectacle. These people are very successful in having their voices heard and tend

to dominate popular media. In contrast, there is the artist, who just wants to explore what is in her imagination and bring it to the fore. These folks tend to be less successful at being heard but are far more interesting.

Lee has described Sonic Youth as part of a constellation of artists. I like that framing, and in thinking about it, you can guess that the Sonic Youth constellation involved a lot of wildly independent individuals and little support from the major institutions of media. Western society is institution-heavy. This makes sense, as the technicians of popular art work with big media to institutionalize their norms of excellence. But we live during a time when these institutions have clearly failed to keep a healthy conversation going, which in turn has created the vacuum Trump filled. We awoke to find that our social institutions weren't as strong as we had thought or hoped them to be.

Lee: I think it's true, and I think everyone was flabbergasted with [the results of the 2016 presidential election]. For those of us who have lived in New York, [Trump]'s been a joke for twenty-five years. And the joke has bit us on the ass at this point. I suppose the institutions are failing . . . From top to bottom they failed. And now I think the press is in a situation where they know all the bad things about this guy and they're dedicated to being impartial reporters, but they're finding it hard to do that. They can see beyond the veil of what a hypocrite he is . . . I think that all of the liberal, left, democratic side has figured out that something big failed. And now they're trying to figure out what to do.

I always said that Sonic Youth — when people asked us about it — had an occasional song that was a little more pointed politically, but that our politics was one of personal sphere. Try to get your own house in order and, hopefully, the reflection of it that other people see will

ripple on out and other people will try to do the same. It's very hard to issue an edict to people that says, "You're going to live a more orderly [and, at the same time,] free-flowing life!" The things I've learned I've mostly learned from the example of people whose lives are being led that way. You're up against a huge Sisyphean battle because most people never care about this stuff or think about it. Most people tuned in to the election a few weeks before it happened — not six months or eight months or a year and a half before the way some of us were. They really didn't even pay attention until the last month. It's hard to get those people to wake up. It's hard to get people to wake up, in general. I think it is humanity's plight, in a way. That there's enlightened souls in a sea of people that don't have any interest in or any inkling that there's something beyond their little routines that they run in their lives — their little, circular routines. . .

Music is called popular for a reason. It's popular, it's on the radio, it's taking full advantage of mass culture. And there's a medium of mass culture. These days, it's the internet and social media stuff. So songs and music just have an advantage or a leg up on the cultural landscape. Plus in a way, time-based arts like music and film are so twentieth century. Especially recorded music! Recorded music is not much older than cinema, really. In the past it was always about a troubadour out playing their songs, but the idea of cinema as a time-based art, or the ability to listen to a piece of music over and over again is a pretty modern thought. So that's where the popular culture is. If you are Rihanna, you are played on the radio. And if you are Godard, you're played in three cinemas across the country. But that's not a value judgment. So often people tend to equate popularity with success, and that's a really bad tendency. Obviously it's not true at all — things can be

super successful without being very popular. It depends on the artists' intention and whether they achieved it or not.

In speaking about his stunning artistic achievement, Lee confirms again that what he creates are imaginative expressions, not arguments.

Lee: Yeah, it's not an argument. It's an observation. And I think oftentimes that's the most interesting or the best way to get at an issue — just being able to observe it or maybe contrast it to some other points of view. Doesn't have to be an argument, like, "You're doing the wrong thing, this is the way it should be!" That hardly ever convinces anyone, as is proven by the fact that Hillary didn't convince anyone by pointing out all of Trump's faults. They didn't give a shit. They didn't give a shit that he insulted women or foreigners or disabled people or anything . . . I have not had an easy day since the election. It's been kind of a nightmare . . . People just have to keep talking and resisting.

Lee played a powerful show that night, and then headed off later in the week to lead a protest show in Washington, D.C., the day of Trump's inauguration, where he was joined by his former bandmate Thurston Moore. He took to the stage lamenting, "This has been such a weird day, and a cap to a few weird months." But he offered hope that we can get through the weirdness, if only we could be brave enough to embrace our vulnerabilities and romantic tendencies. Lee's message is that while dwelling on immersing ourselves in dissonance as a state of being could be depressing, the romantic spirit can allow us to see that consonance and dissonance are simply colors on a palette, which can be integrated into something bigger, into a more hopeful milieu. His point, and this is critical, is that as both individuals and as a society the inclination to withdraw must be resisted. Instead,

participants in the Western social conversation must work to expand their collective thresholds of tolerance. And those on the margins must not fear being heard.

What characteristics need to be developed in support of strengthening our romantic instincts? A commitment to integrity, authenticity and perseverance seem to top the list. Accumulated wisdom can get lost when conversation stops, and the current trend on both the left and right seems to be the embracing of allegedly high-minded rationales for conversation stoppers. It became apparent through our talk that a different strategy is required. And while the idea is not new, it is out of fashion.

If we start by committing to authenticity in conversation, and we find the perseverance needed to see it through, we would then create the boundaries that make it safe for greater inclusivity almost by accident. In many ways, our society has shown a withdrawal from arguments. Many of us are tired and turned off by polemics. But we can, and must, continue to embrace authenticity and persevere in our efforts to keep conversations going. The first path to wisdom is being brave enough to be romantic. Lee Ranaldo, in true prophetic tradition, is skeptical about being heard. Like prophets of the past, he has a distinctly romantic vision of the future but a demanding attitude towards the present and is under no illusions about human frailty. It is up to us to listen.

CHAPTER 2

Reach a Wordless Consensus

The Hasidic professor who opened my eyes to the possibility of romantic vulnerability leading to wisdom had an astonishing number of acolytes. One was a gentle soul who had converted to Judaism and left behind a fairly troubled history. We became friends, and as we got to know each other he observed that I had many traits in common with someone from his past who remained very dear to him. These were the days before social media, so I never saw a picture of this person nor did she ever see me. I had her name and she had mine, and we had the vaguest physical descriptions — we both wore our hair in dreadlocks at the time, although for her it was more culturally appropriate. We were both told through this mutual connection that we were very much alike and should eventually connect. Years later I was at a rave and I locked eyes with somebody . . . who had to be her. This wasn't a romantic connection or chemical attraction. It was simply the person that I had to meet. I knew it was her, she knew it was me. The music was deafeningly loud, the lighting was dis-tortive and there was simply no way to have a conversation in that setting. But we had waited so long to meet and didn't want

to ignore that serendipitous moment. We smiled at each other, held hands and passed the time together in the silent connection of a wordless consensus.

The second path to wisdom is an extension of the first. If we are brave, and if we are vulnerable and romantic, we can connect to other folks through wordless consensus. Little in life tops this all-too-rare experience. It is the outcome of modesty and innovation. It is the unnamed competence of successful communities. It presents the opportunity to bask in the safety of finding agreement without the need to talk about it. The conscious feeling that accompanies a wordless consensus is something that a lot of people don't fully experience in their lives, and maybe if they did, it could lead to more peace of mind.

How does one even start the process of reaching a wordless consensus? Well, in the last chapter we realized that bravery and vulnerability are the traits behind a romantic spirit. And those are the first steps in reaching a wordless consensus. But the next step is trust. Trust is the expectation that the person we are engaging with will not take advantage of us, even if they could. Trust can be in the head or the heart.[1] Cognitive trust is based on the confidence we feel in someone's accomplishments and skills. As the name suggests, this trust is born of intellectual consideration and analysis. In contrast, affective trust comes from feelings of emotional closeness or empathy. A shared sense of trust sets the stage for truly radical explorations. In this setting, the path to wisdom opens up, as there is a reasonable hope of creating something transformational. Looking into the eyes of a fellow human being that we trust completely, knowing that we have turned on both of our imaginations and are transcending from an isolated "I" to · a substantive "we," is life-affirming. It is a sensation far superior to that of winning an argument.

1 Lewis, J. D. & Weigert, A. (1985). Trust as a social reality. *Social Forces, 63,* 967–985.

Through wordless consensus, we can share the same idea across different cultures, unconstrained by language barriers and united by the possibility of accessing the peace of mind, and power, necessary to discover wisdom. Sitting alone reading this book, you may think that this path seems far-fetched and utopian. It is not. I chose to start the chapter with a personal anecdote to drive home how real this is if we are open to the experience. But if there is a teacher who can show us how to transform the unfamiliar into something palatable, something inclusive and something we can trust, it is Nels Cline. Spend time in the presence of Nels and his instrument and you will be brought to a wordless consensus.

Nels expresses himself almost exclusively through sounds and rarely through words. His résumé is astounding, having played with Carla Bozulich in both the Geraldine Fibbers and Scarnella, as well as Mike Watt, Stephen Perkins, Thurston Moore and too many jazz artists to list here. While many instrumentalists are forced to play on the fringes, Nels was invited to join the Grammy–award winning band Wilco in 2004 and share his artistry with a mainstream audience. At the time, as Nels recalls, Wilco founder and frontman Jeff Tweedy was looking for "some random element that was going to take the music somewhere less familiar." Tweedy found that perfect element in Nels, a veteran explorer of sonic landscapes.

Despite his well-earned status as alternative rock royalty, Nels Cline is an incredibly humble, hospitable and generous human being. I was fortunate enough to meet him when Wilco was in Toronto playing a sold-out two-night residency at Massey Hall. The reviews were unanimous in their acclaim — Wilco has solidified a reputation as one of the most reliably impressive live acts touring today — and recognition that something special happens onstage when Nels steps to the front. It is unusual for guitarists to overshadow lead singers, especially one as compelling as Jeff Tweedy, but Nels Cline's solo during Wilco's live staple

"Impossible Germany" is a consistently exemplary expression of improvisation. On both nights, the notes he played coaxed the previously seated crowd to their feet.

What are the personal characteristics that allows Nels to throw himself so completely into his art?

Nels: Even though I may have doubted it at certain points, I almost have a kind of sophomoric romantic streak that I think has enabled me to keep going against all odds. Until I joined Wilco, my life was pretty difficult with regards to making a living playing music — I wasn't doing it, to be honest. But I haven't wanted to do anything else. And this is a combination of the degree of inspiration that I've felt from the very first time I was zapped by rock and roll and also how my parents were very supportive of these artistic impulses. My twin brother, Alex, and I venerated artists in a way that was really rather unrealistic. We didn't realize that so many artists had suffered so much and that society at large had not embraced them in their lifetime because here we were buying books with their paintings inside and going to museums and seeing their work and having people talk in reverent tones about them . . .

Nels is being self-deprecating, but the path to wisdom starts with being brave enough to be romantic, whether sophomoric or not. Nels has matured into an incredibly prolific artist, releasing some sort of new music every few months. His most recent release at the time of our speaking was *Lovers*, a big band jazz album that redefines the great American songbook by creating a musical bridge that carries the listener from Rodgers and Hammerstein to Henry Mancini and finally to Sonic Youth.

Nels: I was working at Rhino Records in Los Angeles and one of the employees was [music critic] Byron Coley who played

[Sonic Youth's] *Confusion Is Sex* one day, and "Shaking Hell" made a huge impression. Later, when I heard the Sonic Youth Iridescence single "Death Valley '69" [with Lydia Lunch], the B-side of which is an earlier version of "Brave Men Run," that was kind of an epiphany for me. You have this beautiful clanging sound with the guitars and the bass playing together and this interesting song with interesting architecture, and I became extremely enamoured with Sonic Youth around this time. Especially when *Bad Moon Rising* came out — that became a hugely important record for me. I began to continuously follow Sonic Youth's music and allow their sound to influence my playing. I acquired a Fender Jaguar and started doing strict fingering of unison notes that were slightly out of tune, to try to get that double chord unison string thing that I find so appealing in much of Sonic Youth's music — their open tuning and the balance by the bridge of the guitar. I find that sound to be like flowers opening up or like an exploding sun — something astonishing and beautiful and yet of this earth or sometimes cosmic.

Lydia describes the music of Sonic Youth as an "interplanetary detonation." Nels describes it as "sometimes cosmic," like an "exploding sun." These are not the usual metaphors one would expect in musical reviews. As Lee explained earlier, Sonic Youth never made a huge distinction between consonance and dissonance. For them, all sounds were part of the musical palette. Nels takes this idea further, elaborating on the philosophical possibilities that emerge when crafting music from all possible types of sounds.

Nels: One person's dissonance is another person's beauty and inspiration . . . It's truly subjective. What skews the objectivity is that there has to be the allowance of other

people's ideas. You have to accept all the voices and take them seriously before you rule things out or start narrowing your focus. In my teens and certainly early twenties, as I'm sure is almost a cliché, I had a lot of very strong opinions and what I'd consider half-baked ideas that created a kind of closed-mindedness in spite of my Catholic tastes. I think that had to do with insecurity, with inexperience — I was working in a record store that was kind of just the classic independent snob-infested, soapbox-mounting, strident kind of place. But it was also a place where a lot of ideas were exchanged. As I've gotten older, I've had these impulses re-emerge. What I want is for the conversation to be balanced and for all voices — even those I oppose or have suspicions of or have qualms about — to be represented and for me to get outside my own predilections or bubble and allow for the fact that I'm still learning and know very little.

As Jeff Coffin will explain in more detail two chapters from now, music is a metaphor for life. What Nels describes is the essential philosophy behind his unique approach to turning on the imagination. Within it are all the essential points of what we need to strive for if we want to be meaningfully engaged democratic citizens: allowance for different voices, serious consideration of oppositional opinions, careful deliberation before ruling out ideas or expressions, consciously creating space for things we may be suspicious of — and, of course, a comfort with dissonance. Beyond these points is another critical insight: the capability to incorporate this diversity in a conscious way means being able to truly listen, which is not a natural disposition, but a skill that develops over time with a deliberate willingness to learn.

This willingness to learn makes Nels unique in our popular culture. As a university professor, I can sadly testify that the scholarly instinct is disappearing. Perhaps this is due to the

omniscience fatigue described earlier. But the malaise goes deeper than that. Ours is a culture that privileges youth, identity and bite-sized blurbs over wisdom, experience and complex understanding. Nels listens closely to the expressions of his teachers, faithfully reproducing their essential contributions in a later context that makes the original expressions seem novel and fresh. Only such a diligent student of music could play his guitar in a way that allows for songs written by Rodgers and Hammerstein to blend naturally with songs written by Sonic Youth and still sound like a coherent singular expression. The argumentative equivalent would be someone equally influenced by the Nobel Prize–winning free-market economist Milton Friedman and the anti-capitalist social critic Noam Chomsky giving a policy speech that proudly wears the influence of both figures while making a coherent argument for something new. What Nels has done to the great American songbook has yet to be done in the conversation of American politics or economics.

So until that time when arguments are once again made by crossing ideological divides in the pursuit of holistic knowledge, hopeful seekers must turn to imaginative expressions for inspiration on how to thrive in the contemporary landscape. We have much to learn from a specific class of artists — those who improvise in a group context — as they are individuals with an advanced understanding of what it means to listen and carry on a conversation without words.

Nels: To be a successful improviser, you cannot have a doctrinaire attitude. In my case, it is the desire to meet the people with whom I'm collaborating at least halfway. And when you find like-minded individuals, you realize that you have to do a lot of listening while you're playing. Which, for some reason is not difficult for me, nor is it for my twin brother — we're kind of weirdly gifted with this ability and that is maybe what led us to become improvisers — but

it's rarer than you might think, even among accomplished musicians. So when you find that person who is listening to you as carefully as you are listening to them, and you create this sound world together spontaneously, I have to say that there is little in life that equals that . . .

With Thurston, I know to be patient enough that when he gets to a beautiful area, I let him stay with it — and it's so satisfying to be watching him emerge as an improviser. The sensibility that informs most of Sonic Youth's music has a lot to do with how he hears stuff. So I'm prepared, after listening to him for so long, to go into his world. But we can still shift and move and explore other things and honor those areas as well. There's something special about that — it's as if you are in agreement without talking about it. That's something that probably a lot of people don't experience in life, and maybe if they started experiencing that themselves, they could have more peace of mind. Because you realize that without talking, you came to an agreement, and then created something that had no pre-existing plan, and if you had to listen to it all over again you'd still like it, you know?

Nels provides deep wisdom on how to reach a wordless consensus in these few words. Successful improvisers need to be open in their thinking. The spontaneous creation of a compelling sound world, this novel artistic innovation, can only emerge when the artist finds a partner who is committed to listening as carefully as she is, in turn, being listened to. This deep listening, of course, suggests the need for modesty in the place of self-indulgence. For even in the rarefied company of like-minded, accomplished musicians, there is an enormous amount of listening that must take place as one is playing.

Nels describes his musical encounters with Thurston Moore as requiring considerable patience. This is not a slight — the need

for patience emerges from an essential generosity. Nels talks about being prepared to go into Thurston's world, to allow this partnership to explore new areas. In other words, the reward for these efforts is the ability to keep a conversation going.

There is deep wisdom in the musical conversation between Thurston and Nels as they come to an agreement without speaking. And it is quite likely that most folks go their entire lives without ever experiencing the gratification of non-verbal consensus. I think that our society would be best served by more people experiencing this for themselves firsthand. Art can offer solace in knowing that without talking, distinct individuals can somehow come to an empowering agreement.

I noted to Nels that there was a line of thought he had composed on his website (words!) that struck me. In the wake of the elections and their disturbing aftermath, Nels used the space to offer a blessing for "a clear-eyed embrace of facts," which I viewed as a dig to the political right, and "deep listening," which I think is what can sometimes be missing on the left. "Alternative facts" and identity politics can be differing expressions of the same fundamental malaise — that many people just aren't that curious anymore and simply don't know how to listen to each other. There is so much emphasis on the issues that divide us that effort is no longer being seriously placed on the issues that may unite us. I asked Nels if that was his diagnosis.

Nels: I like that. I certainly have a number of critiques about the way the left is as doctrinaire and as dismissive as the right. They do all these things that they hate when the right does. But, the reference in that little spiel there (which I'm usually reluctant to do — I've been so upset lately that I had to write something) was a nod to Pauline Oliveros. It's a nod to what she calls deep listening, and to what I've been calling deep listening without realizing she's been calling it that, and what you've been referring to. What

we have to do as musicians, improvisers or listeners is
to inform ourselves — and to extend that to conventional
conversations or reality, whatever you want to call it. Our
existence in society has to be based on acknowledgment
and respect for other voices and other sounds.

Pauline Oliveros, who passed away in 2016, was a composer
who developed a program for "deep listening."[2] She worked
across multiple disciplines; while she focused primarily on teach-
ing deep listening to musicians, the process drew on concepts
from psychology and spirituality to encourage listening that
included empathy, somatic awareness and "listening to listen-
ing itself" to "heighten and expand consciousness of sound in
as many dimensions of awareness and attention" as possible. In
other words, deep listening involves the use of the entire body
and mind and is a practice that needs to be developed. Nels went
on to explain the specific role exposure to dissonant music can
play in achieving this end.

Nels: I think that if one opens one's mind and heart to sound in
general, and to creative expression in particular, whether
improvised or organized, and starts to realize that a
listener is a participant and not just a bystander, perhaps
there is a kind of entryway . . . My hope is that people
will experience music without overthinking, that they
will allow for a feeling of exhilaration or transcendence
in their own bodies as they are experiencing the sound
. . . that they don't actually think about it all the way
through, that they don't analyze it right away, but have
an experience like I did listening to Sonic Youth, where
maybe you don't understand what you are hearing, but

2 Oliveros, P. (2005). *Deep listening: A composer's sound practice.* Bloomington: iUniverse.

you cannot resist being fascinated and even saying, "This is absolutely beautiful!" even though it sounds weird or scary. I would say that by allowing oneself to experience these mysterious if not mildly disturbing elements in one's life, that we are actually engaging life.

He then got technical, but the insight is fascinating even for the non-specialist.

Nels: I guess you could say that one person's dissonance is another person's full-flavored beauty. The "dissonance," as Western music thinks of it, which I developed an interest in is what I would loosely call chromaticism . . . [I came to it] at first from listening to improvisers such as the Art Ensemble of Chicago or Eric Dolphy or Miles Davis in his many different phases, and Anthony Braxton . . . Later, I think that my life's sound palette, if you will, became heavily influenced by Sonic Youth. And the sounds that I heard from Sonic Youth, which I think are probably rather dissonant, especially in their early days, which were distinctly microtonal but not systematically microtonal, I found to be exhilaratingly beautiful. That's why I say it's a pretty subjective area.

Let's try to distill these thoughts. "Chromaticism" comes from the Greek word *chroma*, which means color. In essence, what Nels is discussing is that the somewhat unusual sounds one may encounter in a musical composition can be compared to the unique colors a painter might add to her palette. This is similar to Lee's earlier insistence that when Sonic Youth started out they were considered "noise-icians," but really their desire was to integrate beautiful sounds alongside dissonant sounds so that the dissonance becomes less offensive or distinctive and just another color on the palette of sense-making.

Nels's technical elaboration allows us to better understand why a listener might initially categorize them as unusual. In short, the notes being played are not part of the scale that the song is built on. Our natural intellectual instinct is to expect and look for patterns in the stimuli we encounter to make sense of them. When a musician plays a sequence of notes that includes taking a few steps away from the expected tonal boundaries, it jolts the listener into a heightened state of attention and increases sense-making efforts.

Microtonal is music using tones in intervals that differ from the standard half steps of a scale. Nels is careful to note that the term dissonance in music carries a distinctive Western bias. Indeed, the very definition of microtonal carries with it the implication that deviance from a half step is unusual. Yet, most of the world's music uses different intervals. Curiously, the Western mind does not always know how to process ideas from outside of the established conventions. Non-verbal expressions are given some leeway in escaping from the limiting boundaries of rationality, which supports the notion that imaginative expressions can advance social conversations much more naturally than argumentative ones, especially in the "post-truth" era. However, the bias towards convention can also be exploited to devious effect. One of the tactics deployed by Trump and his surrogates to great effect is the repetition of a lie. Research has shown that repeating a falsehood often enough leads to "illusory truth," a feeling of familiarity that our brains start to interpret as the feeling of truth, even after just a few repetitions of a false claim.[3] But dissonant art has the power to counteract the effect of "post-truth" tactics. The secret is to use discordance as a point of entry, to make the culturally strange become familiar, and ultimately

3 Paschal, O. (2018, August 3). Trump's tweets and the creation of "illusory truth." *The Atlantic.* https://www.theatlantic.com/politics/archive/2018/08/how-trumps-witch-hunt-tweets-create-an-illusory-truth/566693/

welcoming, especially in the face of political efforts to make falsehoods more familiar. Expanding our sympathies will make us more resilient to the comforting lure of divisive lies seeking the status of illusory truth.

Nels: I've had this conversation with various musicians . . . It took me years of circling back to the singer-songwriter after being a total James Taylor/Neil Young kind of dude when I was younger, besides being into psychedelic and blues rock like the Allman Brothers Band . . . to realize that what I was experiencing as an explorer of improvised music, contemporary composed music, micro-tonality and dissonance is that the job of the singer-songwriter is to make the familiar sound fresh, and for the voice and the words of the singer-songwriter to be center stage. Some of the people I know who are in that world kind of have an aversion to what one might call fancy chords, but not such an aversion to handling oddness.

If you were to have seen somebody like Marc Ribot playing with Tom Waits in the 1980s, and how that changed the landscape of what people expected on a song . . . I can't tell you how many times I've been asked to do something like that, which is quite frankly impossible — to re-create those Marc Ribot, angular, spiky, spastic moments. That changed the way a lot of singer-songwriters thought about intonation, and how they thought an instrumentalist can participate in a song. Rather than expanded harmony or polyphony, what we hear in popular music has been an embrace to some extent of a unique kind of microtonality.

And then there's hip-hop! The emergence of a methodology that has nothing to do with playing instruments but rather focuses on sampling and some kind of meticulous attention being paid to intonation. And the sources matching

up in some kind of intuitive way. You have million-selling records that are "out of tune." Now, that dissonance is not perceived any longer as dissonance. So to use that as a way to speak to your question — perhaps it's more repeated exposure and the lack of couching this experience in some sort of arcane term that would help someone embrace it as something familiar. It becomes familiar, and then it's not scary or off-putting.

Chaos itself is frightening to individuals, and I think that's why many incredibly accomplished artists who are in the interpretative or so-called classical realm find the idea of making up a note of their own to be absolutely and abjectly terrifying. That same fear of stepping off into the unknown and making a mistake may be similar to the aversion that one might have to sounds that might be off-putting until one has this feeling of trust. It's great with music, because you create it together — it's collaborative. Whether it's written out or whether it's improvised, generally it's done with others and for others, live . . . We're all in this space — we're sharing something. So if people can feel like they are part of the conversation and all topics will be mentioned, then it won't just be a pure escape, or it won't be a pep talk, then I think that we all come out transformed at the end of the night. We just feel cleansed. People go and have salt rubs, which is probably not a pleasant experience on a tactile, sensory level. It's like getting out of a 100-degree sauna into the snow like the Scandinavians do. Sometimes at the end of these intense experiences our entire being is just flushed with the sense of well-being — I don't know if it's an endorphin rush, or what it is. But if you walk through that fire, we often end up feeling somehow cleansed. We have this warm sense of well-being and happiness that we were part of something. That we participated in

something that made us feel really alive. But feeling alive
doesn't always mean feeling good . . . There are types of
music which take a scalpel to our psyche . . . and we end
up in this weird, maybe hard-to-comprehend, but new
place at the end of the experience that does make you
feel strangely, if not absolutely better, more human.

Encounters with dissonant art can provide a safe space to work
on expanding our individual windows of tolerance and teach us
new models of communication, including better listening. These
are encounters with things that we don't expect, things that chal-
lenge our existing paradigms. They are exercises in training our
minds to pay closer attention to the patterns we expect and chal-
lenge us to reflect on why we expect them. Peering into the chaos
of actual life is, perhaps, an overly demanding undertaking. But
peering into the chaos created by an improvised sound world could
be an exhilarating confrontation to strengthen our senses, expand
our sympathies and build internal defenses against illusory truth.

As Nels noted earlier, echoing the conversation started by
the Grateful Dead, audience members of improvised music are
not simply observers but participants. Experiencing these shows
offers an opportunity to step outside the confines of our indi-
vidual minds and feel something different. Improvisers and their
audience come to a space of agreement that is reached without
verbal interaction. And so artists have the responsibility to act as
more than concerned citizens. Really, the goal of creating disso-
nant art is to lead a social conversation — to help an audience
learn deep listening and be empowered by the transformational
experience of participating in a wordless conversation.

Nels: You're absolutely right, of course [about the responsibility
of artists to offer leadership]. . . It relates to what I spoke to
you about before, my idea that I was going to be some kind
of community participant and take the idea of art as a luxury

instead of a lens through which all of us can see our lives and transform our consciousness. The hesitancy comes from this idea that I was participating in something that was really nonessential, and that it was a privilege from growing up as a white male in a first world country — so it came from this suspicion and self-doubt. And I've been living with that now for decades. So I appreciate you calling me out on this.

But whether or not I'm a so-called artist, I can say that so-called artistic endeavors of many stripes, not just musical, have saved my life. It made my life richer and gave me a sense of not just what's involved in trying to live a fair, balanced and rich life on Earth, but also what sort of cosmic implications there are. When I was ten years old, and we were studying India, that's when I heard Ravi Shankar. Our teacher played Ravi Shankar's music — and even before I heard Jimi Hendrix — I was immediately obsessed with this music. And perhaps in retrospect, more than at the time, that was the introduction of the idea of so-called art, and specifically music, as a spiritual endeavor. And in a way, it's huge. It's a huge, universal well, and you're sipping just a few sips of this cosmic stuff.

As such, I think you're right in that the people in so-called tribal cultures have all kinds of rituals associated with healing and with music, and sound and movement and dance. But I do think that when I look back, I remember seeing P.J. O'Rourke dismiss the hippies for the arrogant and egotistical idea that that they could change the world with music. I have to say — keeping in mind that there are a lot of delusions that go with dreams, and that there were a lot of drugs being taken — we, as a culture, because of the music of that time and also because of consciousness to a certain degree, we changed as a culture. I think that's irrefutable. And I think the same thing is happening right now when you see people like Pussy Riot. I don't think we

have to be addressing political issues as directly as they do, but the universal cry is very political work, and at the same time, it's beautiful. It is music, so it's trying to be beautiful, it's trying to be expressive, and it's hitting on many levels. I think you're right, so thank you for calling me out on that.

Why is art so important today? Audience members of improvised music are not simply observers but participants. Improvisers and their audience come to a space of agreement that is reached without verbal interaction, but through patience, empathy, deep listening and the recognition that all parties in the room are important contributors to the world that is being created. Creating dissonant art presents an opportunity to model the techniques of deep listening to an audience who themselves may then be transformed and empowered by the experience of participating in a wordless conversation.

Audiences trust Nels because of his history, because of his skill and because of the patience and generosity of spirit he demonstrates when building a compelling sound world with his bandmates. He has a unique power to lead wordless conversations born of trust situated in both the head and the heart. If we take this seriously, we are on the cusp of proposing a radical remedy for our current social ills. You've now read the words of two brilliant artists. But if you are to truly embrace your romantic instincts or reach a wordless consensus, it is time for an intermission. The second path to wisdom is reaching a wordless consensus. Put down this book, go outside and experience art in person. Find a piece of art that speaks to you, whether it be a painting, a sculpture, a song, a dance, a spoken-word performance — any type of imaginative expression — experience it and reach a wordless consensus with the artist and the other community members around you who feel the same thing that you do in that moment. And if you are brave enough, scan the gallery or concert hall for someone that you are compelled to connect with . . .

CHAPTER 3

Break Rules Out of Respect

To appreciate just how far back in our cultural history rule breaking was recognized as a path to wisdom, let us briefly consider the foundational myth of Judeo-Christianity: the story of the first humans, Adam and Eve, in the Garden of Eden. The account I am going to share here offers a Hasidic interpretive twist that may make it slightly less familiar to some of you, but it is a reading with deep insight into the psychology of virtuous rule breaking and a feminine twist on the mythological birth of wisdom and subsequent fall from Paradise worthy of your indulgence.

While in the Garden of Eden, Adam and Eve find that all of their wants and needs are met without effort. They are given but one injunction: do not eat the fruits of the Tree of Knowledge. They could have everything we might want — except for wisdom. In a Hasidic interpretive reading, Eve's burgeoning moral consciousness led her to conclude that while it is possible that her creator will destroy her for being curious, she did not want to live in that world. So she bit into the fruit as an act of protest, breaking the rules in hope that a better, more moral truth would emerge. Adam, who was at an earlier developmental moral stage,

didn't get it. To him, rules were made to be followed. That's what his creator told him. But Eve wanted a better world for herself and her future children. She was going to become a partner in creation. So she broke a specific rule because of her deep respect for the notion of rules. And the rule she hoped would be dominant was love and compassion. She set the paradigm for later rule breakers, including Rosa Parks and Susan B. Anthony.

The third path to wisdom is breaking rules — not out of malice, but out of respect. Mindful rule-breaking connects all of the artists in this book, from the magical clowning of Slava Polunin, who is the focus of this chapter, to the punk rock prophecy of Lydia Lunch who is the focus of the final interview. Innovative and imaginative rule breaking provides a clear route through noise-induced anxiety.

It goes without saying that the message is not that all rules should be broken at all times, nor should they be broken by all people. But the best way to counter stability biases is by breaking the rules. Stability biases make us less prone to depart from the status quo than we should be. As Slava will suggest, we need mind-boggling rule-breaking. In times of confusion and dissonance we need to break down the social clichés and stereotypes hampering innovation and re-create the world anew. Rule-breaking is a spiritual task, and an important source of power that good people are often less inclined to access than bad people. No more.

Master clown Slava Polunin is perhaps best known as the artist behind the incomparable *Slava's Snowshow* although it is only one of his many of creative ventures. *Slava's Snowshow*, won him the prestigious Olivier Award, and has been playing non-stop for over twenty years, reaching over five million inspired participants. The first time I saw Slava captivate a crowd with his unique form of artistic magic was when he was a part of Cirque du Soleil's *Alegría* in 1994. There, he presented an early iteration of the *Snowshow* experience that was an easy highlight of the

production. Slava parted company with Cirque du Soleil soon after and launched his own organization. Hungry to re-enter Slava's imaginative space, I experienced what was, in 1997, his newly launched masterpiece. The *Snowshow* had a transformational effect on both the host theater and its unprepared accomplices in offering a return to "Planet Childhood." The images of what took place both on the stage and in the seats are still locked in my mind twenty years later. I can still describe each scene in sequence. It was that powerful.

Critic David Robb explains that the clown's "illusiveness" forms a critical counterpart to a society's rigid social dogma.[1] In other words, the clown is a trickster who uses his tools of deception to free us, at least briefly, from the oppressive chains of convention. Robb further notes that the clown inhabits a world on the boundary between perceived opposites: reality and dream, reason and madness or tragedy and comedy. The latter pairing is of particular interest to Slava.

Slava: There are a lot of great examples to consider. My two favorite Russian writers are Daniil Kharms and Nikolai Gogol. Daniil Kharms combines awe with fear and laughter and joy. In Nikolai Gogol, you see tragedy and mysticism with laughter, which is really a laughter through tears. And then of course, there's Charlie Chaplin, who was the first one to have a comedic character in a tragic situation. So really, I'm just following these footsteps, this literature and art, combing tragedy and comedy, which is something I've always been interested in. As Chaplin said, I'm only interested in laughter if it has some poetry or some beauty in it.

1 Robb, D. ed. (2007). *Clowns, fools and picaros: Popular forms in theater, fiction and film.* Amsterdam: Rodopi.

Slava has praised Kharms for "transforming the theater of cruelty into a theater of poetry."[2] While not as familiar to American readers as he is to Russian audiences, Daniil Kharms was a fascinating literary figure who founded the avant-garde collective Union of Real Art. The group's critical philosophical stance was that artistic ventures be free from social norms, practical rules or even a submission to logic. Instead, members of the union offered nonlinear theatrical performances celebrating the irrational.

Gogol is certainly better known to Western audiences than Kharms. In fact, Jeffrey Frank argued in a June 2017 issue of the *New Yorker* that Donald Trump should add Gogol to his summer reading list, observing that

> Donald Trump may not realize it, but he has adopted the strategy that was recommended to Pavel Ivanovich Chichikov, the shady protagonist of Nikolai Gogol's "Dead Souls," whose lawyer (in the translation by Richard Pevear and Larissa Volokhonsky) advises him that "as soon as you see that the case is reaching a denouement and can conveniently be resolved, make sure — not really to justify and defend yourself — no, but simply to confuse things by introducing new and even unrelated issues." The aim is "to confuse, to confuse, nothing more . . . to introduce into the case some other, unrelated circumstances that will entangle other people in it, to make it complicated."[3]

A year later, the *New York Times Book Review* would feature an essay celebrating "Gogol's Fake News" and arguing that "the

2 Polunin, S. & Tabachnikova, N. (2017). Transmutations of Snow. Unpublished manuscript shared with me.

3 Frank, J. (2017, June 13). Gogol's "Dead Souls" should be on Trump's summer reading list. *The New Yorker.*

Russian writer understood better than any artist since what perfect nonsense goes on in the world."[4]

Chaplin is also a timely artistic reference, as he too explored the dissonance of dealing with tragedy through comedy. While famous for expressing that we "think too much and feel too little," Charlie Chaplin ultimately did not have complete confidence in the ability of imaginative expressions to overpower argumentative ones. He famously, and controversially, ended his classic piece of political protest *The Great Dictator* by breaking character, looking straight into the camera and making a five-minute anti-fascist argument to the audience. He felt that the imaginative work was an insufficient statement at the time, an unfortunate miscalculation.[5]

While Slava is certainly a product of his influences, he stands alone in his field. I asked Slava when he knew he was onto something special with his unique brand of clowning, and how he might describe the artistic wisdom conversation of which he is a part.

Slava: I had done more than thirty shows before, and I had my own theater, and I realized I needed to go to the next level because I was doing something that my partners were not interested in. So I decided that because that's what I had been doing, it was time to close it down and start a new adventure. I started looking for new, contemporary clowning where the absurdity and metaphysics somehow managed to coexist with humor. I did spend two years making it, and I did manage to put it together, and I did know then that I was at a place that was interesting to people and that people would like.

4 Lucas, J. (2018, May 6). Gogol's fake news. *New York Times Book Review.*

5 Brownlow, K. (2002, October 11). The Fears of a Clown. *The Guardian.* www.theguardian.com/film/2002/oct/11/artsfeatures.

Clowning is the main subject for me. I was really trying to understand the boundaries of the field of clowning. This is why I made these departures to different directions to try to bring all the treasures or riches from other places; for instance, I departed into pantomime, musical theater, cabaret, street theater, film, experimental theater. I went to all of those different places because I wanted to bring new ideas into clowning. Because at that point clowning was very tired and did not interest many people. Really, it was just entertainment for kids' birthdays. In truth, it is a great art form that has lost its color. I really wanted to bring modern, contemporary language and color to clowning, which is why I had to learn from other art forms that had made more advances and were further ahead, art forms like music and theater.

As Slava explains, to experiment responsibly and meaningfully, one needs to first be deeply rooted in an artistic tradition. Slava has said that he loves "theater that is always changing," the type of artistic enterprise that both innovates and "diligently guards its traditions."[6] There is a balance between innovating and respecting tradition. If we think back to our conversation with Lee, we remember that great art emerges from an almost obsessive commitment to curiosity and experimental exploration, as well as an unselfconscious romantic vision. In the last chapter, we honed in on the theme of wordless conversation. There, Nels argued for the allowance of different voices, serious consideration of oppositional opinions, careful deliberation before ruling out ideas or expressions and consciously creating space for things one may be suspicious of. Here, Slava is adding something novel:

6 Polunin, S. & Tabachnikova, N. (2017). Transmutations of Snow. Unpublished manuscript shared with me.

folly and nonsense. Only the types characterized as "fools" by mainstream society truly really experiment.

This is a powerful point to consider in the age of Trump. His critics paint him as a clown, while his defenders explain that they admire his rejection of social conventions. In the eyes of his supporters, he is both a clown and a savior. It is important to clarify that in Slava's world, there is no negative judgment or insult intended behind descriptors like "folly" or "foolish." And I'm not saying that Slava would honor Trump with the title of clown — he would certainly not. The fool that Slava talks about is deeply compassionate and avoids causing harm. But a quick Google search of "Trump" and "clown" yielded over forty-one million hits! So it is important to think about the implications of the idioms we use.

Slava's clown opens up the third path to wisdom after following the first two. By embracing romanticism and seeking to build a wordless consensus with the audience, the clown builds the trust to inspire meaningful rule-breaking. Slava would expand on the nature of the romantic instinct by pointing out that childlike naïveté is a kind of romanticized folly. Slava argues that simplicity and innocence are the basic elements behind the instinct to create something that is novel, as opposed to something designed to reflect reality. Authentic creativity will be regarded as foolish by the mainstream, and the more naïve the act, the closer it resembles the original act of creation.

Slava: The first thing I created was a theater that was about playing with the world, a game. I thought it was really interesting. And then I arrived at the fool, because the fool is at the border of art and life. The fool doesn't just create things or create works of art, he also lives according to the rules of art. It may not be common for professional people to make people laugh through their work, but he just lives like that.

What are some of the rules for art that we have uncovered thus far? Don't be self-conscious about romantic tendencies; be comfortable with dissonance; develop patience, empathy and the skill for deep listening; recognize that all parties in a shared space are important contributors to the world that is being created. The conversation with Slava supports the addition of some new rules to our list, drawn from the clown's arsenal: we need to laugh at ourselves, our preconceptions, our priorities, our desires and everything else that seems important (we will explore this further later); embrace the potential of folly, nonsense and the grotesque to critically examine our beliefs and prevent them from dominating our lives; engage in rule-breaking that is extreme and grandiose, because our imagination is fond of the grandiose or mind-boggling. Slava's worldview recognizes that only through gathering incompatible elements can we break down the social clichés and stereotypes hampering innovation, allowing us to re-create the world anew.

Equally important, Slava rejects the retreat to digital spaces; instead, he embraces the physical world. Slava's work is grounded in very real spaces — he starts with creating a living environment, inviting the audience into a transformed theatrical domain that is not bound by time (i.e. curtain calls) but space. The *Snowshow* starts the minute the first participant enters the theater lobby and ends when the last person exits the building, whenever that may be. It takes the participatory nature of being an audience even further.

Slava: This is really the effect. A lot of people go back to the show to see it many times because it is not about a seeing a plot or watching great actors, but they go back to immerse themselves in this atmosphere. It doesn't matter how long it is, it doesn't matter what is going on. This is a space of freedom, fantasy and play. And it really has this pull on people, and so they come back again and again.

Now I actually do lectures on how to be happy, and the
first rule is to create a harmonious space.

In the previous chapter, Nels talked about creating a space
where his improvisational partners can comfortably explore new
sound worlds. Slava creates a space that is not only designed to
enhance the creative potential of the artists, but that of the audi-
ence as well. Specifically, the space created is designed to enable a
return to what he calls "Planet Childhood."

Slava: The main feeling that people share spontaneously is the
joy of returning to a stage of childhood where a sense
of playful freedom overcomes our fears and habits.
This is what I have dedicated my life to achieving on
a daily basis. Children are already a happy crowd of
people — they haven't yet touched the troubles of life,
and the entire world is open and boundless. Imagination
and joy fill them if they are not in a challenged social
situation. Adults, however, often make themselves very
rigid, complicate things and start digging deep into the
convolutions of life as soon as they grow up even a little
bit. And yet, if one stays connected to his inner child,
everything becomes so much easier and jollier. This is
what we try to do.

Slava's immersive art-space encourages us to reconnect with
our inner child. Similarly, in psychotherapy, therapists try to coax
clients into a meditative state that can bring out the inner child
buried deep in the psyche. The exercise was inspired by the work
of John Bradshaw,[7] a self-help guru of the 1990s whose lectures
were notorious for evoking an atmosphere of old-timey religious

7 Bradshaw, J. (1992). *Homecoming: Reclaiming and healing your inner child.*
New York: Bantam.

revivalism and sideshow hucksterism. The suffering and vulnerable flocked to Bradshaw, and he knew how to work the carnival crowd. His hype-man antics spurred damaged souls to let their wounded inner child know to trust the conscious self as a supportive and non-shaming ally.

While for many this narrative is tough to swallow as evidence-based argumentative science, it is quite compelling as art. Slava reaches the inner child without words or arguments, but through imaginative expressions.

Slava: I consider myself an apprentice of both Charlie Chaplin and Marcel Marceau, the two greatest mimes in the history of humanity. Like them, I am in love with the non-verbal capacity of human expression. Like them, I consider that this is much richer than words. It is infinite in meaning and the depth of the meaning of what is being said. It's the little details that tell you what is happening to the person. I can show it to you, but I'll try to explain it. You can put your hands on your stomach, your chest, raise your hands or arms, and all of these are their own expressions. You can have so many different expressions. A human being has this infinite number of ways to express themselves without words. And really, people trust your visual expression more than words because words have lost their truth and been tarnished by lies.

Too many things have been done untruthfully with words. My whole way of thinking is visual. I don't read a lot — I have many, many books, but they're all with pictures. For instance, I first came across a picture of [visual artist] Tina Bauer and I didn't know who she was, or Robert Wilson [experimental theater and visual artist], I had a picture of him. Both of them were above my bed for long years before I actually got to know who they were. Pictures cannot be explained with words — and I hope

that my shows are also hard to explain with words . . . The most magical aspect of this show, as in any form of artful theater, is the intimate communication with the public. In this case, it is the non-verbal fibers of contact which often appear between an artist and spectator during the show. This very subtle interaction is something that creates the magic of the theater . . . I love absurd and fantastic reality and I do not trust "spoken word" — that is what made me choose clowning. For me, expression without words is much more organic and natural than using words onstage. Visual language is much richer, more personalized and elusive, which is why I haven't even thought to use words.

As Slava confronts audiences across the globe with his personal expressions of wordless world-creation, he wearily observes that "tenderness doesn't exist in the West." It's an eye-opening comment that is currently ringing true. What is the tenderness that he sees in other parts of the world, and why doesn't it exist in the West?

Slava: It's because the system has become way too thought-out and logical. And these organizations and systems, they definitely help us, but we lose our organic essence and feelings.

Loss of tenderness is why Trump is not a clown, at least not in the sacred sense used by Slava. Our contemporary elites, on both the right and left of the political spectrum, build relationships only with those they already trust. They are not interested in listening to those outside their web of existing relationships. But trustworthiness is not merely a smoothing mechanism to maintain social order in ongoing relationships — it is necessary for building a social conversation that can cross ideological

boundaries in turbulent and unpredictable environments like ours. We need to be open to the sort of deep listening that will allow trust to develop. Slava invites the audience to explore dissonance, to challenge social conventions and to break the rules of adulthood while in the theater. The audience can trust Slava because the clown is a blank slate beholden to none and open to all. We must learn from him about breaking rules as a path to wisdom.

CHAPTER 4

Change the Way You Listen

The next path needs to be stated bluntly: No matter our political orientation, level of education or status of current listening abilities, we need to change the way we listen. While we have ears that may hear, most of us do not have the skill to listen. The future of wisdom depends on more of us changing the way we receive information. We cannot be expected to carry on conversations across cultural, communal or ideological divides if we do not learn how to listen deeply.

One of the responsibilities of an artist empowered with a platform to expand our cultural horizons is to change the way *they* listen. For an artist, to alter the way they process words and sounds is a step towards refining their own imaginative faculties, allowing for more inspired expressions. It also enables artists to create bridges for audiences to appreciate the artistic creations of foreign or marginalized cultures, thus setting in motion the process of innovation, possibly leading to a future hybrid culture.

Concerned citizens must do something similar. By changing how we listen, we can develop the ability described by Lee — to integrate consonance and dissonance so that the dissonance

becomes less disorienting. Listening requires the ability to perceive and discriminate, to analyze, group and infer meaning, and that goes beyond simply hearing. There is nothing simple about emitting a sound and having that sound accurately decoded by a listener. Our natural instinct is to expect and look for patterns in the stimuli we encounter in order to make sense of them. We can overcome our pattern-seeking and stability biases by improving on our ability to listen. Better listening means a heightened state of attention and increases the sense-making effort so that the strange becomes familiar and ultimately welcoming.

We live in a political environment of heightened sensitivity to the notion of cultural appropriation. Music critic Chris Richards tells a story of hanging out with a rock band who were expressing a desire to cover a beloved R&B album. He approvingly describes how he and the artists came to the conclusion that "a band of white indie-rockers performing the songs of a Black R&B singer? No way. It would be seen as cultural appropriation, and their reverence for that music was probably better expressed through conversations like the one we were having."[1] In a cultural environment where Rihanna is accused of appropriation for tweezing her eyebrows[2] and a white poet is lambasted for "adopting Black vernacular" in a poem,[3] I understand why artists might shy away from stepping outside of their genre for pragmatic reasons. But it represents an abdication of their responsibilities as artists.

[1] Richards, C. (2018, July 2). The five hardest questions in pop music. *The Washington Post.* https://www.washingtonpost.com/news/style/wp/2018/07/02/feature/separate-art-from-artist-cultural-appropriation/

[2] Chávez, K. (2018, August, 2). I'm Latina, and I find Rihanna's skinny brows problematic. *Marie Claire.* https://www.marieclaire.com/beauty/a22552072/rihanna-skinny-eyebrows-vogue/

[3] Schuessler, J. (2018, August 1). A poem in *The Nation* spurs a backlash and an apology. *The New York Times.* https://www.nytimes.com/2018/08/01/arts/poem-nation-apology.html

As Jeff Coffin will explain, changing the way we listen is the antithesis of cultural appropriation. In his own artistic endeavors, his primary obligation is to serve the music. Second, the musicians playing the music. And third, the audience. In other words, respect for the idea comes first. It is the responsibility of the one encountering the art to change themselves out of respect. In fact, to tie this path to that of the last chapter, if embracing elements of other cultures is viewed as a rule that should not be broken in our contemporary political climate concerned with the crime of cultural appropriation, then indeed it is a rule we must break. But only after paying respect to the culture. In the above anecdote, I fail to understand how "white indie-rockers" playing music that they have "reverence" for would necessarily be seen as disrespectful to the experience of African Americans and the artistic form of rhythm and blues born of their cultural experiences.

Learning to listen better is a moral imperative for the curious and empowers us to build stronger and more substantive social relationships across cultural boundaries. We lament that our society is experiencing a post-truth reality of alternative facts and fake news, where rational arguments are afforded little opportunity to persuade in the public sphere. Now it is time to dig a little further into understanding the act of listening, given the prominent role it plays in supporting all manner of conversations. There is nobody better to discuss this topic with than Jeff Coffin, a musician committed to exploring life through sound.

Jeff is not only a master of the saxophone, having played with Bela Fleck & the Flecktones for fourteen years and the Dave Matthews Band since 2008, he is also an accomplished educator who teaches improvisation at Nashville's Vanderbilt University and has presented over 300 music clinics at a host of universities across North America and the world. His musical output includes jazz, funk, soul, rock and big band . . . it is so eclectic

that the ability to name the artistic conversation Jeff is a part of eludes even the artist himself.

Jeff: It's hard to know. I'm interested in a lot of different things. Because of that, it prevents me from going too deeply down the rabbit hole on any one of them at a given time. But I kind of go down the rabbit hole to the same depth with each of them and continue to go further down the rabbit hole.

I've always felt like a bit of a chameleon. I want to be able to go into any situation and perform accurately and appropriately for that style of music. I was having a conversation about this years ago with a friend about Indian music or African music, he said, "I'm never going to be an Indian musician, but I can have those influences in my music." And I feel the same way. I've been listening to African music for thirty years, and the same with Indian music, and Middle Eastern music, and folk music, jazz — there's a lot of cultures of music out there.

I find that when I travel, I want to hear their music and I want to eat their food. Because I think that those are two of the things that bring together communities. I think that's one of the things that made me a musician, also. Because I crave the community of musicians. I crave the togetherness that we share and the exploration that we share and that we encourage and allow and provide a place of safety to actually be able to hear each other. And as I get older, I do realize just how special that is. I'm more interested in what other people have to say than what I have to say personally.

Jeff articulates an artistic manifesto rooted in vast curiosity about the diverse cultures and an intense desire to listen more than be heard. And yet, in the contemporary political landscape,

our social conversation has become so polarized that the mere mention of a non-Indian musician having Indian cultural influences in their music is, in many circles, a controversial assertion. Cultural appropriation has become a hot-button issue with activists of good, but in my opinion misguided, intentions.

The core argument behind cultural appropriation is that it is exploitation and an abuse of power when a member of a majority culture adopts elements of a minority culture's artistic traditions into their own creative output, as opposed to ceding the stage to members of that minority culture. To be clear: appropriation by the powerful of symbols of the powerless as an act of deliberate exploitation is deserving of scorn. But the ideological policing of art is something I can never be sympathetic to. Beyond the stories grabbing headlines in the summer of 2018 shared in the introduction to this chapter, the watchdogs of appropriation were claiming careers more than a year earlier in the relatively small publishing community of Toronto. Three local editors lost their jobs for defending even the possibility of cross-cultural creativity being an acceptable form of artistic curiosity. Why can't an artist both incorporate the influence of the minority culture into their platform, and use their platform to try to turn broader audiences on to the sources of their inspiration? Some defenders of vigilance in policing cultural appropriation argue that the concern is whether or not the influencing culture eventually gets to profit from the cultural exchange. But many of the artistic endeavors labelled as engaging in appropriation are shut down at the start, soon after the criticism is launched, and the artistic goodwill is never given the chance to spread.

Jeff, for example, has brought musicians from minority cultures onto the stage and into the studio with him. But as Kenan Malik writes in his *New York Times* defense of cultural appropriation, the accusation is a "secular version of the charge of blasphemy. It's the insistence that certain beliefs and images are

so important to particular cultures that they may not be appropriated by others."[4] Implicit in the charge of cultural appropriation is that the artist cannot be motivated by the empathy and earned trust we discussed earlier. Any effort by a majority culture artist to adopt creative elements from a minority culture is viewed as an act of making the sacred profane in bringing the images or sounds to a non-native context. I would argue that cultural boundaries are vigilantly policed by those who feel no sense of inter-cultural trust — ideas, sounds or images appearing in new cultural contexts are viewed as "stolen" instead of "borrowed" or "traded" in bad faith environments. The assumption of exploitation and not reciprocity needs to be rejected if we are to shift towards a more inclusive society.

Jeff is interested in all manner of sounds, and given his ability to listen, we as a society are the better for it. In fact, he pushes the idea that an important act of self-betterment is learning to appreciate sounds that may be viewed as difficult.

Jeff: I've always been interested in the way that sounds relate to one another. I remember that when I was young, there were certain things that I would listen to that I would find that would almost repulse me. Not that I found it repulsive, but that it would push me away. Then I found that as I grew as a listener, that it was really me that had to learn to adjust. The things that used to push me away or repulse me were suddenly the things that I was drawn to.

Without deliberately meaning to, Jeff offers an important defense here that is overlooked by those who police even non-exploitive acts of cultural appropriation — acts of borrowing

4 Malik, K. (2017, June 14). In defense of cultural appropriation. *New York Times.* https://www.nytimes.com/2017/06/14/opinion/in-defense-of-cultural-appropriation.html

with intended reciprocity. These critics reframe the cultural encounter as theft, assuming that upon the first experience of foreign sounds and symbols cultural imperialists see the beauty and commercial possibility and decide to steal the potential for value creation away from the culture of origin and for themselves. In fact, Jeff is pointing out that oftentimes it takes work to appreciate culturally-influenced artistic differences. The eventual outcome of the work is a way to introduce that which is culturally foreign to a new audience so that it becomes more familiar, with the ultimate hope that members of the originating culture will get access to new markets.

With maturity came the realization that *he*, as an artist, had to adjust his own perceptual abilities. This is tremendously important. Just as Nels talked about the need to be patient when playing with Thurston to create space for otherness, Jeff recognizes the tremendous responsibility of the artist to change the way they listen in order to create the bridges that might allow audiences in the majority culture to appreciate the artistic creations of other cultures.

Jeff: I say suddenly — it wasn't really sudden. It was a process. I found that eventually I was drawn to those sounds as being more interesting than the things that were a bit more vanilla. The things that were less dissonant or didn't have the color of the tone or of the particular harmony. So I found that I had to learn to listen in a different way. And that's one of the things I have to teach to this day. I talk to students all the time about becoming better listeners — that it's active listening, or the act of listening, it's about participating in the experience and learning to listen a different way.

Those last few lines articulate a major theme of all the earlier conversations. Lee explained how Sonic Youth wanted to integrate beautiful sounds alongside dissonant sounds so that

the dissonance became another color on the palette of sense-making. Nels pointed out the natural intellectual instinct to expect patterns, so that when a musician plays a sequence of notes that includes taking a few steps away from the expected tonal boundaries, he jolts the listener into a heightened state of attention and increases the sense-making efforts. Jeff moves beyond describing the phenomenon from a personal perspective and offers a moral imperative for the curious. Just as he discovered the need to learn how to listen in a different way, so do we.

Active listening is a foreign concept to many. Most folks assume that they mastered absorbing the outside world through their senses as children. They equate hearing with listening. But the act of listening involves participating in the experience in a more sophisticated manner. Beyond hearing the sounds, it requires analytical skills relating to grouping and synthesis skills relating to background knowledge and understanding of social cues. There is nothing simple about the journey from emitting a sound to having that sound accurately decoded by a listener.

Although Jeff teaches a specific method of active listening appropriate to musical improvisation, the technical term is credited to psychologist Thomas Gordon.[5] The push towards active listening can be found in education, therapy, negotiations and other fields. In these contexts, active listening involves verbal and nonverbal behaviors that demonstrate the listener is paying attention, understands what her partner is trying to communicate and is empathetic. The listener wants to let her partner in a dialogue know that he is being both heard and supported. In so doing, an active listener encourages the continued expression of thoughts and feelings by the person she is listening to and thus builds a stronger social relationship.

What are the sorts of things active listeners say to signal that they are paying attention and emotionally invested? They may

5 Gordon, T. (1975). *Parent effectiveness training.* New York: Plume.

repeat the content of what they heard in their own words back to the speaker, or they may reflect the feelings they detected in the speaker's words back to them. They also may explicitly check their assumptions through short questions like "Did I hear you correctly?" as well as engage the speaker with open questions. Equally important to active listening are the nonverbal behaviors, including nodding the head, making eye contact and leaning towards the speaker to signal warmth and empathy. Applying active listening as in psychology with the skills Jeff teaches in musical improvisation to non-musical contexts, like to our current social environment, could bear interesting fruits.

Jeff: Not many people know how to listen well, and everyone thinks that their opinion matters. In some ways it does, and in other ways it doesn't at all. But I think that people are having a really challenging time being heard, and I think that is a difficult thing today. I think that people feel like they have to shout or be vehement about their opposition to something. Sometimes, it's just to seem like they have an opinion. You see it all the time on the news. You'll have six people talking at once and it is not news — it is opinion. Everyone is trying to say that they are right. It's troubling. I don't really understand it. I don't know how we've gotten so far away from actually being able to hear one another.

So for me, I'm not sure I'd say I'm politically active, in the sense of going out and protesting and doing that kind of thing, but I am politically active in the sense that people know where I stand. Although I tend to be quiet about it. I feel like my job is that I'm a musician. One of the things I can do is help people learn how to listen better. And that is one of the things that I'm constantly working on and working with students to help them become better listeners. I tell them all the time: at the end of the

day, we're talking about life but we're using music as a metaphor.

Listening is the most important fundamental that we can work on. Not only in music, but in life as well. I do believe that lesson can be transposed. I also let them know that there is a great big clue on how to become a better listener in the word "listen" itself — and that is that the word "listen" contains exactly the same letters as the word "silent." And that's a big clue.

Jeff wonders how it is that our society has by and large forgotten how to hear one another. If artists are to restore the societal dialogue, they will need to understand what caused the skill of conversation to slip away. I was curious to hear Jeff's thoughts on this, as touring with the Dave Matthews Band exposes him to a rather extensive and diverse group of people. What does he know from his travels and interactions that others don't about the current climate?

Jeff: It's interesting, to say the least. I would say that I think that we're all a lot closer philosophically than we are led to believe. I think that we've been divided by the political parties, but I think that most people want the same things. They want a roof over their heads, they want to know if they work hard, they'll be able to make do with what they have, they want good education for their kids, and people want peace. People want to be left alone, to live the life they want to live. And I think that's pretty much worldwide. We want people to be treated fairly, and I think that goes into being allowed to live how they want to live, to be able to love who they want to love.

I think that there's a real fear people feel that is completely unfounded in reality. And we see it all the time. The pot gets stirred up, and it gets very cloudy. The thing

is that if you don't let something settle, if you have dirt in a bath and you stir it up, and you keep stirring it up, it's never going to settle to the bottom. You're never going to get that clarity. I think a lot of times what happens is that people continue to stir the pot, and it keeps getting really cloudy. I think that's unfortunate. I think that people are looking for more clarity.

When I travel, I see people on their cellphones, but not like it is here. I see people hanging out in communities and talking and sharing ideas and making music together. You can't go back to the way it was, and we can't even necessarily say that those were better days. We are where we are. And we have to deal with the ramifications of where we are on an everyday basis. I think we all have our part to do, and one of my parts is to do that through music. I think settling down a little bit is really important. We think we have to have the latest gadgets, Facebook, Twitter, Snapchat to keep up with all the news — there are just so many distractions that are trying to capture our attention all the time. And we end up having no time for ourselves. We have no time to actually sit down and have a conversation with somebody, or to spend time. It becomes a very frantic kind of thing. I don't think that's good for anybody. It's something that I'm working on for myself too. Just to kind of slow down and to say, "Okay, these are some things that need to be done, how am I going to get them done?" It's a challenge.

Jeff likes to talk about the need to return to fundamentals. Intellectually, he is perhaps most well-known for coining "The Big Five" fundamentals of music: listening, tone and dynamics, rhythm and time, harmony, articulation. These virtues are necessary not only to make creative improvisation work, but life itself.

Jeff: It comes back to listening . . . and understanding the fundamentals of music. Everything that I play, everything that anybody plays in my opinion, you can trace back to the fundamentals. So I think that the fundamentals are the roots of everything we do. If you don't have a good grasp of the fundamentals, the chances are pretty good that you're going to be limited in some scope of what you're doing. It's imperative to continue to work on those things as we move forward.

Poets are not going to stop learning about words and etymology, just as a musician isn't going to stop listening to music or isn't going to stop trying to figure out other ways to combine sounds, or different ways of putting things together. So I think that a good part of it is listening. A big part of it is allowing a dialogue to occur within your improvisation. I do look at it as a conversation. And what I call the Big Five of music, in my opinion, they're the same five basic fundamentals of the spoken language.

You can really see and experience that music is absolutely a language in that sense. So when we're having a conversation together, if I have something to say, I'm going to say it, but then I'm going to allow space for other people to interject. It's not my backup band — they are people that I am having a dialogue with. And hopefully you're playing with interesting people who have something to say.

So I think it's important to live life in a way so that you have experiences, so that you have things that you can share, and that you have a story to tell. One time, when I asked a student why the fundamentals were important — and this is maybe the greatest answer I've ever received — he said, "They're the tools for your narrative." And I was like, wow, okay. That's it! End of story. I think that you have to work on those tools. You have to make sure that if it's a tool that needs sharpening, that you sharpen

it. You have to know how to use those tools to express your narrative.

Artists "use their tools," whether they be musical or poetic or clowning or painting, as a metaphor for life. Fundamental to Lee is the belief that great art emerges from an almost obsessive commitment to curiosity and experimental exploration, as well as an unself-conscious romantic vision. For Nels, the essential responsibility of artists is to consciously create space for others to facilitate reaching wordless consensus. Slava believes folly and nonsense are fundamental to boundless creativity and experimentation. Jeff focuses on the fundamentals of music.

Jeff: I think for me, I've always been very aware of my weaknesses as a musician, and I'm always very aware of the strengths of others. I've often said that I really believe that my weaknesses have more to do with my success than my strengths. And being able to identify those and being able to work around them as I'm working on them. So the way that I compose, the way I play the saxophone, the way that I use the instrument, I'm very interested in what the saxophone cannot do. So I'm sonically exploring the instrument in a lot of different ways, hoping to find other ways or interesting ways through it.

I've always been very attracted to rhythm, in particular, more than harmony. There's also different types of rhythm, for example polyrhythm. I believe that there's dissonance there. There's a pull that's going on. One of the reasons that I'm not a big fan of most smooth jazz is that there's no rub. A couple of nights ago I saw the John Coltrane documentary called *Chasing Trane*. It's a deep personal and spiritual search that goes on with being a musician. And if we're being true to our art, then the conflicts that arise within us as people, as the conflicts arise with us as

a society, as it arises in us as a community, as a holistic group, then these things should be reflected in our music. And with someone like John Coltrane, you hear that. You hear that search and that motion and that movement. It is deep and it is profound and it's very real. And Coltrane's one of the artists who continues to inspire me, even long after he's dead. When you think about the fact that he was 40 years old when he passed, that's fairly profound.

When a musician is true to their art, they explore whatever conflicts are being faced through sound so that an audience engaged in active listening can actually hear the soul searching within the music being played. Witnessing this type of artistic creation is profound, and the sense of wonder felt by the artist is transferred to the audience, who will come out feeling like they have reached a wordless consensus.

Jeff: I think that for me as a composer, I'm looking for the way that I hear music. And that's going to continually expand and progress. I keep coming back to things that I tell my students, but it's not lost on me either. I heard this quote years ago. "You teach best what you most need to learn." And I continue to push the fundamentals. I continue to push things like listening and developing your own way of looking at things.

My favorite musicians were always revolutionaries. My favorite composers and my favorite players. And the reason that I was drawn to them was that they had an individualism that you could hear. It was palpable. I think that's the point of art. I don't think the point of art is trying to please people all the time. It's definitely trying to reach people and find a common ground with connectivity, and at the same time it's about the personal search we're all involved with.

Jeff reaffirms another point important to our second path to wisdom, reaching a wordless consensus. There is "common ground" reached through connectivity, but the point of the journey is personal. Great art draws an audience precisely because the creation is that of another. What does he draw on that has allowed him to thrive and keep making interesting art?

Jeff: First and foremost, it's the fellow musicians. People ask me sometimes, "Who are your greatest influences?" I say all the people I've played with in particular. And then there's other people that I've listened to, the people that I've worked with, the people I've been on the road with, the people I've been in the studio with, that I've written with, that I've recorded with. Those are my greatest influences. Fourteen years on the road with Bela Fleck. Now this is my ninth year in a row with the Dave Matthews Band. I've had my group on and off for almost twenty years. And I've been playing with some of the same musicians for that whole time. That's an important part of what allows us to do what we do as musicians and improvisers.

But I also look at what we do as a service industry. First and foremost, we have to serve the music. The music always has to come first. No matter what. And anyone that sells that out, I am not interested in making music with them. If it starts to become about something other than the music, then you've got to come back to the home base. We talk about that a lot with Dave — how it always has to be about the music. And everybody had the same thought, which is a beautiful way of approaching it. We serve the music first, then the musicians who are playing second, and third, we serve the audience — the audience is a big part of our success. If there's nobody to listen to it and nobody wants to hear it, then you're just kind of playing in the basement or something. Which is okay too — but

I want to reach people. I want to share my music with people, and I want them to enjoy it. It's not like I'm writing for them, but I'm writing and sharing things that I think are wonderful and beautiful and thought-provoking and with good cause.

I'm somewhat cynical sometimes, but I also see the world as an amazing and beautiful place, full of incredible cultures of music, and we're not always going to agree on everything, but how do we get people together? I think that it's the arts. It's the arts that survive. When I go to a museum or an anthropology center — I was just down in Peru for a little over a week — it's the art that survives. It's not the politicians, it's how people express themselves, or what they did with what they had.

I really dislike the music business. The way that I look at what I do is that I play for free, and you have to pay for all the other BS that I have to deal with before I actually get to take the stage. And there's a lot that we have to deal with. I'm not saying that "oh, woe is me," I'm saying there's a lot of very difficult travel, there's a lot of work that goes on behind the scenes to get to that place. And I'm very, very grateful for what I do. I'm grateful for every day that I have the opportunity. But there's a lot that we have to do to get to that place to be able to create with one another. That's what I look at as what I do. For those of us making the music, that's our sanctuary. That's the purity.

Every artist encountered thus far had said that great art needs to be indie — it just can't be done under the umbrella of a big corporation. But I had the sense that Jeff had a different take on that question. For while there is a huge corporation behind the commercial entity that is the Dave Matthews Band, there is also a group of committed musicians creating interesting art.

Jeff: A lot of it has to do with intention. I don't think that anyone can negate anyone else's art — I don't think they can determine whether somebody else is creating art or not. I think that there's no way to compare that. There's no way to make that determination. Now if I think that something is good or bad, that's my opinion. And my opinion is based on my almost forty years of working on music. I base it on a lot of history, on a lot of education, on a lot of playing. I can back my opinion up, is what I'm saying.

I don't think there's a band in the world who's out there performing who wouldn't want greater success than they already have. Anybody that tells you that is lying to you, I think. The purpose of art is to reach people, is to connect. And we want to try to connect with as many people as we can. I've heard artists say, "I saw people leaving the club, you must be doing something right," and I'm like, "You're out of your mind." If you think that driving people away is the idea of success, then you're sadly mistaken. I come back to the Coltrane or Miles Davis, two of the giants of music — and they wanted to connect. They did everything they possibly could to connect with their audience. And that doesn't mean that you have to give it a lot of energy, it doesn't mean that you have to be available, that you even have to be a role model. It's very individualistic.

There's a lot of stuff that Dave Matthews does way behind the scenes that nobody knows about. And he's an amazing guy. He's an incredible leader, very down-to-earth, very solid, very humanitarian, one of the most altruistic people I've known in my life. Anybody that thinks that he has "sold out" or doesn't care anymore doesn't know the man. Doesn't know his heart, doesn't know his intention. And I would say that for everybody in the group. The things that we do outside of that band, nobody really knows about. And that band is an anomaly in the sense

of the music, the players, the intention, the purpose — it's a very sincere group of musicians. Some of the greatest musicians on the planet are there.

I've had two of the greatest gigs a saxophone player could ever ask for — Bela Fleck, and now Dave Matthews. The artistic search continues to inspire me. It keeps me creative. I want to be creative for everybody in the band, because everybody in the band is being creative for themselves, also. And so by bringing that into the fold, it inspires everybody. Everybody in the band practices. I don't mean just collectively as a group, but I mean individualistically also. We're all practicing, we're all working on stuff, we're all writing music, we're all creating. And it's not always just in the medium of music. It might be photography, it might have to do with sports, it might be visual. It's not limited to the stage by any stretch of the imagination. That's inspiring to me. I really enjoy that and I'm very grateful for that.

To close, let's return to the main theme: the need to change the way we listen. At the end of the day, learning to listen and wordless consensus building will be critical to getting the social conversation back on track. But like Lee, Jeff is ultimately cynical about the potential to be heard, even though the goal of creating art like his is to lead a social conversation.

Jeff: I'm not sure I'd like to be in charge of anything, because it's an incredibly difficult position to be in. I'm not sure I'm very good at it either. I try my best, though. I think that leading through example is very important, and that's one of the reasons why I do a lot of education work too. Because I'm not trying to say, "Look, my way is the only way," or that you should follow me because I know what I'm doing. One of my points is to tell them what the word education means. That it has a Latin root of *educere*,

which translates to "to draw out." So the idea of thinking for yourself, the idea of doing some research rather than looking at a headline and thinking that you know what's going on — get involved. Go deeper into something. The deeper you go, the more the mystery starts to unfold.

I think that there are people who are natural leaders, who see the world in a particular way. And I think that a lot of artists are like that. Politically, and I don't mean to open a can of worms here, it's strange to me when I meet or find out that a fellow musician is a Republican, I'm honestly surprised. It means they're likely a very conservative person. I'm just like, "Wow, how can you create like that and have those views?" And I'm not saying that I feel that everybody should be a Democrat. I'm just surprised when they support and advocate what I think is a very exclusive, white-dominated, male culture. And when I look around at the Republican National Convention, and I see basically a complete lack of diversity, and then I look at the DNC, and I'm like, "Oh, those are my people." These are all the people that I love. These are all the different cultures and colors of people that I surround myself with. I feel at home then.

There are a lot of ideas and a lot of concepts and a lot of cultures in this world. And again, by traveling, I've seen a number of these. I've just seen little glimpses of them. And I don't claim to understand any of them. I don't even understand our own, let alone someone else's. It's a real challenge. But by listening, I think that's the key. Whether you agree or not, if you can learn to listen, you're going to learn something. When people say, "Oh I know I'm preaching to the choir," I'm like, "So what, it means we're on the same page." It doesn't mean I'm not going to learn anything from you, but we could talk about the things that are important to each of us. For me, I've nearly

dropped out of social media. I still use it, but I don't use it for much, other than business and a few photos. I'm kind of like, "What's the point?" Sometimes it makes me feel better to get things off my chest, but it's like, Why not get off your butt and actually do something that's going to benefit the world in some way, shape or form?

I'm not saying that what I'm doing is changing the world on a grand level. But what I am saying is that I feel what I'm doing is important. It's what I'm supposed to be doing. I'm doing my part. I'm doing the thing that moves me to every end and that if we all find that, if we all search for that, if we look for the things that move us, that inspire us, then that will change the world. I think those are universal principles. Great sports figures, great artists — people listen to those people for whatever reason. I think that we have more of a public presence, maybe there's a little more mystery to it, whatever. But that doesn't mean that my opinion is any more valid than anyone else's. I love that Ornette Coleman quote. He said that all listeners are equal in their opinions. The first time I read that I thought, "Wow, that's pretty good."

All listeners may be equal in their opinions, but not in their abilities to use listening as a path to wisdom. Listening well is a virtuous undertaking that feeds curiosity and supports the development of substantive social relationships across cultural boundaries. It presumes a meaningful commitment to listen as opposed to being heard. Deep listening supports the other paths to wisdom developed so far, as it can help us discern which rules to break and when, it can support reaching a wordless consensus and help us share our vulnerabilities in the pursuit of romantic ideals. The future of liberal democracy may depend on us getting these abilities right. We need to change how we listen.

CHAPTER 5

Trade Fairly

Nearly ten years ago I published an academic paper with the self-explanatory title of "Why Moral Failures Precede Financial Crises." While the problems that caused the 2008 financial crisis were often framed by the destructive industry players in ethical terms, the proposed solutions were offered in terms of risk and probability, not ethics. As a consequence, the failure to think in explicitly ethical terms led to an incredibly damaging global financial crisis. I have come to realize that our current corporate behemoths are making similar mistakes. While more Fortune 500 companies are talking about ethical problems than ever before, they are framing proposed solutions in non-moral terms, preferring the language of engineering, for example. And this is leading to further crises.

In March of 2018, BuzzFeed published an internal Facebook memo crafted two years earlier by Andrew Bosworth that proved to be a very timely reveal.[1] In it, Bosworth states, "The ugly

1 Mac, R., Warzel, C. & Kantrowitz, A. (2018, March 29). Top Facebook executive defended data collection in 2016 memo — and warned that Facebook could get people killed. *BuzzFeed*. https://www.buzzfeednews.com/article/ryanmac/growth-at-any-cost-top-facebook-executive-defended-data

truth is that we believe in connecting people so deeply that any-thing that allows us to connect more people is *de facto* good." What are the types of things identified as inherently justifiable? Facebook's strategy of aggressive growth at all cost, questionable competitive practices and misleading language that leads users to unwittingly give up their privacy.

Even if we disagree with the principle, we can respect a com-pany that views greater social connections at all cost as their moral vision for the future. But we cannot tolerate a firm who then denies their vision publicly. In a follow-up tweet after the memo leaked, Bosworth stated, "I don't agree with the post today and I didn't agree with it even when I wrote it. The pur-pose . . . was to bring to the surface issues I felt deserved more discussion." So are we to believe that the executives of Facebook don't believe that their questionable growth practices serve a greater good?

If Bosworth's backtracking is sincere, it represents the worst of all moral positions. As internal company communications continue to leak, it seems as though Facebook does everything it can to avoid clarity in its ethical positioning. We have a right to know what values guide Facebook, what kind of firm it is and wants to be. Facebook users cannot "Like" the ethical positions of the company if they are not shared. And why are they avoiding moral clarity? Because executives at Facebook ultimately believe that the right algorithm can make all of their ethical problems go away. Unfortunately, despite the great technological advances being made by their computer engineers, these deep-learning algorithms that the industry view as their future "haven't been optimized for any definition of fairness."[2] Ethics remains the great unknown.

2 Vanian, J. (2018, June 25). Unmasking A.I.'s bias problem. *Fortune.* http://fortune.com/longform/ai-bias-problem/

The problem of relying on engineering solutions for moral problems has even hit the music industry. Spotify recently walked back a policy[3] designed to punish artists accused of misconduct, a sensible response to the #MeToo movement. Within days of the initial announcement, an uproar emerged over the perceived racism in the policy, as the initial targets were two African-American artists. In the end, Spotify released a further statement revealing that they were not in the business of regulating artist behavior, but would instead focus on the algorithm behind their playlists.

Ethical issues are profoundly difficult for companies. They need to figure out the right balance between concerns of civic, economic, social and environmental responsibilities. They need to respond in real time to a myriad of issues that arise in their complex, fluid and situation-specific competitive environment. Many companies look to their engineers, hoping that advances in engineering or the scientific method will offer a clear path forward for their decision-makers. But a good-faith effort requires framing the solution in explicitly ethical terms. Tough as it is, we need to insist on ethical solutions to ethical problems. The next path to wisdom is through a prescription to trade fairly. This is among the oldest pieces of advice, and yet centuries later it still remains, for many, an incredibly difficult task. Those who are committed to seeking wisdom need to ask themselves what it means to trade fairly in the economic realm, and how it can be supported in the political and spiritual realms.

For years, I have taught that an ethical firm is one that can explain its value proposition in a clear, concise, non-technical sentence. It's a test that many of the digital age giants fail. Take a look at Facebook's investor relations page. It's littered with platitudes about all the social good they create . . . but not a word on how they make their money. Why can't it be clearly stated?

3 Spotify Policy Update (2018, June 1). https://newsroom.spotify.com/2018-06-01/spotify-policy-update/

Author and technology critic Franklin Foer helpfully defines Facebook's business model as the "evisceration of privacy," aiming to get users to share personal information that the company then uses to generate "the insights that will keep them engaged on its site and to precisely target them with ads."[4] Even though they do not charge their users a fee, Facebook does not trade fairly. As recent scandals have shown, when some users discover what they are giving up to have a Facebook account, they are angry and frustrated. For all Facebook's talk of "community building," healthy community is built on a shared sense of fairness and social responsibility.

Fairness is a primary virtue found in almost every intellectual system, from secular philosophers such as Aristotle, Rawls and Derrida, to religious ethics. And with that, let's meet Sunshine Jones, an innovator in house music, an artist who has been at the helm of a number of record labels and someone who loses sleep worrying about how to make a living doing what he loves while treating all stakeholders with the highest standards of fairness.

In the mid-1960s, writer Ken Kesey and the Grateful Dead hit the road to lead adventurous souls on the American west coast through a now mythical series of social and artistic experiments. Known as the Acid Tests, these all-night psychedelic dance parties shattered the artist/audience divide. Everyone in attendance was an imaginative participant, equally committed to an atmosphere of mass creativity. While the mission was proselytizing the powers of LSD, these early career shows nonetheless helped the Grateful Dead create a new DIY experience in American music. The movement was rooted in improvisation, sonic explorations and large-scale dance parties where the band and audience were one creative force.

4 Foer, F. (2018, March 21). It's time to regulate the internet. *The Atlantic.*
 https://www.theatlantic.com/technology/archive/2018/03/its-time-to-regulate-the-internet/556097/

In the 1980s, Lee Ranaldo and the rest of Sonic Youth melded the DIY and improvisational commitments of the Dead to the decidedly non-hippie artistic sensibilities of the east coast punk and no wave scenes. Lee has admitted to the formative influence of the Dead on him personally, and how at times Sonic Youth mimicked Jerry and company's template of musical excursions with a devoted fan base happy to join the band for a ride into novel territory.

Then in the 1990s, a band emerged that unconsciously answered what it would sound like if a San Francisco–bred punk melded the best elements of the west coast hippie aesthetic and the east coast no wave philosophy. While the Grateful Dead and Sonic Youth were two-guitar rock bands, Dubtribe Sound System was made up of electronic musicians. And while their music was played live and extensively improvised, the primary goal was to get people to dance. With Dubtribe, Sunshine and Moonbeam Jones brought the worlds of house music, rave culture and psychedelic dance parties into these ongoing artistic conversations, and in so doing created a powerful new form of artistic expression.

Sunshine: My philosophy is the "Play Live!" theory of improvisational electronic music. My tribe is house music. Not the genre on Beatport, but the music of the Warehouse, the Paradise Garage and the Loft. Anything which can be syncopated and mixed is eligible to be played in my house. No limits, no rules, and if there are rules they need to be pushed, broken and used like a life preserver when we need them rather than a finger to point with. My tribe is revolutionary beyond gender, or race, or social trends . . . where the dancer is the brightest light in the room, and it doesn't matter who you are, or what you have, or what you're wearing, or what you know. It's being present, and opening your heart, breaking your heart wildly with love to the rhythm of the music that sets us free.

Sunshine Jones has spent over three decades enacting his philosophy of "Play Live!" — converting thousands of adherents along the way. I count myself among them. I must confess to at least two occasions where immersing myself in the art of Sunshine Jones helped me through tough times. These were critical instances when I first turned to the rational philosophies that are my bread and butter and found them wanting. Arguments and thinking left me cold. Only bearing witness to Sunshine's exuberant "Play Live!" manifesto helped me navigate the dissonance of these specific disruptive moments.

The first of these events happened in the summer of 1997, as I was midway through the completion of what increasingly felt like a soul-destroying MBA program. The decision to trade philosophy for finance emerged from an inner debate where the dominant voice, allegedly pragmatic, was convincingly arguing in favor of a narrowly defined conception of adulthood and respectability. The losing voice embraced a broader calculation that included like loss of intellectual passion and depleted integrity.

Feeling lost and self-destructive, I got into a car with my girlfriend of the time late at night on a humid July weekend and drove two hours to the newly named World Electronic Music Festival. Despite the grand title, the event was a fairly modest gathering of Toronto and Detroit area ravers on some rural property in Orillia, Ontario, being put on, ironically, by my MBA classmate Ryan Kruger and his Destiny Productions. As an urban, uptight, neurotic Jew with no rhythm or outdoorsmanship, I should not have found peace and solace at an all-night dance party taking place on a remote campground. The fact that I did speaks to the power of Dubtribe. I was in their tent until daybreak, immersing myself in the repetitive beats, tribal sounds and inspiring messages of hope pouring out of the speakers. And despite being a rational pragmatist — and absolutely not dancing — I emerged from the tent with the formerly marginalized internal voice now more audible.

The second internal realignment massaged by Sunshine and Moonbeam occurred seventeen years later, as I was contending with the clichéd, but no less real, nervous breakdown that often accompanies the arrival of forty. Earlier in the evening, my wife and I marked the occasion by seeing the incomparable Nick Cave perform, without his Bad Seeds, on piano at a 350-person theater in Midtown Manhattan. Then, after midnight on August 5, my actual birthday, we headed to the Meatpacking District to watch Dubtribe perform live at Cielo. It was the first time I had stepped into a dance club in years. But watching Sunshine perform live, seeing him in his element, immersing myself in the slow builds and surrendering the hours necessary to fully take in Dubtribe's realized artistic vision, clarity and acceptance emerged once again amid my psychological dissonance. It was the moment that planted the seeds of inspiration for this book. I resisted the message for another year or so, but the truth would not be silenced: imaginative expressions are more compelling than argumentative ones, especially when they come from experienced artists devoted to their craft.

I touched base with Sunshine during a period of transition for him. Days earlier, Sunshine had shut down his record label Treehouse Muzique, recommitted to live performance and live instrumentation after a decade of digital creations and launched a new company, the Urgency of Change. Sunshine is a blissed-out entrepreneur, as strategic as any I've met in the business world, but with a joy and a soul that is the rarest of resources. To fully actualize his recommitment to analogue instruments, Sunshine decided he needed to build his own synthesizers. As an outsider, this seemed to me a logical evolution for him as an artist. I asked Sunshine about the motivation to return to wholly created sounds as opposed to pushing buttons.

Sunshine: Well, a lot of things happened here. I spent the entire 1990s traveling the continent, really the world, performing

live electronic music. All of the music was actually being performed through improvisation — in the moment. And in 2001 it suddenly became very difficult to travel with all that analogue equipment. For the first time ever, I was missing flights, missing performances and being barred from airplane travel because the TSA agents didn't know what the heck was in all my cases. As a result, I needed to find another way to work. I was forced into finding equipment that was more portable . . . a laptop, a series of controllers, external effects and a microphone. That really opened my mind, as I had been pretty down on people using computers for performance . . . but I had no choice. I did that for about ten years and had a lot of fun. Then, in 2015, I loaded up a rental car and was headed out to the desert. I had all my equipment and in the nine minutes that I was away from my car putting a check in the bank the car was broken into and my entire life was stolen. That was absolutely the worst thing that ever happened to me, I thought. They stole my entire music collection, all of the preproduction for my next album, all the production for the new Dubtribe album, every device that I owned for making music.

Needless to say I was devastated. People were very sweet: they organized a GoFundMe and generously contributed to help restore what I'd lost. I managed to put together a purse to try to replace my laptop and things and realized that I wasn't really sure that's exactly what I wanted to do. I'd enjoyed the previous decade: performing digitally was interesting — there is a freedom in being able to take a track I love and loop the exit beats, mix in a breakdown from a disco classic and loop that, then start a third song, maybe something I wrote that morning, loop in its starting rhythm, grab the mike and start singing . . . it was very immediate and fun. In a weird way, it was almost too easy. But I wasn't happy. In the midst of this loss and grief I asked

myself, "When was I last actually happy and productive?"
The answer came at once: when I was playing live.

In the aftershocks of the moments of loss, Sunshine asked and answered the fundamental question that would allow his life to proceed: "When was I happy?" As we noted in the introductory chapter, living means taking action, even when we need more time to think. It means finding a way to accept the bumps of dissonance, unsettled as we may be, and move on with our narratives. And so he did.

Sunshine: I decided that I would assemble a setup and see if it were possible to put a live set together and perform with it. I put a humble little rig together and booked a show and played. It was amazing. I read up on how to expand a semi modular synthesizer and discovered an entire world of wonderful and seemingly endless possibilities. I got even more curious about electricity, circuitry and how this was all working . . . I'd been an electronic musician exclusively for more than 25 years and I didn't understand until that time how important a role voltage actually played in the music I was making. Naturally I had to build something.

Sunshine's "natural" instinct to build something is a further example of how an artist can shift the direction of a wider social conversation without even necessarily meaning to. Author and media theorist Douglas Rushkoff was warning throughout the early years of the new millennium that for the first time in history most people don't really understand the mechanics behind the tools central to their daily lived experiences.[5] He observed

5 Rushkoff, D. (2010). *Program or be programmed: Ten commands for a digital age.* New York: OR Books — although he addressed the issue in earlier works as well.

that as technologies are becoming more complex, the human beings using these tools are becoming simpler. Nobody understands everything going on in an iPhone, yet its presence is ubiquitous. Most people acknowledge they make compromises of understanding for pragmatic reasons — the results of a cost/benefit analysis. We need to be more efficient, get more done, cover more virtual ground in our day and thus cannot simply shut off these tools. But Sunshine the artist *could* pull back and investigate the tools of artistic creation.

Sunshine: The mobile phone zombies make me sad. I live and thrive at ground zero for the tech explosion. The cultural impact is negative, the economic impact is negative and in a lot of ways the world is alien to me now. I do not feel like a Luddite, I think my mobile phone is a useful tool, and I'm not angry about the internet. But we've gone so slack. We've really lost each other in a very deep and serious way. I find abandoning the computer completely as a tool for making art has revived my love for the music. Visual art has become a piece of my arsenal as well, and cutting paper, mounting pieces and printing has been as inspirational to me as building electronics, or performing live. Closing the laptop, switching off the screen has given me a new set of eyes.

I'll tell you a story: I was in Victoria in the middle of a set which was going great. I'd been touring for about a month, so I was tired, but I was just sort of hitting my stride. I went into a portion of my set which is just called "acid," and it's an improvisation where nothing is pre-considered. I program the song in front of people. I got the 303 going, and built the drum beat, I looped the 303 and then added a second line and looped that with the delay and the entire club was just throbbing and surging, and I was vibrating, out of my body, so present that it

almost didn't feel like I was really even there. People were cheering and tracing my aura and undulating and smiling and dancing — it was great — and I raised up the frequency of the delay, and stopped the drum machines until there was only this piercing high-pitched loop going into the delay and it faded off into nothing . . . I quickly reset the 303 to a different bass line and set the drums to be a steady rhythm and looked up at the crowd just as I pressed play and we all burst into euphoria. I began to weep. I could truly see the music and intuitively knew what was happening and what to do. I was weeping because it felt so good, because I felt so close to all of these people, because I was home.

It's a beautiful story, earnestly told. In Sunshine's ecstatic moment shared by audience and artist in Victoria, feelings of dissonance were mediated by art and the unbalancing perceptions could be integrated into a comforting sense of inclusivity. The artist and the audience were one in their joy and emotional outbursts. Experiences like that have the potential to foster a more effective society-wide wisdom conversation.

Sunshine: When I close my eyes, I can see music. Rhythms, patterns, melodies, words, prose, refrains just move through me. I thought for a long time that this was something I was supposed to have mastery over, as if I could somehow navigate and control what was happening. Because the nature of my art is so public, there's organically a service call-and-response nature to it. And because it's so public, there's also a sociopolitical aspect to it . . . singing, drumming, chanting or speaking produces a response from the audience. Because of the way I perform — as close to the dance floor as possible — I very much feel that I'm part of the crowd, wherever I am in the world.

I grew up in San Francisco, which was politically motivated at its heart. I grew up with Black Panthers marching down Market Street, the SLA, the kidnapping of Patty Hearst, the assassination of our mayor, women's rights, gay rights and the AIDS epidemic. And for much of the 1970s I jeered and derided social consciousness. I was a punk, in every possible way. I associated social consciousness with hippies, and I wasn't into that at all. I think I felt the hippies took a little too much of the spotlight, and for all their good intentions, had ultimately failed . . . So when it was time to express myself in front of an audience, at first I didn't actually want to say anything . . . I found great comfort in instrumental, repetitious electronic music.

But being me, I don't leave anything alone . . . so I begin to say words into loopers and delay units. I begin to filter sampled pieces of my voice and use them as instruments in the music. And eventually I found the courage to actually start singing. It took a little while for me to discover that when I spoke, I really just let the words inside of me out — very often without even thinking about it — to reach people. And I think for the first couple of years I didn't have a second thought about what I was saying. I wasn't trying to "do anything," it just felt really good to forget myself and let myself go.

So I think that there's a degree of political activism, poetry and social connection at the heart of every song I wrote or write, but I would be remiss if I didn't point out that after a decade of considering the "we" of the world, I was feeling a little empty and lost. I wasn't sure anymore how "I" felt about anything and needed to get my head together. So I began to express myself in the first person and stopped attempting to embody the experience of found objects or witnessed events. The work comes out very differently when you're talking about yourself.

> Persona is a fantastic shield. To put down the force field and reveal my own self was scary . . . I seem to always be reaching for the lost, the heartbroken, the discouraged and the hopeless and asking them to think for themselves, and to stand up . . . I think that the last decade has really been about humility for me. I just had to let go of the past completely and strip myself down to the truth, or at least as close to the truth as I could possibly get.

Prophets and artists channel a message that comes from somewhere other than their rational faculties. Prophets and artists are poetic, carefully choosing emotional and imaginative language to share their vision. Prophets and artists are iconoclastic in challenging the revered, and unwilling to tolerate human mediocrity. When Sunshine closes his eyes, he can see music. As an artist, he is compelled to bring what he sees in his imagination to the world. And even if you are not interested in house music, it is worth exposing yourself to it at least once. What does it sound like when rhythms and melodies move through someone in submission to the muse?

The core critique of Western capitalism is that greed is either celebrated as virtuous or tolerated as pragmatic. I call out greed as a vice when it hampers the positive possibilities of economic exchange — when folks seek greater economic returns than what their efforts should reasonably earn. The intersection of art and commerce requires difficult trade-offs: integrity, uniqueness and innovation can stand in opposition to profit, or at least a larger audience. Some of Sunshine's recent experiences offer interesting case studies on these challenges and the many potential paths to resolving these tensions.

Sunshine: Because we live in a capitalist society there's always the ego, and the threat of fame or the promise of money, behind what a lot of people do. But the only thing that

matters is the work. These things must be given life and be brought into the world. These words must be said, or sung. If you're worried about money, go make money. If you're worried about selling out, then you are more like me and we are shooting ourselves in the foot. There's no shame at all in success. But we must determine and consider what success means to each of us, and be grateful for what we have.

While my heart is still beating, I will continue, but I've got no real expectations of owning another home, or having any degree of stability or security (or even health insurance) . . . I don't know if the business of music exists to support art. Occasionally we get a Stevie Wonder or a Tom Waits, but for the most part the business of music is exploitation — like any business.

People want widgets, so someone labors out of love to develop a beautiful thing, and then someone comes along and says, "Hey bub, I could make that for you and we could split the money." And that sounds like a good deal. We have built the North American continent on this concept. But this takes all the love out of it. It becomes the brainwash of advertising, the amalgamation of incorporated endeavors, and the political payola of greasing the wheels to permit pollution, avoid fees and fines, and inevitably leading to some advantage for the few, and a higher wall to climb for the many.

I don't think that "business" is in support of art at all unless they need to gain credibility, or to make things pretty. To money, art is an investment with the promise of more money, or just a decoration. Nothing more. So I don't blame business for failing to support the arts. I blame artists for selling their souls for money.

These days many artists have grown wise and are accomplishing a lot of great work and really reaching

people. It's a great time. So maybe the failure of the business of music is a positive thing. Maybe now they are free to operate as the marketing machines, advertising factories and PR mechanisms they were before without the distractions of having to pretend they are culturally relevant. So if I make a record and need assistance, I might be able to make use of the distribution channels in place. Otherwise I am free to produce, distribute, perform and tour as I feel is appropriate and warranted by my art itself.

Artists don't create widgets. They create a product that is valued for reasons other than its practical characteristics, like the meaning an audience attaches to it. The tension of profit as opposed to integrity blew up on the music industry when new technologies disrupted their traditional business models, and profits started to vanish as tech companies moved in. After this creative destruction, perhaps the relationship between artists and commercial channels can now be more honest.

Sunshine: What would happen if you were so successful that you were able to form a huge indie and collaborate with a great manufacturer and even strike a deal with a shipping company so that your efforts to produce the best, most beautiful music in the world were easy, low cost and efficient? It was so good that you could take huge risks and release weird seven-inch ambient singles and special-edition silk-screened fold-out posters of a cappella folk singers and sell them to the people who loved them? What if folk labels and hip-hop labels were crawling all over you to help them? Imagine yourself gathering up your resources and making a go of lending your skills and insights into collaborating with the best of them to get the music to the people. Wouldn't you then be a record industry giant? Wouldn't you be the man? I can just see

you in your suit at some wine bar being lame, and kids out front heckling you for selling out, right? Can you see it? I think that's essentially what all big business really is. People who overthrow their intentions, hearts and dreams for money . . . You haven't really made it until you got the money . . .

I look at someone like Beyoncé Knowles as a model of what's possible. She took a disciplined childhood where she danced and sang and performed and groomed herself with very hard work to become a member of a pop group. They were the right thing at the right time, and kids loved them. That story should have stopped there. But instead Beyoncé appeared to consider what this means to her, and what else she might want to do. So she took a healthy step back, and has been following her dream since then. I admire her choices, and how she carries herself. I love how she's taken her little sister under her wing and helped her to thrive as an artist without having to appeal to the mainstream. Solange is as wild and left-field as Beyoncé has become. It's as if their efforts have made a positive impact on music and culture itself. That's a lot different than wearing a funny hat and getting the world to buy one too. The deeper and more internal themes in these women's music, plus their popularity, and the efforts to resonate within the hearts and minds of the people, all people, has spearheaded a revolution, a creative renaissance in R&B. It's beautiful.

Now anyone who follows electronic music knows that we have those revolutions every year. We transform, and we introduce new ideas, new sounds, new energy, and things shift and flow and change. That's not happening at the festival level. It happens in the little dirty bar that most people feel uncomfortable in. It happens in basements and out on the street. The problems begin when you connect.

I've got a song, and my audience loves it. They want it. So what do I do? Shall I give it away? Package it up for the masses? Make a few and sell them out of my trunk? The answer can be a success story or a heartbreak depending on the artist, the time, the place, the audience . . .

It's hard to survive in the increasingly expensive world trying to hustle 99¢ MP3 files to people who don't want to pay for it. And you can't get your music into the Spotify streams without money. In many ways the digital world is far more of a disadvantage to the indie than the olden days of radio and record stores. There is a blur of meaningless data being hurled towards everyone all the time. The blur is curated, run through an algorithm, and you only get to see what the computer has determined you might be likely to want to see. So your exposure to new things is curtailed, and your experience grows smaller and smaller until something catches with a hashtag, or a mainstream wave, and then it's shown to all. And we seriously see the world this way. It's how Facebook connects us, how Twitter associates us, how SoundCloud suggests and even how Netflix recommends. So we aren't looking into the eyes of the green-eyed weirdo at the record store and asking, "What is playing right now?" This is how organic movements grow and rise.

It feels like culturally we are attempting to change from the outside in. Capitalism wants desperately to feel free, and to appear bohemian. Thus the event prices have risen from $25 to $250 in about five years. The status quo asks us to be decked out in fancy clothes in order to be the star of the show . . . so we buy, we buy, we buy . . . It's at best going to be fun, but ultimately it will not succeed in saving anyone's soul or creating any real social revolution. Dissent becomes commodified the moment it's up for sale. But the authors, singers and musicians must be able

to house and feed themselves. That leaves anyone with a heart asking questions, and in need of guidance. What's wrong with creating commodities? What's wrong with a fair exchange? How do you feel about these things?

The innovation question that Sunshine touches on here is a fascinating one. How do cultural industries encourage innovation in a commercial landscape while at the same time supporting artistic integrity? If customers view cultural creations as commodities, then the consumer gets to determine a "fair" valuation of the artistic product. With increased streaming and decreased purchasing of albums, creators of music cannot continue to create at market prices. Consumers have become greedy, impeding the ability of artists to claim what is fair. Further complicating the equation is the tension between creativity and social responsibility. The artist, committed to integrity, is trapped by the claims of their conscience — claims that traditional profit-focused entrepreneurs tend to ignore.

Sunshine: I've just killed myself over T-shirts. During the T-shirt binge of a few years back I wanted to add my voice. I researched and found a way to make very high quality, North America–made T-shirts in an environmentally sound manner. I even found a method of creating fabric first, and custom making each T-shirt to order in a way which would mean education, health and well-being for a family for a year from the sale of each T-shirt. The trouble was that by the time the shirt was made and shipped it cost about $34 U.S. So I agreed to ask for $1 over the cost, and sell them that way. I sold a lot of T-shirts, and people love them. But I didn't get anything out of it apart from the love and joy of participating in the conversation. Chuck Aubrey's kitten is being worn with laser beams shooting out of her eyes all over the world now as people's favorite shirt, but that was

for the kitten, that was for Chuck, that was for the people who wanted that shirt. I got a buck.

There's just no way I could have asked people to do the customary retail markup of 50 percent and pay out 68 bucks for a T-shirt. I wouldn't have been able to sleep at night. Further, in order to fetch $70 for a shirt I would have had to brag about how the shirts were made, and promote the ethics of what's happening here, and commodify my decisions in order to pander to an audience that even had $70 for a T-shirt. In that dance we are all prostitutes, and I don't really get my inspiration from that. So they each made me $1 and no one knew. They just loved their shirts and that's why I did it.

I'm willing to hustle and work, I love my work so that's the easy part. The music, mercifully is still flowing through me. I have a lot to say. My efforts are mostly to just organize myself in such a way that I'm able to be places, and get out of the way and let it happen. That's the most vital and nourishing piece of all of this. I'm blessed that I still have the opportunity to do it.

What Sunshine discusses here can almost be seen as social entrepreneurship. Social enterprises start with a social motivation to create. Sunshine wanted to create wearable art. He wanted to pay tribute to an artistic vision. He wanted to empower the families of those who created the fabric. He wanted to be environmentally responsible. And he wanted to create a product that even the middle-class could afford. Put simply, he was an entrepreneur who was less interested in profits, and more concerned with positive social and ethical outcomes. In Sunshine's case, the venture necessarily became a not-for-profit.

But maybe that result is evidence of the failures of business thinkers, of our capitalist elite . . . of folks in the business schools . . . of people, quite frankly, like me. Those of us on

the frontline of capitalism have an extremely poor understanding of how entrepreneurs motivated less by commercial logics than by artistic integrity can achieve successful outcomes. How could we have helped Sunshine's venture to be successful, given these noble goals? Future iterations of stories like this must be able to end differently. Only because Sunshine is an artist is his story even being told in the first place. Those who still believe in capitalism need to heed this new conversation and figure out a response.

Sunshine: Love is what we do. Love is how we drive in traffic, it's what we say under our breath when we end up in a long line. Love is how we treat people who are ugly, or fancy, or in our way. That's what love is. So who do you want to be? What is truly in your heart? Tell the truth . . . aren't most of us impatient, selfish, small and afraid? We are. Why? Why are we so small and snotty? Because we are terrified. We are all afraid that it's not going to be ok.

I say in any moment we are free to abandon these capitalist-imposed chains of shame and self-hatred and choose love. Maybe only for a moment, but we are in fact free to make these unselfish choices. I'm not saying it's easy, or that I'm amazing at doing it. I'm not. I'm human and flawed and as afraid as everyone else is. But I am asserting that when we are aware that it's only fear, then we are free to choose love and change the world.

Think of all that we've done in our lives because we were supposed to. All the work we've done, words we omitted, kisses we didn't offer and forgiveness we couldn't find because we were saving our faces, or following instructions, or doing what we were told . . . Lives are built on lies, denial of our own human hearts, and we are blind to what we're doing to the planet, our air, each other and to ourselves. We shrug and try not to

think about it. We don't want to think about it because it makes us unhappy. We are already unhappy, and we will never be happy until we tell ourselves the truth. So a little unhappiness avoided for a lifetime appears to produce a dysfunction which has created a world which is in serious trouble. I vote for stepping off this conveyor belt and taking a collective moment to find our true selves and be grateful and celebrate who we truly are.

I think that until the people get their heads together, and begin a healthy dialogue where we can take action which the establishment can understand — stop shopping at Walmart, for example, divest completely from all national conglomerate banks, settle for crappy internet service and turn off Comcast, shop locally and pay a little more for food, and all of the many things we can proactively do with thoughtful purpose — then we will continue to be pushed around and talked down to by the establishment. For them it's all about money and power . . .

It's time, way past time, for a change in how we see ourselves, and how we relate to one another. I think that art and music have a huge and substantial voice in this dialogue, but it's fleeting and it's obscure. Until we are able to rally the people, and reach them where they are, for $5 instead of $500, we're going to continue along on this course. We may never choose to work in our own interests. We may always find it better to fall deeply into sleep and strive to remain there, unconscious. Each person rationalizes their own experience and has to face themselves in the mirror. So if all you want is money, then have at it. If you wanna be right — good luck with that. If you want to be happy, find out what's really going on inside yourself. If you wanna be free, then educate yourself and stop fighting everything. And if you wanna get down, well, let's go, baby . . .

Wisdom demands that we learn how to make our economic exchanges fairer. This will require a major socio-cultural and political shift. But we cannot be wise so long as we celebrate greed as virtuous or tolerate it as pragmatic. Institutionalizing norms which impede the positive possibilities of economic exchange by allowing the greedy to claim unreasonable returns and letting their crimes go unpunished will only encourage more folks to reject capitalism as they reject making the trade-off of integrity for economic efficiency. How many more cycles of crises need we experience before this becomes clear? We need to commit to fairness on a societal level, and we need to learn from artistic entrepreneurs the many potential paths to resolving the tensions currently deeply entrenched in our economic system.

CHAPTER 6

Educate for the Future

For fifteen years, I taught at one of the largest business schools in Canada where the students are, for the most part, not American, not white, not undereducated and not unprepared for the changing economy. They are the future global business leaders and many of them view Trump as an aspirational figure. Their defense of his most immoral behavior invariably falls along the lines of "Look, he's trying to close a deal. It's smart business." At the heart of the "business deal-closer" defense are a few troubling ideas that still dominate mainstream capitalist thinking:

1. Economic transactions — "deals" — are the most important units of analysis. Moral or social concerns are less important than possible financial gains.
2. The value of maximizing — go big or go home.
3. The uncritical pursuit of creative destruction: change the competitive playing field so that it better suits your particular needs and don't give a damn about the ethical safeguards that may be discarded along the way.
4. The *Wall Street* cliché, "Greed is good."

As an in-class exercise, I asked our MBAs to raise their hands if they thought it was a good idea for their company to reach out to children's cancer advocacy groups. All the hands went up — after all, this is an exercise without real commitment, and nobody wants to overtly signal a disinterest in dying children. Prostate cancer advocacy? Well, that's a disease that only affects old men, so a few hands dropped. Animal cancer advocacy? More than half dropped. KKK-organized hospice? All the hands dropped, and the students chuckled at the ridiculous suggestion. But I push a little further. What if it was a small town, where the KKK are part of the community, and it would help your business? A noticeable number of the hands sheepishly popped back up. And, generally, it was not white hands that led in the rethink. When I added the caveat that there wouldn't be any reputational damage to your brand, even more hands popped back up. The students argued that as abhorrent as they may find the KKK, the deal must come first. But then they laughed and said a situation like that wouldn't happen. Except in Trump's 2016 presidential campaign, it sort of did.

Trump's aspirational status amongst businessmen is thus easy to understand: he is destroying institutions to create an alternative reality that he can better exploit, he is reaching out to certain stakeholders that he argues have been ignored, he promises to create a new form of shared social and economic value for certain constituencies that he privileges and he is undeterred by the lack of principles needed to achieve these ends — wholly familiar business logic.

This should be a wake-up call. Business academics and industry leaders should no longer be allowed to lead the conversation on the future of capitalism. Many artists are innovators, entrepreneurs and committed to integrity and the claims of their consciences — claims that traditional profit-focused entrepreneurs tend to ignore.

A society committed to wisdom educates its citizens rather than micromanaging them with aggressive governance. The

capitalist era has brought with it many social blessings, in addition to harms. We need to be careful in developing the next economic system and be sure to empower moral folks to lead. The laws have always lagged behind the moral sense of the people — from slavery to suffrage to marriage equality and beyond. Dissonance will often precede a moral paradigm shift. An educated population is more empowered and better suited to navigating the changes associated with progress and increased inclusivity than a population that turns to laws and rules for guidance.

Social innovation means creative destruction. Marriage, for example, means something different when it is no longer tied to the rules of the Church but instead becomes a way to formalize a diversity of loving commitments. As such, moral crises are endemic to societal change. Both those pushing for social change and those resisting it will often find the process traumatic. And while moral shifts can eventually result in more equitable laws, a truly progressive society can never reasonably expect that good governance alone will prevent the next social crisis. We need a populace with a robust moral education and forward-looking critical thinking tools.

I don't know what economic organizing principles will come to dominate our post-capitalist era. But I do know that a society that celebrates innovation must be very focused on the moral character of those they empower. We need to educate and empower our society in a wisdom tradition of shared values as opposed to looking to government to play catch up through law. Where and how we educate our future business leaders matters a lot, and business schools as they stand today are just not up to the task.

Business schools produce more narcissistic monsters than transformational leaders. We need to rethink capitalism, as well as how we educate those who we allow to claim social power. In the last chapter, we asked what it means to trade fairly. In this chapter, we will ask a related question: Who are the critical folks

at the heart of the Western system of capitalism: workers or entrepreneurial innovators? And if the answer is the latter, then are there important differences between entrepreneurs? Should these differences inform how progressive societies support entrepreneurial initiatives? How we as a society choose to answer these questions may be at the heart of rethinking capitalism. If our artists are more than working craftspeople, if their types of innovative activities create an invaluable social good, then the health of a society might very well be inextricably tied to the ability of their artists to make a fair living.

Mike Doughty considers himself to be a working craftsperson. He has few pretensions about his art and puts himself squarely in the blue-collar world. While some folks may learn the craft of welding or bricklaying, he learned the craft of songwriting and performance. And he has certainly put in the time and hard work to now emerge as a master craftsman. Mike Doughty has done it all: from playing arenas and festivals with Soul Coughing in the early '90s to a living-room tour in 2015, Mike plies his craft wherever there is an appreciative audience. But despite his humbleness in portraying himself as a craftsman for hire, he is also very much an entrepreneur who is constantly seeking innovative models to bring his art into the world while still making a living. And he is one of those rare musicians whose latest project is always as interesting, if not more so, as the last.

Mike: I set out to do this as a kid. I grew up at West Point — my dad was in the army, if you want to talk about dissonance. It's a weird place to be if you're an army kid. But as I grew older, I uncovered the Protestant work ethic. One thing I did notice when I went to college with all these kids who would say they are a playwright, a director . . . but then everyone would sit around, getting high and talking about what they were going to do. I'd be the one to actually go

and do it. I was the one that was actually creating work. I definitely made the connection early that this was a craft. I don't want to say profession. It's being a working craftsperson.

Getting back to the opening questions of this chapter, we can conclude that there are indeed important differences between classes of entrepreneurs, and Mike Doughty exemplifies why they matter. Entrepreneurs are generally thought of as folks who create new types of organizations, or new combinations of businesses to create new products or services. Artists like Mike are a generally underappreciated class of entrepreneurs who try to create social and commercial value through innovations within their craft. These efforts are focused through the prisms of distinct artistic visions. The dominant thinking is that all entrepreneurs are basically the same where it matters most, whether they privilege profit maximizing, social betterment or an artistic vision. The implicit assumption is that we don't think that an entrepreneur who creates art may be more important to our society than an entrepreneur who makes widgets, as both create value, loosely defined. It also assumes that we should not care that our artistic entrepreneurs may be more vulnerable than our widget entrepreneurs. And it definitely assumes that capitalist societies have no great interest in compensating their ethical entrepreneurs for the massive extra costs they take on when trying to create in a manner that benefits all the stakeholders.

In short, these folks believe that artists are simply another class of businessperson. And what's perhaps most disheartening about this line of thinking is that it's not only coming from the community of business elites, but from certain segments of the cultural elite as well.

Mike: What's funny is that this thing started coming from hip-hop in the late '80s — this persistent theme of "I'm a businessman,

not an artist." It has slowly seeped into all forms of art. People will compliment you by saying that you're really a businessman. So-and-so is a great choreographer, but she's also a great business owner. That's true, and it's good to have that skill set, but isn't it also okay to just be an artist? It's gotten really strange to me that being a great artist is not a pure ambition anymore. It's like, "I want to run a company." I believe in the pendulum swing, and I do think the pendulum is swinging back that way.

Mike Doughty doesn't want to be known as an entrepreneur or businessman. He is content with being a working craftsperson. But the work he does is so important for getting our social conversation back on track. And historically, most societies have, at least superficially, created a privileged space for their artistic class. Arts and cultural industries are one of the only industries managed by the national government of almost every country. Traditional cultural policy privileged the artist over the consumer, providing subsidies and support directly to the artists that needed it. In this way, a society formally recognizes and celebrates the importance of art that may not find a path to profitability or mainstream attention.

Unfortunately, for the past few decades American cultural policy has shifted to focus more on the fiscal implications of art. While life for artists in Trump's America is proving to be a disaster with cuts to arts funding and granting organizations, life for artists like Mike and Sunshine wasn't that blissful in Obama's America either. How a society defines what type of art matters — whether it be narrowly restricted to the "high arts" appreciated by small, elite audiences or broadly defined to include popular culture — determines which artists qualify to be protected and nurtured under cultural policy. Sometimes, how art is defined for policy purposes is not indicative of a

government concerned with artistic integrity but with economic implications.

Artists who innovate beyond the scope of the cultural policy may find themselves without protection, thus steering artists towards the status quo. And so a fatal flaw in Western capitalism becomes apparent. Too often, even progressive societies fail to protect or nurture their entrepreneurial artists. We rarely encourage new ways to meet social needs through non-mainstream art forms or stimulate social change through radical messages or that burden themselves with going the extra mile in being accountable to multiple stakeholders. And we really don't know how to take care of our artists, many of whom are made to feel more like laborers than entrepreneurs.

Mike: I have to count my blessings, because not a lot of people have made it this long after this many years. I put it into two categories. The art category is what I get up and do in the morning — the essence of life, or what vibrates our atoms — and then the business category is just about money. And there's all kinds of stuff in between, like what's cool, what's uncool, what's relevant, what's not relevant — that is essentially useless. I care about making a living, and I care about making art that I'm proud of.

The tension Mike identifies is the one upheld by market-based cultural industries and government-managed cultural industries. If an artist cares about making a reliable living, that artist needs to temper their creative impulse in order to fit into someone's conceptual box. The box established for government grants and subsidies may be different than the box of commercial appeal, but neither are there to support the creative whim of an innovative artist. And we as a society are weaker for it. That artist needs to be an innovator, operating on the margins, honing their

craft with patience and empathy, waiting for the opportunity to be heard and bring something novel to the social conversation.

Mike: In terms of where money is coming from in media — it's coming from adults with credit cards who subscribe to Netflix, and then they may not even watch it for six months until they discover *Stranger Things*. Like, "Oh, I still subscribe to Hulu?" when they look at their credit card invoice. I think those are the people I will eventually be making money from. I think there is an original content model where there will be services that create original content and people will want access to it. It will be completely removed from the idea of the album.

In terms of making a living, I was very much trapped in the album publishing model. Because to get an advance, you had to do either twelve songs, or forty-five minutes of music, whichever came first. If you had a ten-song work of art that was thirty-nine minutes long, you were not going to get your advance, or you would get a lesser advance. And there's the fact that I don't think it's worthwhile to release big batches of music . . .

I think a song here and there is the way to do it. I have a Patreon feed and I would love my Patreon feed to be what my life is all about. In terms of recording, right now I'll do weird double-electronic pieces, or I'll do standard acoustic guitar songs, all kinds of different stuff. I would love my entire output to be through something like that where I put things out periodically as I write them.

The entrepreneurs behind Patreon have a simple but ambitious mission: to help artists to run profitable creative businesses. In Mike's case, his audience can subscribe for $5 per month. In return, every week he creates one new song and releases one classic live song. His subscribers get access to both innovative and

familiar material, and Mike gets to create freely knowing that he now has a reliable income stream.

Mike fluidly navigates between artistic innovation and still giving his audience access to the familiar. He moves between offering solo acoustic music and reimagining those same songs with dissonant beats. To the surprise and delight of his longtime fans, he decided to revisit some of his old Soul Coughing hits. Those who have read his memoir, *The Book of Drugs*, know that Mike's time with the band was a dark one, as he found himself crafting what would become iconic music with a dysfunctional band and working through the throes of addiction.

Mike: That was dissonance to be sure. It was really just so hateful. It was really dark. I don't know of another band that was as dark of a marriage as Soul Coughing was. As my career progressed, it became ever more remarkable for me to meet people that were in bands that were functional or if they were dysfunctional, they were only slightly dysfunctional — not the complete, full-on, hate-in-the-band dysfunctional.

I don't think it is healthy for art to live in emotional turmoil. I wouldn't call that a poetic connection — the conflict in the band and the dissonance in the music. It really came from all those guys being in the Knitting Factory scene. Mark, the keyboard player, had a degree in music composition — he was really aware of music in a very academic way. I was just more of a weird sound on a Boogie Down production record.

Yet after the book tour, where he spent night after night recounting the tales of this tumultuous period, Mike sat down with an acoustic guitar wanting to figure out what he meant when he wrote those iconic Soul Coughing songs. He wanted, in his words, "to separate the songs from the darkness." The subsequent

release presented Soul Coughing songs as Mike meant them to be when he wrote them. What does it mean to take familiar melodies and make the presentation more dissonant?

Mike: I guess it comes from hip-hop, which is atonal, largely, at least the stuff I was listening to in the late '80s and early '90s, like Public Enemy, who made deeply atonal music. When I was twenty-one, I got a gig working at a club, the Knitting Factory, which at the time was in the first of its five different locations, and it was an avant-garde jazz club. So it had John Zorn, Yamatsuka Eye, Marc Ribot, Roy Nathanson — all these avant-garde guys were coming through, and I immediately drew the line between the hip-hop I was listening to and that kind of stuff. Dave Douglas, the trumpeter, once came down from the upstairs performance room, and there was something going on up there. There was music playing in the bar, and he stood exactly in the mid-part of it and said, "Charles Ives!" So I was like, "Who is this Charles Ives? I want in! What is this?" I was very attracted to it.

The dissonance in Mike's art is not restricted to recordings or Soul Coughing material. On the night I sat down with Mike, he was in town performing a particularly captivating show, quite distinct from anything I have seen him do before. First, he was playing with a rather large band — six folks onstage backing him up, including cello, drums, guitar, organ and a female vocalist. Second, the core of the show consisted of live remixing, with Mike improvising changes in what the musicians were doing, somewhat like what Bob Weir currently does leading Dead and Company. Mike described it as a simplified version of what he saw John Zorn doing with avant-garde jazz in the 1990s, but with a hip-hop sensibility.

Mike: Curiously, I met both Mark from Soul Coughing and Jeff Buckley doing a production of Cobra, a John Zorn piece. It was absolutely wonderful — a little golden moment in music history at the Knitting Factory when they were performing a different version of Cobra the last Sunday of every month. Each performance had a different group of twelve to sixteen people, but with the same guy doing the calling or the conducting. Sometimes Zorn would conduct, but I never took part in one that he was conducting, which was a drag, and then there would be a different curator. . . What we're doing is a very simplified version of that. This is start, stop, louder, softer, change what you're doing, go back to what you're doing.

It all comes from James Brown — with the kicks and whoops and stuff like that. Zorn and Butch Morris — stuff to jam to but in a way that you're at a mixer and putting things up and bringing them down. Pushing against the boundaries of the song structure — you let people go, start/stop, let them go, and bring them back in — it's great, it's super fun. And the jamming is not soloing — it's trying to come up with parts, which is infinitely more interesting to me than soloing.

With Mike Doughty it's not just the music that tends to defy mainstream conventions, but his vocal presentation as well. His stream-of-consciousness lyrics are a unique imagination entry point that goes beyond the music. I asked him about the tradition of his lyrical style, and why he prefers it over more straightforward narrative structures.

Mike: I don't know where I would put myself in terms of a tradition. The real teacher that I had was a guy named Sekou Sundiata who was a poet at the New School. I learned everything

from that guy — stylistically, and general life lessons about how to be a poet. I grew up listening to rock music, and it was sort of indie rock, and then when I was teenager, I moved to New York in 1989, and it was this weird jazz stuff and this weird hip-hop stuff and Sekou. I couldn't tell you if I see myself as following that way.

I think so much of pop music is just words that sound cool thrown together. What makes them great is the title or the way the words feel or taste. It wasn't even an aesthetic decision — I came into it thinking that I'm into weird words, pop music is all about weird words, so I'll just do this — and then it was baffling to me when Soul Coughing would put out a record and it was this intellectual, strange, obscure magic — and then Oasis had "I don't believe that anybody feels the way I do about you now." It's all weird. It's all sensible but not sensible. I just worked in who I was and what I found interesting. It was sounds of words, and meaning is definitely a part of it, but I don't know that meaning is necessarily discernable to the average listener — I think it's great when someone assigns their own meaning — some wild story that they project on a song. But I don't go in expecting people to be able to see the narrative.

Mike's fight against the commercial pressure that discourages musicians to innovate goes beyond his art and unique business models. He is also a vocal critic of the music industry. The establishment has been decimating the music industry, often appearing to be clueless in how to manage their business. In 2017, Mike took to the editorial pages of the *New York Times* to publish a scathing critique of the Grammys. It's a must-read article that laments how an awards show broadcast focused almost entirely on artists who already make big money is not smart business. In contrast, the Oscars promote some smart films that won't be

blockbusters. He sees the Grammys as a lost commercial opportunity.[1] It really seems like as an institution, the music industry does everything wrong.

Mike: With that piece I was trying to say that I'm not just a guy saying, "José Gonzalez should get album of the year." I'm saying you are wasting money. You have this big old chunk of culture staring at you that you have failed to do anything with. It is crazy to me how well HBO and Netflix and AMC have turned the Golden Globes into this real, powerhouse prestige product monetizer. In music, no one thinks of it.

His thinking on the topic resonated with me as a former record label employee. I got into the business as a bright-eyed, newly minted MBA who had hopes and dreams of using corporate platforms to expose folks to better art. At the label I worked for, most of us swallowed the bitter pill of pushing trite pop music in order to get brilliant, innovative bands like Luscious Jackson (who we will encounter in the next chapter) greater mainstream attention. In hindsight, it's clear that using corporate resources to push great art was viewed as a luxury . . .

Mike: It's not like you have to make money hand over fist — but you can have something like that and make it profitable in a worthwhile way. I do think that there are incredibly smart people in streaming TV, in cable and in tech who could look at [the music industry] and say, "This is an incredibly valuable asset — everyone wants music. How can we make money on this?" I think everyone in

1 Doughty, M. (2017, February 13). Make the Grammys more like the Oscars. *The New York Times.* https://www.nytimes.com/2017/02/13/opinion/make-the-grammys-more-like-the-oscars.html

the music industry right now is just playing defense until they get their golden parachute and they're out of there. Eventually, someone smart who understands the way people consume culture and use media these days will come in and build a better mousetrap.

Unfortunately, I'm cynical about that possibility. My biggest complaint as a record label employee in the late 1990s was that all of the VPs and critical decision-makers were lawyers by training. The paradigm through which they analyzed strategic challenges was a legal one. So when Napster emerged as a disruptive innovation, rather than rethink how to steer the industry through the disruption, they embraced the restricting view of customers through a legal lens, i.e. were they pirates or not. That was the day the battle was lost . . . when your customers are no longer viewed as consumers of art in a changing landscape but adversarial pirates, it becomes impossible to even think of stakeholder engagement strategies . . .

Mike: Everyone's still talking about piracy and that was eighteen years ago. That's like "I Want to Hold Your Hand" on *The Ed Sullivan Show* to *Thriller*. Eons in pop culture history. And everyone's still like, "Piracy is a problem." We are two generations past anyone that downloaded anything. Everyone is streaming, it's all on your phone, and nobody considers music something they want to hoard or collect. It's a completely different paradigm.

Once I got out of Soul Coughing, I had to get really simple, and tour as cheaply as possible, as a solo guy — talk about dissonance. Being in a weird band and suddenly being a troubadour — it was weird. For the audience, the first couple of tours had more people than the next tours because people eventually were like, "Oh he's not doing that thing that we like anymore." The core

of people who stayed is who I built my career from. I have really taken advantage of the music business in a number of ways — standard publishing deal, standard record deal through ATO [the record label founded by Dave Matthews].

Committed to experimentation in both his art and business model, Mike has become a true road warrior, working his craft across the U.S., Europe and the wider world whenever possible. I was curious to find out what he has learned from his travels that perhaps can offer hope.

Mike: This isn't hopeful. The weirdest thing I discovered was seven or eight months before Brexit. I toured, opening for Wheatus in Britain. This was long before it seemed even likely that Trump was going to get the nomination. I would be talking to Brits in pubs, music fans, kind of arty people, and they'd ask me, "What do you think of Donald Trump?" And I'd always say how much I hate that motherfucker, and they'd say, "Oh, we really like him." And I'd be like, "Are you kidding me?" And they'd say, "No no, he's really tough on immigration," etc. I was just astounded. I had this naïve, liberal elite view of England as innately hoity toity and liberal. Then I started hearing stuff like from this one guy who was working as a tech on the tour: "Britain's going to be 30% Muslim in five years." And I'd be like, "No it's not." Like, let me get out a calculator and some demographic info and data.

So we did a ton of shows in Britain, and we crossed over into France, did some shows on the continent. On our way back, Syrian refugees tried to stowaway in our bus to get to Britain. That was just a shock. We were sitting up on the bus, and to get commercial trucks and vehicles on the ferries at Calais, you wait in a line that's

like a mile long, literally. And somebody had left the luggage compartment at the side of the bus open, and we heard this commotion and there was yelling, and it turns out the bus driver had yanked two guys out of the luggage compartment. It was just insane. My first reaction was to feel violated — like you're taking advantage of my stupidity in leaving this luggage bay open — and then the next day I realized in shock that that's somebody that if I was in my right mind I would've been like, "By all means, hide under these suitcases."

It was really shocking to meet so many soon-to-be Brexiteers. But I travel from bubble to bubble. I live in Memphis, Tennessee. Tennessee is red as red can get. You look at the county map for who voted for Trump and who voted for Clinton, and there's one little dot where Memphis is, and there's another little dot where Nashville is. Even in this vast redness with Arkansas next door and Missouri and Alabama and Mississippi, I'm in this little five-square mile of a liberal bubble. There are still Bernie signs on the lawns.

I have a thing when someone says something really strident from a liberal point of view, essentially implying that being conservative is stupid. I say, "Well, another creationist just got into a state legislature. There you go — we lost another one." Every time you're like, "Those idiots don't understand that gun control is the way it should be," well, you just did it. I do believe in approaching people respectfully and I do think it kind of works. My dad's side of the family is from Louisiana, and I was talking to a cousin of mine, and they're all major gun owners, like AR-15s. And she said that the way these people get guns is through crime anyway, and I said, "No, actually in New York all these idiots running around shooting each other get some straw buyer in North Carolina," and she was

shocked. It completely turned her head around on the issue. I don't know if I changed her mind, but I think I made a point that she got.

I don't know what that looks like as a mission statement for an artist, but it's certainly what I think we all should be aspiring to. In the midst of the Iraq war, I'd say things like, "We have to get Bush out of office," and then I started noticing that there would be two or three people in the venue who looked really angry and hurt. Eventually I was like, "Wow, not everyone believes what I believe!" Even in this weird little corner I occupy, there's ideological diversity.

But I am actually hopeful. I think we're looking at Berlusconi, not Mussolini — just a shitshow for a few years, and then people are going to have learned from it. I think the biggest lesson isn't necessarily about Trump himself, but just about the idea that a businessman should run this country. Like, someone who knows how to make money should run everything. I think that this is completely untrue, that is not the job description of a world leader. You're engaging empathetically, and ideologically, and historically — it's not just about cutting a deal or budget.

As we have seen through our conversation with Mike, the contemporary musician is more than a working craftsperson: they need to become entrepreneurs managing a business at the intersection of arts and commerce. They contend with unique trade-offs not faced by traditional entrepreneurs. The commercial world is consumed by the pursuit of profit in a way that is foreign to most artists. While generic business strategies focus on reducing costs or creating premium differentiation, artists focus on symbolic value, integrity and innovation. Mike Doughty resists the push by many in cultural industries to identify primarily as "a businessman" and not an artist. The disease of

privileging "businessman" as aspirational persona has permeated our culture so deeply that it has infected the presidency itself.

Mike's resistance has come at a price. In 2016, Mike moved out of New York, his home since 1989, to settle in Memphis. He laments how his beloved New York City has gentrified, no longer offering much space for people dedicated to making art. But he has found a way to remain an innovator, and there is much we can learn from him. He may be a less than successful "businessman," but he's an inspiring voice to turn to as we think about educating to reshape capitalism for the future. The sixth path to wisdom is choosing to educate and empower our society so that we can experiment and innovate our way to alternative methods of conducting our economic exchanges. We need to educate for a future where craftspeople are as valued as businesspeople, where citizens have a range of ethical thinking tools to draw on and do not need to be micromanaged through aggressive governance. We need to ensure that those tasked with developing the next economic system have the right education to draw on for them to lead us through the cultural and political shifts that will take place alongside the economic ones. An educated population is more empowered and better suited to navigating the changes associated with progress, especially one with such far-reaching effects.

Mike's show that night in Toronto was more appreciated than I think even he was aware. Too often, concerts in Toronto are ruined by talkers in the crowd. But when Mike took the stage, the audience was enraptured, traveling with him on an unexpected journey that blended the familiar and the novel. From the stage, he lamented that it is unlikely that we will get to witness a show like this again — touring with so many people was too costly. But I know that Mike will find a way to overcome the costs and keep working his craft for audiences that will be more than happy to pay for it.

CHAPTER 7

Eat at a Table

For a recent class project, my eleven-year-old son was instructed to collect and analyze survey data on two cross-referenced questions. The goal was to create a useful chart of findings that the students' parents could conceivably use in their professional lives. I shared my keen interest in knowing about the relationship between who his peers ate dinner with on weekday evenings and where this dining physically took place — a relationship my son's facial expressions signaled he did not understand the value of knowing.

While the sample under study represents a narrow population, the findings are nonetheless interesting. If the children ate dinner with both of their parents, there was a better than 60% chance that the meal took place at a dining room table, thus demonstrating a direct correlation between familial interaction and the dining table as a hub of activity. If only one parent or a babysitter/nanny was present, the odds of escaping from the TV room for meals plummeted by half. If no parents or nannies were present at dinner, the odds of eating at a table dropped to less than 10%.

For generations, the first item of furniture people would buy were large dining tables. These tables gave access to a dignified civil routine that supported all manner of communities: place, interaction or identity.[1] As scientist and author Louise Fresco writes, "The table is a place of memory where we . . . become aware of who we are and with whom we are."[2]

In many cultures the dinner table has been historically viewed as a sacrosanct space of gathering. It cannot become a relic of the analogue past. As humanity drifts towards increasingly digitalized spaces, eating is favoring efficiency at the expense of potential paths to wisdom. Such a trend weakens our ability to listen, weakens our communities and strengthens the powerful institutions of the digital age.

If we want to find wisdom, we must reclaim the power of the table. This prescription may throw many of you for a loop. But there is no better way to signal a rejection of oppressive institutions and a desire to reconnect with our most primitive community-building instincts than when we sit, with people, at a table. Not a desk at work, or a fast food takeout counter, or at a food truck or on transit. When we sit and listen to the conversations that emerge in this setting, we have an opportunity to nourish our minds as well as our bodies.

Writer Adam Gopnik recounts an exchange he had with Chef Fergus Henderson, who incredulously questioned how young couples can begin adult life by buying a television and not recognizing that the table must come first.[3] Need we listen to screens or people? In that same spirit, Louise Fresco bemoans

1 Lee, D. & Newby, H. (1983). *The problem of sociology: An introduction to the discipline.* London: Hutchinson.

2 Fresco, L. O. (2015). *Hamburgers in paradise: The stories behind the food we eat.* Princeton: Princeton University Press.

3 Gopnik, A. (2011). *The table comes first: Family, France, and the meaning of food.* New York: Knopf.

that, much like conversation, the dining table is disappearing. Fewer are being sold now in rich economies — another bit of support to the claim that conversation and direct familial interaction are declining, even when we account for physically smaller living quarters. As the dining room table become less and less the center of life, and people, especially younger people, have less opportunity to develop their listening skills.

In the prior chapters, we met entrepreneurial artists who are on the road for the majority of the year. But what happens if you can't go on the road? What happens if you want to create art but be in one place most of the time? What if you value eating at a table with your family? Luscious Jackson decided to give up on the road life. They are a band of women who have inspired me for decades, and I was fortunate to have a chance to speak with founding vocalist/bassist Jill Cunniff. The band always pushed against efforts to label them or restrict their creativity by musical category, and continue to be unafraid to claim all of their identities. Most recent to the time of this writing, the band self-released two albums, one of which, *Baby DJ*, is an album of dance music for children. As the bandmates move through different stages of life, it would be inauthentic to not allow their art to move with them. Just as bringing dance beats to alternative music was radical in the '90s, bringing beats to the children of their fans is radical today:

Jill: We started the album *Baby DJ* when my kid was little and we finished it when Gabby's kid was little. Kate also has a younger son, my kids are a bit older. And when you are in that world, you think like that. That's what you're thinking about. That was the original album that we had to do on our own.

We were trying to make a kids' album that wasn't cheesy. A lot of children's music is really hard to for me to listen to and super corny. We wanted to make something

fun that kids could dance to with their parents. I think that with the parents, especially in the winter in the Northeast, you need stuff for kids that can't go outside. Kids have so much energy. We were just trying to add some fun to people's lives.

Luscious Jackson was always motivated by a desire to bring an element of fun to art. When the band's first EP, *In Search of Manny*, came out in 1992, people were really excited by the mixture of hip-hop, punk, folk and soul that Luscious Jackson had created. The band credit their childhoods growing up in New York City as the biggest influence behind their unique sound. The spirit of innovation that was present in 1980s New York City downtown culture was the seed for everything the band set out to do. As we heard from earlier conversations with Lee, Nels and Mike, there was immense cross-cultural experimentation going on in NYC at the time. Many women played in bands in clubs like CBGB, and being female was just not an issue the band thought about when they first picked up their instruments.

When people think of powerful female voices taking center stage in the early 1990s, they inevitably reference the riot grrrl movement and feminist punk bands like Bikini Kill, Huggy Bear or Sleater-Kinney. But at the same time, there was another group of strong women changing underground culture by exposing alternative kids to hip-hop and dance music. Luscious Jackson were the first band to sign to the Beastie Boys' boutique record label, Grand Royal. Here were creative and talented women trying to make headway in an industry that needed easy marketing labels to sell their artists, and Luscious Jackson could not be so easily categorized. I know this firsthand, as I happened to be working for the Canadian arm of Luscious Jackson's record label during this time.

Nobody sounded like Luscious Jackson, which proved to be the band's greatest strength, but also made it difficult at first to

sell their music to a wide audience. As we discussed in the last chapter, the tension between the novel and the familiar is felt more acutely by those in the artistic industries than other industries. I asked Jill to talk about the band's motivations in exploring the type of sounds that many of us fell in love with when played by her band, but that did not have an obvious place in the industry as they were coming up.

Jill: Our roots were in the 1980s music scene of New York. Especially New York City, as we all grew up in Lower Manhattan. When I look back on that time, it really was the foundation for us. We were public school students, going to school every day with a lot of kids from different cultures and from different areas of the city. In that period, I exchanged punk and post-punk records and ideas with hip-hop kids — that really was the root of it. And I'm really glad that we got to experience it as we did. The fact that we could trade punk records for hip-hop records and 45s . . . That's where we came up with the sound — it's a mixture of all of the things that we loved as teenagers. There was also a massive club scene, like at the Roxy, where downtown Manhattan music and art culture mixed with break dance, graffiti and hip-hop culture. It was this overwhelming feeling of excitement — like we were seeing history being made.

The formative experiences that inspired the members of Luscious Jackson are far less likely to happen today. With kids turning to streaming their music, the music industry has shifted its focus to algorithms and Big Data — algorithms that don't expect punk kids to be interested in dance music, and as we discussed earlier, algorithms that are not designed to encourage cross-cultural exchanges or support fairness. In fact, writer Liz Pelly engaged in an experiment and uncovered a deep gender

bias in Spotify's algorithm leading to "the continued 'othering' and marginalizing of non-male artists" and normalizing "the idea that gender is a genre, or the idea that women artists should be valued for their gender instead of their music."[4] As critical thinkers begin to turn their attention to a deeper scrutiny of digital-era behemoths, problematic practices are slowly coming to the fore.

Consequently, established artists, as Sunshine laments, have a hard time innovating and making money off of their music. And for new artists, the digital world is far more difficult to navigate than the old world of radio and record stores. Young listeners are primarily exposed to what the computer program thinks they'll like, and punk kids getting exposed to dance music is much less likely. With it, the likelihood of another Luscious Jackson appearing also drops significantly. For it was the face-to-face human interactions in record stores, DIY warehouse parties and other physical places of counter-culture, gathering with types of folks different than themselves, that allowed the women of Luscious Jackson to craft a sound that hadn't been played before. And these places are becoming increasingly scarce. Furthermore, Pelly observes that streaming culture may be "reflective of a relentlessly male-centric status quo" and data-driven echo chambers shift us "back toward a more homogenous and overtly masculine pop music culture."[5]

Jill: I think that openness that we found was crucial. I think the fact that we were all young people and not locked into any belief systems as such, it was just like, "Hey, you're young, I'm young, we're all here at the club, we're into

4 Pelly, L. (2018, June 4). Sexism on Spotify. *The Baffler.* https://thebaffler
 .com/latest/discover-weakly-pelly

5 Pelly, L. (2018, June 4). Sexism on Spotify. *The Baffler.* https://thebaffler
 .com/latest/discover-weakly-pelly

music," so I don't think that gave us a lot of barriers. And people hung out. We would hang out. We had fanzines, we would all dance together, watch music and experience things together as a group that was very diverse and integrated. And that was what was so great about it.

It was a unique time, but I think people are doing it in their own ways today. I see how the internet can form a certain kind of exchange between music lovers — it's the exchange of ideas. That element of social media connectivity has potential there. It's almost the same as going to a venue. Also, big festivals are often musically diverse. And I think that idea is at the foundation of music festivals that we are seeing — bringing as many different types of things together. I'm really happy when I see it. All the people all hanging out together. In a most basic human way, people want to commune with others.

Art to me was a refuge. It was a place of happiness, of rejuvenation. When I put on a record, it brings me back to myself, it takes me out of however scattered I might feel or pulled into anger or anxiety — that's what art does for me. It really takes down that edge. There's a psychological piece too. I try to make art that I hope people will get sucked into and, as a result, learn something new about themselves.

I think artists today can have a voice, I think that we have a very divided country, and we do have very differing beliefs. If I travel down South, I'm going to see a very different outlook — a lot of people have a very religious outlook, they have a gun, their free time is spent doing target practice or that kind of stuff. My family and I, we were traveling and went into a convenience store in Arizona, and there were two teenage girls in camouflage gear and their faces were covered in camouflage paint, and obviously they had just done some kind of training

or hunting game, like military or paramilitary, kind of enjoyment. This was their recreational activity. That's the kind of stuff you don't see in the Northeast, at least near the big cities. You don't go into a convenience store and see people in paramilitary gear, and you won't see guns around. It's not our view. And if we're going down South, it's like we're in different worlds. Those people are looking at us saying, "Who are these people?" We're a family with a Black parent and a white parent, with mixed kids, we're just Northerners or Yankees, whatever we are, "elites" in the jargon of today's America. And we're looking at them in the same way. We quickly judge them as people who are religious zealots with guns and probably racists.

So we've got these different worlds going with these opposite views. The only thing we share is that we're not rich. How do you, say, get everyone who's not rich to come together to create a country that takes care of people?

Jill's question touches on a major theme of this book. In our ever narrowing world, how do we rethink what it means to be democratic citizens working together to create more caring and supportive cultures? Each of the paths to wisdom discussed thus far, from embracing our romantic tendencies to eating at a table, are partial answers. To Jill and the other artists I interviewed, art must be inclusive, and each of them creates work that facilitates conversation in support of greater inclusivity. Our collective, society-wide moral imagination is fed by the advancement of each of our individual moral imaginations, which are themselves fed by our exposure to art. There is a unique power to artistic expressions and a healthy society needs to assign a privileged place for its artists as facilitators. Yet we are not doing a great job in creating an economic infrastructure that can support the efforts of our artists, forcing these "working craftspeople"

to expand their skill set and do more on their own. In Jill's case, she's moved to the other side of the mixing board.

Jill: I've been working in a studio setting since about 2000. I set up my own studio after the band broke up. I created a space for fellow artists, for their music. So when I had the chance to get back with the band and make new music, we had the studio there and we did it ourselves. We do use some outside help in mixing and mastering, we've got people who do that, but the rest of it we did ourselves. I engineered the record. And that is the way it's basically done now — that's the economy of music.

The music industry is in the throes of, basically, the zero-paycheck era. The very-low-paycheck era. And once you're on the road, you've got to figure that out. You have to have your own facilities, you have to make it bare-bones, unless you have some kind of fund from something. Only then can you spend as much as you want and use the best facilities and hire the best people. It's all there still, it's just not for the average musician.

Going on the road is no longer a viable possibility for Jill's band. All of the members of Luscious Jackson have families, and the thought of disrupting the lives of those dependent on them for months at a time and for very little money is, unsurprisingly, not attractive. This is not the first time that I have thought about the biases in the music industry. Working for their record label in the '90s, I saw firsthand the challenges Luscious Jackson faced as an all-female band, challenges that weren't faced by, say, the Beastie Boys. One example that comes to mind was booking the band for Lilith Fair. I remember being so proud of Sarah McLachlan at the time, being another artist on our label and a fellow Canadian to boot. I remember her righteous anger over the fact that neither radio stations nor promoters would program

female talent back-to-back. But, at the same time, I had mixed feelings about the concept. On the one hand, many of the female artists booked for Lilith Fair could certainly benefit from a bigger platform. So the economic need was there. On the other hand, it was heartbreaking to think that music had to be compartmentalized by gender. I never viewed the music of Luscious Jackson as having any logical connection to the music of Sarah McLachlan, other than the fact that I was a fan of both.

Jill: We didn't do Lilith Fair the first year because the name Lilith Fair sounded like some ladies floating through a field in dresses — it sounded very different from our music. Because we had this very urban, eclectic sound, and it appeared to be a different genre. At first, we didn't want to do it, because it was going to be that other type of music — girls with guitars and long hair singing harmonies. We liked that music, but we didn't think we would fit in. It was too far removed from us. And then the next year, we looked at it again, and they were trying to make their lineup more eclectic. Then there were people we loved on it, like Missy Elliott, Bonnie Raitt and our friend Emmylou Harris. Not to mention Sarah McLachlan who is a very cool person and artist . . .

By the time the second year of Lilith Fair went on, we did it, and yes there was the marketing issue because that was not our sound, however, it was the best tour we ever went on in terms of the environment. We were kind of blown away by the way the artists were treated and the social and musical environment, which was amazing. And every night we all watched each other's shows, just because. Sarah McLachlan ran it and she cared about that aspect of it — how the artists felt, the morale, the treatment. It was not a degrading atmosphere, where many other shows we played were very degrading. By

that I mean people were on drugs, wasted, you know. It could sometimes be pretty filthy backstage at venues.

I remember going backstage at the Toronto stop of the second Lilith Fair tour and being shocked by the absolute calmness and civility. It's very sad that we expect backstage to be a degrading space. In the aftermath of the Harvey Weinstein scandal exposing sexual harassment in Hollywood, women in the music industry started speaking out as well. Coupled with #MeToo efforts on Twitter, more stories of abuse are finally coming to light. Hopefully, the toxic misogynist atmosphere is changing. I asked Jill if she thinks that the positive touring environment of Lilith Fair was because of the gender of the individuals who were populating it.

Jill: It's possible. I'm sure that may be the case. It may be the artist's choices. I think making separate groupings by gender is probably not a good idea ultimately because what happened was that the radio stations that we were getting played on, for our previous songs, the rock and Top 40 stations, they took all the female artists off and put them onto these other stations — they were like women's music stations. It kind of became a situation where these stations would be women listening to women's music. So when our song "Ladyfingers" came out, we were being shoved off into this smaller area of music. And what we really benefitted from was being on the male-dominated radio broadcasts. I think that when we had "Naked Eye" out it was a top-40 hit song. Our album sold over half a million copies. At the time, there were No Doubt and a bunch of other women-led groups being played. And then by the time *Electric Honey* came out, everyone had been shoved off onto these little stations. So that was the response of Big Radio to women's music . . .

it was arguably better for our band than when we were on K-Rock, which really had a larger audience. Our live shows were always fifty-fifty male to female, and that was something we really liked.

I knew firsthand, from behind the scenes, that the record label executives tried to understand the band through gender, which became an unfair hurdle for the music to overcome. The male-led bands on the label simply did not have the same obstacle. Carrie Brownstein, of Sleater-Kinney, often expressed exasperation at the question of what it was like to be in an all-female band. She would respond that she has no other point of reference. She resented "girl" being an identifier that made you an "other" in guitar-based music. But, sadly, the otherness was real. Female bands were viewed differently with decidedly negative business implications. And if Liz Pelly is right, the industry shift away from reliance on radio and towards online streaming services may not lead to a better environment for female artists.

Jill: Plus we were doing a genre that wasn't a genre. So the thing that really bothered me — and still bothers me! — is that there is white music and Black music, called "urban." Those are your standard industry genres. As a songwriter, I came up against that too — if you have somebody trying to break genre, they're considered Black alternative, or a white thing. A white soul singer or white R&B singer is going to have a harder time. The commercial industry is going to push them into pop. Like Ariana Grande type of stuff. It's still very much that way, unfortunately, which represents the way our country is, so it doesn't surprise me. It's really hard when you're making art and you have this vision and this comes smack in the face of it. Like, "We don't understand this type of music, we have no idea how to market it, we don't know which bin it goes in or what

category it goes in." However, I can say that audiences now are very open to beat and rhythmic underpinnings in guitar-based music and pop.

As far as the band, the biggest pushback we had would be opening for the Beastie Boys in Europe in the early to mid-1990s. The audiences wanted male hip-hop, and they didn't understand what we were doing and they would throw stuff at us. And we played at a K-Rock radio show called Dysfunctional Family Picnic where the audience were throwing stuff — I think they were throwing things at everyone, regardless of the band. We had to leave the stage after I got hit with a huge bottle of water. It made me think, "What am I doing here?"

Like Sunshine Jones and Mike Doughty, Luscious Jackson had come to accept the need for forward thinking in order to get their art into the wider marketplace. While Jill proudly identifies as an artist, a parent and musician, she did not expect that she would also have to identify as an entrepreneur. Artists like Jill want to use their skills to create music that brings people together and offers an ecstatic release, clear social goods. But most of these artists do not want to be businesspeople, which is why they all started out by seeking record deals, where they would not have to deal with the business side of things and just be paid to create. That model turned out to be exploitive, and so artists without huge commercial appeal are no longer even offered the opportunity to be exploited.

Jill: Our band made money through music publishing and licensing. We had very creative people who supported our music. But the publishing world is really opaque and probably fraudulent on the question of royalties. You just have to accept it unless you do an audit. So auditing is something that we may end up doing, and that requires

people to do your audit. As a business professor, I have an idea for you. You should start a non-profit that has a business angle that helps musicians because they have been so screwed for so many years by every deal under the sun and you really get the sense that the people doing the accounting and the bookkeeping and the business management and the lawyers made documents that were impossible for the musicians to understand, to break or to get paid by. The way the accounting was done, something always had to be pulled out of your tiny percentage before you would get any money — that was the deal everybody got.

The skill set certainly exists for the not-for-profit venture Jill imagines. There are an abundance of well-trained accountants — where are the good ones prepared to step up and take on something like this? Just as accountants seemed to have left the artists to fend for themselves, management researchers have also left it up to individual artists to figure out how to create in the current economic reality.

When I started working on this project, the big question for me was political. I wanted to give the artists who continue to inspire me a different type of platform to express their thoughts on social and political issues and encourage them to be more active leaders of change. But I came to realize that if an artist is not making enough money to live a life of dignity, then that artist can't lead a social conversation. We need to talk about greed and the extensive role it continues to play in capitalist economies, and how we are crippling our cultural entrepreneurs not motivated by profit-maximization.

Greed is considered by many to be less than virtuous, notwithstanding that the "greed is good" mantra of Oliver Stone's *Wall Street* has been adopted without irony by many more. Greed is a rather difficult concept that has engaged thinkers across all

religious and philosophical traditions throughout history. In Western society, it is perhaps most notably associated with the seven deadly sins of the Christian faith, but author and lecturer Phyllis Tickle noted Hindu, Buddhist, Taoist, Sikh, Muslim and Jewish sources that support her assertion that every system has explored greed and all its "aliases" including (but not limited to) acquisitiveness, covetousness, avidity, cupidity, avarice, miserliness and simony.[6] Greed is certainly considered a main source of economic immorality in traditional Judaism, where economic activity and the acquisition of wealth can be viewed as virtuous undertakings depending on the source and the purpose of the activity. In the light of Judaism, business is good, economic growth is good, but greed is not.

In my work as an academic, I argue that greed rooted in economic behavior has the potential to become a negative institutional force that impedes the positive possibilities of economic exchange.[7] When an individual seeks compensation greater than what her input should reasonably earn and in so doing imposes costs upon others, that's greed. In the context of a company, we can call it greed when a firm attempts to avoid paying the full costs for its behavior. So while mutually beneficial exchange can be the ethical core of economic activity, the one-sided economic returns, unusual financial structures and lack of transparency associated with most record deals institutionalized greed in the music industry.

Jill: Ultimately, the artists were kind of powerless over the existing contracts. It was boilerplate. All the stuff that's in these contracts, I'd be looking at and say, "How is this

6 Tickle, P. A. (2004). *Greed: The seven deadly sins*. Oxford: Oxford University Press.

7 Weitzner, D., & Darroch, J. (2009). Why moral failures precede financial crises. *Critical Perspectives on International Business, 5*(1/2), 6–13.

possible?" The thing with digital royalties like iTunes, they were like, "No, with digital you're going to get a lower royalty rate." But there's no costs for manufacturing! But it was a new technology, so therefore the label could justify a lower royalty rate and that was in your contract. But, that was the cost of signing with a major label. And ultimately we were very successful and supported by our label. We made money, and we had creative control. It would be bullshit for me to say that we were victims of the record industry. Having hit songs was the thing that pushed us into the realm of monetary success. I think now it's even harder to make money as a recording artist *because* streaming platforms pay so little. For example, for 100,000 streams the total payment is like $500.

How can we encourage all companies, but especially firms in the cultural industries, to behave virtuously, and how far should we go in protecting ourselves from the harmful actions of the greedy? While improved technological innovations have opened up some new doors for artists, this should not blind us to the negative effects of greed and the role it may play in new media titans and active monopolists like Apple, Google and Facebook. There is a link between the last three paths to wisdom. If we strive to trade fairly, to educate for the future, to gather at tables and express our shared humanity, we may be able to figure some of these things out. It's critical that we do so quickly, lest the next generation be disincentivized from pursuing the romantic life of an artist, and our culture lose the voices most able to expand our sympathies and lead the way on moral progress.

CHAPTER 8

Laugh at Yourself and
Everything that Seems Important

From the smiling Buddha to the laughing Hasid, tuning out noise, turning on the imagination and finding wisdom needs to be undertaken with laughter. The nineteenth-century Hasidic master Simcha Bunim exclaimed that joy is a wisdom that prepares one for prophecy.[1] Abraham Joshua Heschel further notes that "satire serves to destroy falsehood by ridiculing foibles, pretensions and delusions. In this manner, caricature may be the most effective way of loving Truth."[2] This is a remarkable insight, as it seems to position humor as an extension of the scientific method in that it helps the seeker uncover truth by systematically dismantling false beliefs and assumptions.

In her book on Jewish humor, Harvard professor Ruth Wisse shares both a classic Yiddish joke and a fascinating analysis that is superbly insightful. First, here's the joke:

1 Heschel, A. J. (1973). *A Passion for truth*. New York: Farrar, Strauss & Giroux.

2 Heschel, A. J. (1973). *A Passion for truth*. New York: Farrar, Strauss & Giroux.

When you tell a joke to a peasant, he laughs three times, once when you tell it to him, the second time when you explain it to him, and the third time when he understands it.

The landowner laughs twice. Once when you tell it to him and again when you explain it, because he never understands it.

The policeman laughs only once when you tell it to him, because he doesn't let you explain it so he never understands it.

When you tell a Jew a joke, he says, "I've heard it before. And I can tell it better."[3]

While I might try to tell the joke better, I do not think I could do a better job explaining it than Wisse does, so I will quote her at length: "Failure to laugh at a joke signifies something like dimness in the peasant, remoteness in the landowner and severity in the police officer. The slowest to laugh is the most threatening, and the one who laughs soonest is the most human. If the Jew fails to laugh, it is not, God forbid, because he missed the point of the joke but because he has exhausted the fund of laughter."[4]

One of the surprising turns of this era is that an invitation to laugh is greeted carefully by an impossibly complicated analysis. Before one can assess the potential humor in an observation, one needs to first engage in some background research and an algorithmic calculus involving the cultural/social/racial/sexual/religious/political/biological identity of the speaker, the audience and all

3 Olsvanger, I., ed. (1947). *Royte pomerantsen: Jewish folk humor.* New York: Schocken.

4 Wisse, R. R. (2013). *No joke: Making Jewish humor.* Princeton: Princeton University Press.

possible intersections. This paradigm reverses the Jewish one described above. In progressive circles, the one who laughs soonest is the most threatening. The one who is the slowest to laugh, indeed the one who never laughs — the "PC police" in colloquial terms — is somehow the most human and caring. A further extension of this trend noted by commentator Jonathan Chait in 2015 is that "under p.c. culture, the same idea can be expressed identically by two people but received differently depending on the race and sex of the individuals doing the expressing."[5] When did severity become the ideal?

Increasingly in our culture, the instinct to find offense trumps the instinct to laugh.[6] Even worse, Gina Yashere, a comedienne who jokes about her Nigerian heritage, observes that she has seen many people coming to her shows for the explicit purpose of getting offended and then expressing their outrage.[7] It is a terrible reality. In his first show of the year, comedian Bill Maher warned that "the nothing-is-funny people are trying to take over the world and we can't let them!"[8] He instituted a new rule that in 2018 it is more important than ever to keep laughing.

Laughing in response to the "nothing-is-funny people" is a spiritual response to a cultural challenge. As writer and researcher Shadi Hamid observed in 2018, identity politics have many characteristics of a theology. Hamid explains that "identity politics and the virtue-outbidding it necessitates often signal the absence of religion in

5 Chait, J. (2015, January 27). Not a very P.C. thing to say: How the language police are perverting liberalism. *New York Magazine.* http://nymag.com/daily/intelligencer/2015/01/not-a-very-pc-thing-to-say.html

6 Goldberg, M. (2014, April 2). #CancelColbert and the return of the anti-liberal left. *The Nation.* https://www.thenation.com/article/cancelcolbert-and-return-anti-liberal-left/

7 Is political correctness killing comedy? (2016, July 27). *National Post.* https://nationalpost.com/entertainment/theatre/is-political-correctness-killing-comedy

8 Maher, B. (2018, January 19). *Real Time.* HBO.

search of religion — with followers mimicking its constituent elements: ritual, purity, atonement and excommunication."[9]

Buddhist monk and peace activist Thich Nhat Hanh teaches a powerful approach to body scanning meditation that situates laughter as a spiritual practice that offers relief from the stresses of dissonant politics. Starting with the head and slowly moving down to the toes, body part by body part, he instructs the practitioner to use the conscious mind to recognize a certain part of the body while breathing in. Then, while breathing out, he encourages us to not only meditate on the notion of smiling to that part of the body, but to actually relax our faces and smile. Even where there is pain, even when the world is confusing, even when our futures are uncertain, we are to smile, laugh and release the tension.[10] I assure you that this exercise will have a life-changing impact even if you are not spiritually inclined. Sometimes the simplest of exercises offer the most profound relief.

Given its political, spiritual, cultural and therapeutic power, our next path to wisdom involves laughing at ourselves and everything that seems important. Learning to laugh in an era where many believe that nothing is funny means learning to devalue oppressive sources of power. It means signalling to a humorless world that we are releasing tension and inviting social connection through laughter. It is a rejection of fanaticism. It means we are able to apppreciate the moment and those around us. If enough of us keep laughing, it will draw respect and social power away from the embittered and towards the hopeful. This path to wisdom was first introduced by Slava, but now is the time to consider it in detail.

9 Hamid, S. (2018, February 17). Bari Weiss and the left-wing infatuation with taking offense. *The Atlantic.* https://www.theatlantic.com/politics/archive/2018/02/bari-weiss-immigrants/553550/

10 Hanh, T. N. (2013). *Peace of mind.* Berkeley: Parallax Press.

Over the course of the last three conversations, we got to hear from some brilliant and innovative artists who suffer from not easily fitting into a pre-established marketing label. Teren Delvon Jones, popularly known as Del the Funky Homosapien, is a dazzling rapper who was never fully accepted in the mainstream hip-hop world. Instead, the futuristic beats and innovative rhymes that he has reliably crafted for decades have been embraced by fans of what was once called "alternative" music, which now includes indie, punk and skater kids.

Del began his career trying to play the mainstream game, as one would expect from a talented youngster. He had the good fortune to release his first album on a major label with the creative and economic support of his cousin Ice Cube. However, even though he was offered an opportunity that other rappers could only dream of, Del needed to be true to his artistic sensibility.

As a self-described "huge P-funk fan," he was happy with the production on his major label debut. However, his associates at the time were not. They felt the sound didn't capture what they wanted Del to convey. Del explains that since he was just a kid at the time, the opinions of those around him had an undue influence — he "felt like I had something to prove." Del, like almost every other artist in this book, decided that he needed to release his art independently and remain authentic.

In many ways, Del the Funky Homosapien is the odd man out in the surprisingly rigid subculture of rap and hip-hop. I got in touch with him as he was leaving town for a show, so the conversation needed to be brief. While most in the genre celebrate a brute persona of classic masculinity and aggressiveness without irony, Del embraces humor in his lyrics and storytelling.

Del: I'm studying humor now. Mainly because of the rap battles. You have to do something with humor. What can I say about that? It's kind of hard to speak from a past mindset — it's hard now. But that's kind of what it's

about. Like, next week I'll be trying to get away with what I can get away with. You say what you can in a way that people think is funny. Hopefully, your lyrics will stand out for some reason — something's wrong with it, or it's the opposite — you know what I mean?

While still releasing traditional hip-hop albums, much of Del's current artistic interests have shifted to the arena of rap battles, where humor is a weapon. Battle rap has crafted a fascinating place for itself within the ecology of the contemporary music industry. On the one hand, battle rapping has its origins in what 40 Cal has called "extracurricular activities"[11] like the slam-dunk contest that NBA All-Stars participate in. The goal is not to create music, or even songs, but to launch inventive insults and self-aggrandizing tirades in a live "battle" setting. Participants do display technically impressive rapping, but it's showboating that has little to do with the game.

On the other hand, at a time when artists are struggling to make money on songs or albums, battle rap's commercial potential has spiked. With battle raps being streamed on pay-per-view and the subject of a 2017 satirical film produced by Eminem, the outlet can let talented rappers earn a decent living as, to use Doughty's term, working craftspeople. More importantly, it demonstrates another cultural approach to putting laughter first. Both aspects of the phenomenon seem fitting to Del.

Del: Ok, all battling is just a battle of wits, that's it. It's just something for entertainment that doesn't cost anything. It also prevents other more violent modes of expression from happening.

Hip-hop is based on this type of competition. It was

11 Edwards, P. (2009). *How to rap: The art & science of the hip-hop MC.* Chicago: Chicago Review Press.

something other than gang activity to be involved in to express yourself or settle things. There's some kind of incongruence there or somebody's doing something that's not a social norm. All these things would be considered to be funny, strange, odd. Back then I didn't really think about it, and it just was the way I am. I'm just naturally an odd kind of person. Now I'm starting to learn more about it, and I'm starting to control it more. So it's not just left to chance. And I have a lot of things that I want to say . . . It better be funny. Otherwise it's not going to work.

In 2000, Del, along with Dan "The Automator" Nakamura and Kid Koala, released a stunning piece of art: *Deltron 3030*. The work was not simply a showcase for three veterans of hip-hop mastery, but an ambitious science-fiction concept album. For his contribution, Del had crafted an elaborate, novel-type narrative about life in the year 3030. He would further expand his reach into the alternative world by appearing on two songs on the debut album by Damon Albarn's Gorillaz, including the hit single "Clint Eastwood," before revisiting the Deltron project in 2013. With the *Event 2* album, Del explores how the Deltron world he created had gone too far in terms of their societal faith in technology. He has the same worry for the real world.

Del: I think about it sometimes. I almost got hit by a car like three different times. Like within the last week. I don't have a car, so I skate everywhere I go. Like three times I almost got hit by a car, not because I was in the way or something, but because they were running red lights. So I'm thinking, like, "What are you doing? Are you on your phone? Are you trying to rush somewhere?"

Del comes across as a very down-to-earth and humble person. He is an artist who recognizes that art matters. While he

may play with the humorous and the outlandish, he is not naïve about the necessary trade-offs between the novel and the familiar that artists must constantly contend with.

Del: Art matters, but people matter more to me. My father was an abstract artist. So that's where I got it from. But we've got different ideologies. Him, he's more of a pure artist, he wants to do whatever he feels like doing, and he won't deviate from that. Me, I'm not like that. I'm a musician, so you have to consider what the audience wants to hear too. So I don't let them dictate what I make, but I do pay attention to them. I try not to go too fast for what they can take, otherwise they're not going to listen to you.

As an artist that's how I go about it. I tried to get the simplest form possible of what I'm trying to do at this point. That's the hardest thing to do. And my art form, as far as music, that's pretty much what it's about. It's not about writing a book on its own. I tried to do that, and in a lot of ways it doesn't work. *Deltron* took me like ten years to write. I didn't get that much out of the process. The people that appreciate it have appreciated it but it wasn't that much.

Studying comedy and humor too, it's just reinforcing that in my mind and that kind of ideology. You have to be concise when you're writing comedy. No waiting around to get to the punch. You have to be quick. It's hard to do. I'm thinking more in terms of concepts now and situational things as opposed to just rhyming. A lot of my focus and mastery before was rhyming. But at this point, the rappers that are good, they go beyond that. They're more conceptual. And it has to be written down. Stuff they do battle with, they definitely write it down. You try to freestyle, it's not going to work. Like a joke has to be

written over and over and over again before it works, it's a different thing but I like it.

I'm all over the place. I'm the type of person that can relate to a lot of different things. Pretty much anybody or anything — I'm open to anything. My work shows that. It's made its way into my art. It wasn't intentional. If I had it my way, I'd be a little bit more direct with it. My art reflects the type of person I am. Part of being an artist is trying to get to the purest expression that you can, and that's what I'm trying to say, really.

I guess the fact that I never really changed — I stayed myself, which a lot of people seemed to like. A lot of people that liked my stuff are like skater kids. Pretty much I'm still a big-ass skater kid. So I haven't really changed — I can still relate to you. Skater, I'm still a skater, which has a lot to do with my popularity. We're similar in an aesthetic idea. That kept me for a while. That whole culture right there. The hip-hop culture, to a certain extent too, but they're kind of choosy.

Del probably has lot more in common musically with post-punk adventurers like Lee Ranaldo than Ice Cube. He does not mince words when describing the origin of his musical influences.

Del: I like dissonance. I don't like nice sounds. Not to say that I can't appreciate nice sounds. That doesn't really work where I'm coming from. It's why I got into hip-hop in the first place, because it wasn't like R&B. It was hard, edgy and aggressive.

For Del, there has long been a disconnect between the reality he observed and the "ought" of his imagination. The pop music of his youth didn't feel true to his lived experience. And so he withdrew into the familiar confines of his inner mental space.

Del: Funk, actual R&B or any other good music I didn't have
a problem with. Basically I had, and still have, a problem
with how the industry works. I guess I'm just odd like that.
I like all kinds of sounds — doesn't really matter. Every
sound has its place to me. I agree with you. A lot of people
tend to steer away from that. I've studied music theory, so
I understand that most people don't consider sounds like
that to be music. They consider it noise. Public Enemy
changed a lot of that. Hank Shocklee, he's like one of my
heroes. He did a lot with sound samples.

Public Enemy was, at one time, a dangerous band. As I have
written elsewhere, listening to Public Enemy as a Jew has always
been both rewarding and challenging.[12] While Flavor Flav's mis-
adventures on reality TV have prevented the band from aging
well, in their early days there were few bands like them. I remem-
ber the very first time I saw Public Enemy live. They were on
a very adventurous package tour which included post-punk leg-
ends Gang of Four, heavy metal band Warrior Soul and goth
headliners Sisters of Mercy. Some of the American dates were
canceled by local authorities over concerns that the Black fans of
Public Enemy would get into fights with the white fans of Sisters
of Mercy. Amazing to think that in the 1990s there were estab-
lishment worries about mixed-race concert events. That speaks
volumes to the notion of making America great "again."

And in truth, Canada at the time was only slightly better. To
be sure, the authorities did not cancel the event in the theater at
the amusement park Canada's Wonderland. But racism did appear
to disrupt the show. Despite the fact that Warrior Soul were very

12 Weitzner, D. (2018, June 20). How art can bridge divides between
Jewish and Black communities. *The Forward.* https://forward.com/
scribe/406265/how-art-can-bridge-divides-between-jewish-and-black-
communities/?attribution=blog-article-listing-1-headline

open about their anti-establishment anger and drug use, and Gang of Four had a notorious history with drug abuse, only Public Enemy had their tour bus stopped, searched and prevented from timely entry at the Canadian border. The delay meant that Sisters of Mercy would go onstage first that night, even though they were billed as headliners. And even after their set was over, the audience was still made to wait as Public Enemy were delayed for hours.

Finally, when their trademark sirens boomed over the loud-speakers, and the crowd roared with anticipation, what they got was a very incomplete band. In the end, Flavor Flav was not allowed to cross the border into the country. So Chuck D was onstage without his hype man, delivering an angry and powerful four song set. Fifteen minutes in, the band had the power cut on them due to curfew restrictions, a frustrating end to a day of delays. Being that this was 1991 Toronto, the crowd did not fight the power but exited the theater in a controlled manner. But we heard the sirens, we saw the rage and we got the message about racism. As Del notes, the sirens and cacophonic sounds that accompanied Public Enemy when they took the stage were far more dissonant and unnerving than anything offered by the goths, punks or metalheads who had performed before them.

But at the same time, something else was happening in hip-hop culture. As Doughty complained earlier, being a busi-nessman suddenly became more important to rappers than being artists. Some of the anger and political inclinations of the art form were being tempered by choices being made by the art-ists themselves. They weren't being explicitly censored. Rather, they were self-directing towards the new potential for upward economic mobility.

Del: I think that for me, they go hand in hand. Because if you're an artist, I would think that you want somebody to look at your art or listen to your art. If you wanted to just do it for yourself you could just do it for yourself and that would

work. So if that's the case, you have to consider what somebody might want to listen to or look at or whatever. You don't want to let them dictate what you're doing, because they don't really know what they want. But you kind of know what might be the way out there — how far you can go or how far you can push it. That would work in business too. If you don't want to be limited in what you are trying to do, then just do whatever you want to do, I guess. For some people it works out and that's great. For me it boils down to relating to people, just on a people basis. I feel like if people like it, they'll want to hear it or they'll want to be a part of it. I feel like if you consider people, then they'll consider you.

What I mean to say is that I don't have to think about necessarily copying others, or any other ploy, to gain people's attention. I believe that if you keep the listener in mind when you make your music that would be enough as long as they get the chance to hear it. Some people worry about sales to the point their art suffers.

Del has come to rely more frequently on digital platforms to get his art out and sees important differences between the economics of emerging technologies and the classic music industry mechanisms.

Del: It's easier now, and now you don't have to have half of the things to get started. We would have to actually get to a label to get your music out there. So first you had to somehow figure out a way to make the music, maybe you could get a four-track or something like that — before, we didn't even have that. You were lucky if you had a four-track back in the day. So now it's just advanced to the point that the industry is dominated by one big force, pretty much. You can't play, no one has the money to play

at that level unless you go through them, so it seems like it's hopeless but it's not, because you can get your stuff out there, and if people like it, it could pop. Take Chance the Rapper. He's a good example. He's never released a real album, just mixtapes. And just from that he's been to the Grammys, he met Obama, all this crazy shit — but that just says a lot about him and his type of art.

To close, I asked Del if he was optimistic about where things are headed culturally.

Del: Honestly, I won't say I'm optimistic, but I'm not overly pessimistic, either. We just have to wait it out and see. In times of trouble, you look to art. The way I feel personally is that it doesn't matter. With all this stuff going on, you're living your life on your scale anyway. You have to think about what you've got to do as an individual to make things better around yourself. If every person was just kind to whoever they met throughout the day, you know how much of a change that'd be? When it happens to me, it's like, "Oh my god." Because it's so rare . . .

Del represents a rare type of artist. While creating in a genre that often privileges aggressiveness and machismo, he finds power in laughter. He has come to recognize what seekers of nearly all spiritual paths eventually find: the wisdom in laughing at everything. Even this insight. We need to follow suit.

CHAPTER 9

Be Curious

If you are curious, you are likely to find your way to the music and art of Angelo Moore and Fishbone. Curiosity led me to discover Fishbone as a teenager. All the bands that I admired were at one point or another photographed wearing T-shirts with Fishbone's . . . sorry, there's no other way to describe it, fishbone logo. And when I finally got to see them live for the first time, it changed me. Walking into the venue mid-show, I have a snapshot of what I saw onstage that is as vivid today as it was twenty-five years ago. It was November 14, 1991, in my final year of high school, and I could not convince any friends to go see the double bill of Fishbone and Primus at Toronto's legendary Concert Hall. The combination of the hillbilly strangeness that was Primus and Fishbone's Black punks was an impossible sell to my mildly adventurous social circle of fellow Hebrew-school nerds.

Instead, we compromised and went to see Metallica, who were in town performing that same night at Maple Leaf Gardens. Metallica still had some danger associated with them, although it was the beginning of their re-creation as a mainstream rock

act. But, the gods of punk intervened on my behalf that evening. In the middle of Metallica's somewhat uninspiring set, Angelo was led by the promoter to a seat on the floor right next to us. Although not recognized as the celebrity he should be, Angelo stood out. As I remember it, he was the only person of color that I could see in the venue. With his bleached dreadlocked mohawk, oversized suspenders, wide-eyed gaze of curiosity and seemingly endless smile, he got noticed.

For me, it was an irrefutable sign that we needed to see Fishbone that night. My friends were very curious about this Black dude who slipped into the show, danced up an enthusiastic storm amidst the head banging and then quickly disappeared. The begrudging group of peers were curious enough to be convinced that it may be worthwhile to head over to the Fishbone show, once the final cheesy pyro display from the Metallica stage had burned out.

The spectacle we saw after a few blocks' walk down the road was unforgettable. What Metallica could not achieve on their gigantic stage with endless explosions and blinding lighting, Fishbone attained by playing music and being themselves. Seven shirtless Black men, cramped on a platform designed for four-piece bands, drenched in sweat, but sustaining a wordless consensus between all of them and the equally sweaty audience. What unfolded moment to moment might lead an outside observer to fear that the entire efforts were going to be overtaken by the chaos. But that fear would only occur to someone not part of the consensus. The band was so remarkably in sync . . . A trombone went flying through the air — Chris Dowd caught it and he briefly turned away from his keyboard to demonstrate his expertise in yet another instrument. Then it was not an object, but a person, that took flight as Angelo leapt offstage, mike still in hand, screaming, "SWIM!" as the crowd created a wave of hands for him to surf on. Norwood Fisher blissfully took in the scene while holding down the bass line, keeping the rhythm amidst the chaos . . .

Our curiosity was rewarded that night. A social conversation rooted in wisdom requires participants who are always curious. They are curious about each other, curious about the potential to be more inclusive, curious about how to bring more unique individuals and novel ideas into their shared exchange. If we want to pursue wisdom, we need to be curious. Even if we have never listened to punk, or jazz or rap; even if we don't read comic books or like clowns or consider ourselves spiritually inclined. Be curious as to why these artists were chosen, and how the argumentative expressions that are captured here are reflected (or not!) in their imaginative output.

If there is one major trend shared by both the left and the right in the contemporary West, it is the devaluation of curiosity as virtuous. Whether it is shouts of "fake news" or "resisting" triggering speech, more and more folks are choosing to celebrate their confirmation bias instead of overcoming it. Even the brave souls who try to speak out are bullied into submission when "the mere expression of opposing ideas . . . is presented as a threatening act,"[1] as reported by Jonathan Chait. We choose echo chambers that reinforce what we already believe, an especially dangerous selection given how quickly the digital mobs can turn on those previously regarded as members of the in-group.[2]

To be curious means to risk encountering a distressing idea. But this type of risk can be a prelude to innovation, as failure and error no longer become dirty words. It's a noble type of rule-breaking that often leads to practical wisdom. As writer Ian Leslie observes, "A society that values order above all else will seek to suppress curiosity. But a society that believes in progress,

1 Chait, J. (2015, January 27). Not a very P.C. thing to say: How the language police are perverting liberalism. *New York Magazine.* http://nymag.com/daily/intelligencer/2015/01/not-a-very-pc-thing-to-say.html

2 Wilson, B. (2018, July 14). I was the mob until the mob came for me. *Quillette.* https://quillette.com/2018/07/14/i-was-the-mob-until-the-mob-came-for-me/

innovation and creativity will cultivate it."[3] Throughout this book, we have been working with Richard Rorty's definition of wisdom as the ability to keep a conversation going. Psychologists define wisdom as a broad category covering the acquisition and use of knowledge.[4] Specific traits of wisdom include curiosity and the related characteristics of creativity and open-mindedness. Think about those relationships — curiosity and creativity go hand in hand; those who are closed-minded will never be wise.

There are different types of curiosity, including: diversive (an attraction to all things novel), epistemic (a more disciplined and effortful quest for knowledge) and empathic (focused on the thoughts and feelings of others).[5] Listening with curiosity suggests a discontent with the status quo, which is why it is often viewed by those with power as a threat. The curious harbor a deep-rooted belief that things can be better. In addition to being masters of their craft, each of the artists in this work are known to their fans for always being curious. They exemplify an uncanny ability to retain childlike wonder, which in turn allows them to tap deep into the imagination.

Many in our society have forgotten what conversation means. They hide behind screens, launching screeds against those who somehow manage to infiltrate their echo chambers. Listening with curiosity is the antidote to a culture dominated by social media that has been overtaken by manipulative and exploitative parties. Journalist Maggie Haberman writes how "the viciousness, toxic partisan anger, intellectual dishonesty, motive-questioning and sexism are at all-time highs, with no end

3 Leslie, I. (2014). *Curious: The desire to know and why your future depends on it.* London: Anansi International.

4 Peterson, C. & Seligman, M. E. (2004). *Character strengths and virtues: A handbook and classification.* Oxford: Oxford University Press.

5 Leslie, I. (2014). *Curious: The desire to know and why your future depends on it.* London: Anansi International.

in sight."[6] One positive outcome, though, of having easy access to a platform that expresses the basest of beliefs is that it allows the curious to see how expansive some echo chambers are. For example, when in March 2018 D.C. Council member Trayon White Sr. blamed the Jews for bad weather, it offered an important window. As writer Yair Rosenberg observed:

> The scandal here is not just that an elected Democrat, the youngest on the D.C. Council, believed that a family that has been the target of anti-Semitic conspiracy theories for centuries is controlling the weather. It's that he exists in an information bubble where this sort of thing is apparently both common and not considered outrageous or reprehensible. And the existence and influence of that bubble is far more disturbing than any single anti-Semitic eruption . . . When public figures feel free to share such content unselfconsciously on their feeds, it is the sign of a broken culture. It means that within their ideological universe, they do not expect to experience any opprobrium.[7]

The next path to wisdom will involve harnessing the power that emerges from being curious, as opposed to the power that comes with contempt for people whose arguments do not coalesce with our worldviews. We need to challenge ourselves and those with whom we agree to step out of our own bubbles and be curious about the lack of wisdom that may exist in our safe spaces. Building on earlier paths, we need to be brave and

6 Haberman, M. (2018. July, 20). Why I needed to pull back from Twitter. *The New York Times.* https://www.nytimes.com/2018/07/20/sunday-review/maggie-haberman-twitter-donald-trump.html

7 Rosenberg, Y. (2018, March 21). Conspiracy theories about the Rothschilds are a symptom. The problem is deeper. *Washington Post.*

romantic, as the powerful often view the curious as threats. And those with power may be right to have this fear, as when we are curious we will be motivated to break rules out of a respect for higher principles. Curiosity will lead us to rethink education and laugh at everything that others may be afraid to even question. Curiosity will draw us back to sacred gathering places, like the table, as we hone our listening skills and seek wordless agreements. Being curious will keep the conversation going.

Despite the racism he had encountered throughout his life, and despite being an outcast in the world of hip-hop, Del ended the conversation captured in the last chapter with some positive guidance: embrace laughter and make an effort to be kind. It is a message of hope that will be reiterated ten-fold in our next conversation, as we explore the power of curiosity. Perhaps no artist has felt the bias of the music industry as severely as Angelo Moore and Fishbone. And yet despite the challenges, Angelo retains his infectious curiosity. While bands who were influenced by Fishbone both personally and musically, such as the Red Hot Chili Peppers and No Doubt, went on to sell millions of records and headline stadiums, Fishbone continues the hard work of constant touring in small clubs and managing ongoing financial difficulties.

The struggles of this band have been well documented, perhaps most notably in a critically acclaimed 2010 documentary, *Everyday Sunshine*. Many of the biggest names in alternative rock will explicitly state that Fishbone should have the success and respect they have instead. And while almost everything that could go wrong for a band did go wrong for this band — along with some things you would never imagine, such losing a founding member to a Christian cult — it cannot be denied that at least part of their problem was the fact that they were Black folks playing what was (and maybe still is) regarded by audiences and industry gatekeepers as white music.

Chaos continues to engulf Angelo. Finding a serene moment with him was mission impossible. When we were first scheduled to talk, none of his handlers could find him. Then, when we later connected, it was in the middle of a hunt through New York City to find a shop that could quickly repair his computer before showtime. The third time I caught him he was getting off a tour bus in Vermont, shocked to discover that his band had been booked for an outdoor mountaintop reggae festival . . . in March . . . in the snow. Native Californians do not have a great handle on the weather-related realities of the Northeast. Needless to say, I didn't have a lot of time with Angelo, but I could not write this book without talking to him. He has been inspiring my curiosity for three decades and continues to be the living embodiment of the ever-curious artist. Angelo is a legendary figure for me and thousands of others, leading an African-American punk band in a genre dominated by whites, offering insight into overcoming the challenges of racism even in outsider communities with a philosophy of "Optimistic? Yes!" His curiosity knows no bounds and should inspire us all.

Angelo: I've spent my entire life in the dissonant zone. It's all about liking what I hear. And it's not coming from pop radio. There's so much — pop radio has a really big influence on a lot of people's music. Sometimes it's good, you know. Me, personally, I've always gone for the more eclectic sounds in music. That kind of music is like an addition of different sounds that you hear, all being put together to make one new, unique sound. I remember what I did is that I threw my tennis shoe in the washing machine. And I threw in a monkey wrench, and then a screwdriver, and a couple of paper clips — and I recorded it.

I was probably fifteen. I recorded it, but I threw one in at a time. It turned into just beats after a while. Like

maybe the record scratching, or the record skip, and with that record skip, it created a beat from the record skip too. And of course, growing up listening to James Brown and Funkadelic and a lot of jazz — all that kind of stuff. And then after a while, the ska and the reggae came into the picture. That was probably around high school. When I was younger I was more into the James Brown and all that, the jazz and Motown and stuff. I got my fill of what was considered pop music. But I've always leaned more towards the more challenging genres of music.

It's also from the tour days. On the tour bus, it's like the magic sounds. But then when you step off the tour bus, you automatically hear all the sounds of the city. The horns, the car horns, the construction worker sounds, that's music right there.

From an early age, Angelo was curious about sound, and the artistic impulse to experiment got the better of him. As a parent, I can only imagine how frustrating it might be to come home and find your teenaged son destroying your appliances with shoes and tools. The world should thank Angelo's mom for having the patience to nurture and support her son's curiosity instead of shutting it down.

To Angelo, the rhythmic thud of shoes in a washing machine was music. The metal clang of a screwdriver in the machine was music. Sounds of a city overrun by traffic congestion was music. Angelo hears all sounds as potentially musical and wants to share his inspiration. Angelo experiences Heschel's shattering experience, the rousing of our souls when the critical faculties of our mind are confused, in every sonic facet of life. We need to be curious about this approach to life and listen to him. And that can be tough, even for those closest to him, as his curiosity and love of dissonant sounds takes him down some socially difficult paths.

Angelo: With the theremin, we were with this badass band in Atlanta. And I was downstairs, walking around in the hallways in the studio. We were recording there, and I walked past this . . . thing. And when I walked past it, it went "woo." And then I backed up and it did the "woo" thing again when I got close to it. And that's how I discovered the theremin, because it was left on, and I walked in the field of the theremin's pitch. And from there on out, I was just hooked on that thing. Everyone in the band hated that I liked the theremin. They thought it got in the way. It was a nuisance. It was "ear garbage." Ear garbage is what they called it!

Even for a band as eclectic as ours, the theremin was even more dissonant. Crazy dissonant sunrise shit, man. I love it. I pride myself on playing it in tune. Ninety-five percent of the time, I'm playing the theremin in tune, man. There are only a few people on the planet who can play it in tune. A lot of other people are just doing that "woo woo woo" shit and making noise.

In keeping with the theme of the last chapter, I had to laugh as Angelo told this story, and he laughed along with me. I can picture him making his bandmates crazy with the noise of the theremin. The same wildly curious child that made his mom crazy with banging her washing machine is alive and well and making his seemingly chilled Fishbone colleagues lose their shit with the "ear garbage" he was bringing to their practice.

If you are not familiar with this notorious instrument, the theremin is named after the Russian inventor who created it as part of government-sponsored research into proximity sensors. It's the only instrument that I can think of that is played without being touched. There is absolutely no physical contact between the musician playing a theremin and the hardware of the instrument itself. Instead, the artist will stand in front of the theremin

and move their hands around in the air between the instrument's two metal antennas. The theremin is played by manipulating the electromagnetic fields that are around these two antennas. How far the shaking hands are from one antenna determines the pitch of the ensuing sounds, while the distance of the hand-waving from the other antenna controls the volume. Higher notes are played by moving the hand closer to the pitch antenna. Louder notes are played by moving the hand away from the volume antenna. Accomplished thereminist Rob Schwimmer describes playing it like "finger painting in space" or "having sex with ghosts."[8]

I'm laughing even as I sit and transcribe my conversation with Angelo. I can see Angelo excited by the prospect of creating sound that is birthed through intimacy with a ghost, and I can also see why his ecstatic joy in discovering new ways to make noise might have exacerbated tensions between Angelo and the rest of the band, accomplished musicians who suffer already for playing "outside of their race." But, it's a credit to the evolving unit that is Fishbone that the creative impulse ultimately rules the day.

Angelo: The creativity in the music is the only way out. Even though everyone was dysfunctional, and everyone was still discovering themselves and discovering one another. The music was the way everyone connected to escape. We had the music together. Automatically we had that together. We just didn't have the business right. We didn't know who was off stealing money and all of that other shit. The music kept us going.

When I'm creating a piece I actually get into the piece of whatever it is that I'm making. I don't really think about

8 CBS News. (2013, October 27). The theremin: A strange instrument, with a strange history. https://www.cbsnews.com/news/the-theremin-a-strange-instrument-with-a-strange-history/

— I try my best not to think about what I hear on the television or the radio. Because I know that stuff has been put together by a programmer — somebody else with a musical taste that is probably different than mine. I try not to listen to too much of that. I put out or re-create what's in my head through my instruments.

Throughout their history, Fishbone have positioned themselves as a part of a number of musical conversations. Some elements, like reggae and funk, are traditionally associated with Black American artistry. Some elements, like punk and metal, are associated with white America. But Fishbone never cared for segregation — not intellectually, artistically or socially. They were artists, first and foremost, following their muse despite the socioeconomic pressures to conform.

Angelo: There's so much to say about it. As an all-Black band, playing so many different genres of music, especially rock and roll — it gives us access to a different audience. It's how Fishbone started. We had a majority of white people at our shows because they were into the rock and roll. Eventually everything started to even out — but our audience. We were like playing music, playing in the genre of music, playing in a scene where, you know, Black people don't play. They just don't play rock and roll. So that was interesting at first. But it's been like that the whole time. It's not really weird to me anymore. When you asked me what do I feel when I'm doing these different places, it's just regular to me now. It's what I've been doing.

Even today, the music industry is not geared towards Black musicians who choose to play rock and roll, despite the obvious roots of the genre in African-American artistry. Given that sort of

oppression, I asked Angelo what it is that has allowed both him and his Fishbone brothers to keep making interesting art, despite the lack of support from the industry. Unsurprisingly, it was the romantic instinct, our first path to wisdom.

Angelo: First of all, I love doing it. The romance. The only kind of romance that I've had in my life that never failed me was the music. And that's my main bitch right there. It doesn't argue with you. But the whole business for the financial part of it is another story. It's a pity you have to attach your music to the business part. All that other shit doesn't have anything to do with music.

I would hope that our paving the way has made it easier for Black folks to play rock music. I want us to have contributed to all of that and a lot more than all of that. The reason why it's an issue is a fundamental problem with America. We got the stereotypes of Black people only playing R&B and hip-hop and reggae and soul, so with Black people playing rock and roll, it's a whole separate, racist stereotype. It shouldn't be there in the first place. Everyone should be able to play everything. When it comes down to it, there shouldn't be any of the stereotypes. We helped with breaking that.

I'd like to be able to put my music out to the kids. We're still trying to get the kids to our shows. I think a lot of them get it. It's important. They're the next generation. And we at least want them to have a nice flavor in their heads so they can enjoy it when the hard times come up.

Folks are still coming to see Fishbone. From my perspective, that's how I see it. Like, they're still coming to shows, they still get this shit, they still see this band as important enough to get out of their house to come to see the Fishbone show, then right on.

After everything Angelo faced, you would expect him to be angrier. He is not. He always finds the optimistic yes, even amidst the racism, discrimination, band dysfunction and seemingly endless bad luck.

Angelo: You've got to be positive, man. Of course you're going to go through hard times, sad times, whatever. You can't just have that shit hanging around forever. Or else you won't think that you're going anywhere. That's why you've got to have that positivity to pull you out of it. It's all in your mind, anyway.

Everything is perspective. And optimism is one perspective that I feel. Even with Trump in office, it's like, "How are you going to be optimistic with that?" How are you going to find the diamond in the doo-doo with that one? At least with Trump, everybody hates his ass so much that we have no choice but to band together and come together as one against his ass. And that's going to bring us all together. So Trump is actually working, in an asshole kind of way. You saw all the women he had together, doing the pussy power march? It was against his ass but it was like one of the biggest fuck yous in history. Trump is like a big monster coming over here, like a Godzilla.

In talking with Del and Angelo, I thought about how for decades, members of the African-American community had been speaking out about police brutality through media ignored by the mainstream. Technology brought indisputable evidence of their truth, giving pause to those who dismiss messages coming from marginalized critics. I fear that the anger arising over race-based oppression may now be matched by anger over class-based oppression. Alternative voices on campus and in the arts have suggested that Western capitalism is irreparably damaged. And those at the helm of capitalism have by and large dismissed those

claims, pointing to allegedly growing interest in business ethics, corporate social responsibility, shared value creation, sustainability and social enterprise, to name but a few areas that show the best capitalism has to offer. But the dissonance between the words of apologists and the deeds of those in power is growing.

After the global financial crisis of 2008, those of us advocating for better business ethics said, "Now things will change." We were wrong. A decade later, only one banker has gone to jail. We who still believe Western capitalism can be saved say, "It's complicated, but the financial industry is changing — give it time." And our marginalized critics who seek to resist the capitalist model get angrier. In 2010, BP was responsible for the Deepwater Horizon oil spill, and we said, "That's it — BP is done." But their cover-up and rebranding efforts worked, proving that we don't really take environmental violations seriously. In September 2015, the *New York Times* called Volkswagen's decision to install software that would cheat on emissions tests "one of the great corporate scandals of our age."[9] We in business ethics said that those who were once drawn to VW will abandon it. Less than a year later, VW reports better than expected earnings and the *Wall Street Journal* exclaims, "Volkswagen: From Despair to Euphoria."[10] Again, we were wrong.

I'm curious about where all of this is going. If capitalism won't be saved from the inside, then we need artists to show us the way. We need them to be successful. Sure, we need to hear their stories of racist, sexist and classist exploitation. And sure, we need to tie the economic narrative very closely to the

9 Hakim, D., Kessler, A. M., & Ewing, J. (2015, September 26). As Volkswagen pushed to be no. 1, ambition fueled a scandal. *The New York Times*. https://www.nytimes.com/2015/09/27/business/as-vw-pushed-to-be-no-1-ambitions-fueled-a-scandal.html

10 Wilmot, S. (2016, July 20). Volkswagen: From despair to euphoria. *The Wall Street Journal*. https://www.wsj.com/articles/volkswagen-from-despair-to-euphoria-1469018692

political narrative as we try to get our social conversation back on track. But most importantly, we need to learn from them how to be curious, how to stay optimistic and follow them on the path to wisdom.

CHAPTER 10

Try Fairy-Tale Logic

If it is wisdom that we are seeking, then we need to stop trying to explain away what other cultures find magical. The next path to wisdom can be expressed as an extension of the last: be curious enough to try and embrace fairy-tale logic in your cognitive toolbox. I got this term from artist and legendary comic book creator Mike Mignola, who will explain in the following conversation that the curious and creative mind wants *all* wisdom traditions to coexist. The curious mind wants to believe in fairy-tale logic. Allowing for this coexistence means accepting the beauty in the unexplainable. It's the point made clear to me by my Hasidic professor decades earlier: if I really wanted to understand him, I had to try to do so on his terms. Fairy-tale logic is the rhythm that you can feel in mythical stories even if you can't rationally map it out. It's celebrating the possibility that certain things just happen the way they happen because it feels like that's the way it should happen.

Like finding a way to laugh at everything, trying fairy-tale logic is an effort to oppose fanaticism. It creates a bridge that allows for a safe encounter with the bumps of life, expanding the

social threshold of tolerance and our collective imagination. We need artists who study the mythologies of the world and decide that they want all of these mythologies to coexist as a counterpoint to our overly argumentative cultural tendencies. By being in tune with this rhythm, an artist can push imaginative boundaries without making arguments. More of us need to learn how to use this unique intuition to better navigate our own imaginative faculties and creative potential.

A more familiar term for successfully trying out fairy-tale logic might be *transcendence*. That is, the ability to forge connections to the larger universe and provide meaning, exhibited by traits like an appreciation of excellence and purpose.[1] My conversation with Lee started with sociologist Peter Berger's gateways to transcendence in a modern secularized world: creating order, living with hope, playing, damning and humor-making — all elements found in artistic expressions.[2] I knew from the beginning of this journey that it would be through art, not argument, that the contemporary spirit may most likely be stirred, but I did not yet know the specific paths.

Artistic creations that point in mystical directions become critically important in times when intellectual pursuits fail to answer the fundamental question of how we can make the world a better place. Art offers transcendence, a spiritual path to escape the troubling dissonance of difficult times. As we rethink listening, politics and capitalism, we also need to rethink spirituality to allow for artists to have a more prominent voice.

Beyond these positive motivations to rethink spirituality and open up to the possible wisdom in trying out fairy-tale logic, there is also the issue of social balance. Writer Franklin Foer observes that the Big Tech monopolists are seeking to mold

1 Peterson, C. & Seligman, M. E. (2004). *Character strengths and virtues: A handbook and classification*. Oxford: Oxford University Press.

2 Berger, P. I. (1970). *A rumor of angels*. New York: Anchor Books.

humanity with a theological sense of conviction, making their efforts both wondrous and dangerous.[3] As the powerful have begun to rethink spirituality to achieve their ends, we must rethink spirituality to protect our communities, open our social conversation and reclaim power for ourselves.

In famously giving up on philosophy as the dominant source of wisdom, Rorty turned his attention to "the comic book, the docudrama and, especially, the novel."[4] Rorty's insightful decision to single out the comic book makes this next conversation important. Comic books are a distinctive type of imaginative work, often underappreciated, that redescribes our world, such that these stories inspire changes in the world of lived experience. Richard Rorty explains that encounters with imaginative literature like comic books "help us break with our own pasts" and can result in "one's becoming a more sensitive, more knowledgeable, wiser person." Rorty would concur that the fairy-tale logic found in comic books offers a path to wisdom.

In his introduction to *Hellboy: Wake the Devil*, the legendary Alan Moore, author of the only graphic novel to appear on *Time* magazine's 100 Greatest Novels list, offers the insight that "Hellboy is a gem, one of considerable size and a surprising luster . . . it is in the skillful cutting and the setting of the stone that we can see Mignola's sharp contemporary sensibilities at work."[5] Mike Mignola uses the medium of comic books to create art that is at once both deeply personal and fantastical. Mike is an artist who very explicitly thinks as a public intellectual and whose work offers multiple levels of engagement for diverse audiences. For the casual reader, Hellboy is a superhero who fights evil. For the deeper reader, the art offers a point of entry into a long tradition of mythological storytelling

3 Foer, F. (2017). *World without mind*. New York: Penguin.

4 Rorty, R. (1989). *Contingency, irony, and solidarity*. Cambridge: Cambridge University Press.

5 Mignola, M. (2004). *Hellboy volume 2: Wake the devil*. Dark Horse Press.

and a very intimate look into the mind of a generous artist. Despite (or, perhaps, because of) Disney's takeover of the Marvel Universe, the serious reading of comic books is still regarded by some as the geeky pastime of the lonely and socially inept. So why did this brilliant artist choose the medium of comic books?

Mike: The beauty to me is that it's really the one place where anybody who can write and draw can tell a complete story. It's one thing to write a story — but to be able to do it with words and pictures in an inexpensive way — unlike film, where there is a massive compromise, where you have to deal with other people and their money. With comics, you can control everything, and you can really put your vision out there without having to deal with a lot of other people . . .

In the 1970s, art historian David Kunzle took on the challenge of trying to define the discreet subset of artistic endeavors known as comics. He identified at least three key features of the medium: First, comics presented "a sequence of separate images." Second, there was "a preponderance of image over text." And third, comics would tell "a story which is both moral and topical."[6] Three decades later, critics Greg Hayman and Henry John Pratt proposed a definition agreeing with "a sequence of discrete, juxtaposed pictures" and that these images "comprise a narrative, either in their own right or when combined with text," but gone is the insistence on moral or topical storytelling.[7] Mike's work tends to hew closer to the first definition, but his explanation for his preference of the medium adds an important insight.

6 Kunzle, D. (1973). *The early comic strip: Narrative strips and picture stories in the European broadsheet from c. 1450 to 1825.* Berkeley: University of California Press.

7 Hayman, G., & Pratt, H. J. (2005). What are comics? In *A reader in philosophy of the arts.* Goldblatt, David & Brown, Lee (eds.). London: Pearson Education, 419–424.

While the cost of producing movies has plummeted due to technological advances that can put a high-tech lens or an entire editing studio into a device that fits in the palm of your hand, reaching a large global audience remains extremely expensive. Movies created on a million-dollar budget are considered cheap. And even then, filmmakers will tell you that they spend more time fundraising than filming. So the comic book emerges as a renegade platform of sorts, where the artist gets to tell a story with words and images but utilizes the most analogue of platforms. It's ironic given that the contemporary Hollywood blockbusters with half-billion-dollar budgets are more often than not adaptations of comic books. But as Mike has defined it, what makes the medium so special is lost in cinematic translation. The art of comics remains closely tied to the unique characteristics of the book.

Despite using a pen and paper as the primary tools of his trade, and despite the book form of his work, Mike is loath to call himself a writer. The comic book is for artists who are primarily interested in juxtaposing pictures, in telling stories where the image dominates over the words.

Mike: I'm a big reader . . . to me a writer is a guy who writes books. I know it's not fair, I know it's narrow-minded, but it's what is ingrained in my head from being a kid, reading, in awe of people who could write. I never set out to be a writer. I really started writing my own work so I could draw what I want. I'm comfortable calling myself a cartoonist. I shy away from calling myself a writer. Unless I'm saying I'm a writer and an artist. The artist part of me is really what drives it. The writer is there, to sort of pull things together but artist is always first.

As an artist, Mike offers expressions that would not be as compelling if they were articulated in words. For example, in past interviews Mike has said that he doesn't have much interest

in the modern world. It's a curious statement from someone who continues to shape popular culture. But instead of a boring argument critical of where the modern world has gone, Mike gifts us a visual representation of the world he dreams of living in. It's an imaginative world stacked with gothic buildings and technologically untouched landscapes, all of which combine to provide a very romantic vision of Hell, quite distinct from that of Milton or Dante.

Mike: Hellboy in Hell was a good title. That book was really me taking that character and bringing it back into myself — into a world that could only exist from me — because it was made entirely out of everything I like. There was no attempt to create someone else's version of Hell, or really my version of what Hell would be. It was just my personal fantasy world where I was completely free of any kind of logic that would be the logic of the real world — so Hellboy could float, and he could fly, and he could change color, and there could be giant forests, or be piles of old buildings. It's my world. It's important to me because maybe the character had become my commercial thing, with movies, so it became something so far beyond the weird little project I was working on — and it was really kind of an effort to reclaim that character and put him someplace where he was just mine again.

Hellboy in Hell exemplifies the kind of art we've been exploring throughout this book. On the surface, it's not at all clear why a serious person would be interested in a comic book written by a lapsed Catholic about a demon spawn wreaking havoc in a Hell that's not really Hell. Every bit of that suggests dissonance and commercial rejection. Yet, as people encountered the character of Hellboy, both through the comic and later through Guillermo del Toro (in 2004 and 2008) and then Neil Marshall (in 2019)

reimagining Hellboy as a movie, it sparked something special in our imaginations.

I would argue that the success and, ultimately, the appeal of Hellboy is due to the intentions of his creator. Hellboy wasn't just an attempt to draw a demon — it was a representation of the artist himself. The world we are being invited into isn't Hell, but the welcoming space of a very creative imagination. The reader wasn't being bombarded with arguments, but invited to soak in an atmosphere, to feel the mood of the artist, to be part of a conversation. Making the acquaintance of Hellboy is, as Rorty has stated in another context, "a matter of finding oneself transported, moved to a place from which a different prospect is available."[8]

Mike: I got to do that something that turned into a relatively commercial success, but it was always a very personal thing. There is really something about creating a thing that you don't expect to go very far, so you can do exactly what you want, and because I wasn't really a writer, I modelled the character's personality on me. It wasn't like I sat there and said that I needed to create this commercial thing, like I needed to create my own version of Batman. I'm just going to create this cool thing so I would be able to look back on it and say that I created something that was a very "me" kind of character, reflecting my personality, my likes, my dislikes, and if it doesn't go very far, at least I got to do it once. But I got away with it.

So . . . at the end, with the Hellboy in Hell stuff, I was not interested in doing certain kind of things anymore. I wanted to do something about mood, and atmosphere, and it reflected my personality over twenty-something-odd years. You kind of want to leave a record of where

8 Rorty, R. (2010). Redemption from Egotism. In *The Rorty reader.* Voparil, C. J. & Bernstein, R. J. (eds). Hoboken: John Wiley & Sons.

your head was at over those twenty-something-odd years. There were times where I wanted to do big, adventure pulp-magazine stories, and there were times when I wanted to do quiet, little odd fantasy stories. Perfect example of that is right after 9/11. I did this little mermaid story — and I was in New York for 9/11, and I was about to do some other project, and I didn't want to do that anymore, and I thought I'd do this fun, little light fantasy story. But if you look at the mermaid story, it's much gloomier, it's much sadder, because it reflected what was going on in my head at the time. What I wanted to do with the book was let my current mental state get into the book. I know very commercial writers who can switch off every external stimuli and make this kind of story, 2+2=4, but I always wanted to see it just bring in a little bit of what my mood was at the time.

Hellboy is successful as art because it completely immerses whoever encounters it into the imagination of the artist. An encounter with Hellboy builds wisdom as the reader is invited into a conversation that was born of creativity, curiosity and open-mindedness and demands these three traits back. Yet these demands are not off-putting. On the contrary, as a reader, it's almost calming to be allowed into someone's head so completely. Through our exposure to the work of authentic and committed artists, we can be rewarded with a greater inclusivity of perspectives, as real art is absolutely unique. But the encounter brings with it a responsibility on the part of the reader/viewer/listener, which is to be open and curious. Rorty insists that means "being ready to be bowled over by tomorrow's experiences — to remain open to the possibility that the next book you read, or the next person you meet, will change your life."[9]

9 Rorty, R. (2010). Pragmatism, literature and democracy. In C.J. Voparil & R.J. Bernstein (Eds.), *The Rorty Reader*. Hoboken: John Wiley & Sons.

Mike: I'm always asked what kind of artists I like, and I look around the comic book medium, and I see a lot of brilliant draftsman. I see a lot of artists that are a hundred times better at drawing than I am. But with so many of these guys, I look at their work and say, Yeah, you can render the shit out of a car, but I have no idea who you are. The artists I always like are the guys where I look at their stuff and I can see that I am seeing you, and no one else could do what you do. I always wanted to be one of those guys. This connects us back to the Hell thing. Any number of people can draw Hell. But with my Hell, you are looking at the inside of my head, made up of all my years of liking certain things or wanting to draw certain things — it's uniquely me. It's not better than anyone else, but no one could put those things together the way I put them together.

Hellboy is Hellboy is because I knew I'd be bored drawing a regular person. That's where it started . . . Monster aside, he was very much a stand-in for me. There was no real thought about what humans would do, what monsters would do, he's just my guy — he's my everyman sort of, except he has to be the beast of the apocalypse, but other than that, he's just a guy. There was no real statement, even the nature vs. nurture that a lot of people have attached to the Hellboy stuff — that, to me, is the struggle of any real person on some level — what you want to do versus what you feel like you are meant to do. I've blown it up to some fantasy thing, of good vs. evil and the beast of the apocalypse stuff, but really that's in any kind of person, wrestling with other people's expectations.

So the conversation is one on the nature of responsibility, the internal conflict we all feel, yet explored through a tradition that extends from folk tales to pulp to classic comics . . . and what is amazing is that, filtered through Mike's imagination, this seems

a very straight line. Inclusivity is achieved as the social conversation is broadened. Suddenly, the work and thinking of people who may not have mattered to you before become important. If Hellboy stimulates your imagination, then you are drawn into a conversation that includes horror writer H. P. Lovecraft and comic book innovator Jack Kirby. Even if you don't explicitly recognize it, the conversation, the wisdom tradition, has been extended, mediated by the art and artist.

Mike: I'm the product of my influences. I remember talking with or watching other artists and realizing that they made up a lot of different projects — they would make up a different thing for all their different interests. Maybe I was just being lazy, but if I'm going to make up something, I wanted it to be the product of everything I liked. So a lot of what went into creating Hellboy was embracing all of the different stuff I like. Part of it was having a short attention span — realizing that if this is just a pulp thing, at some point I'm going to want to do a Victorian ghost story — I don't want to make up a separate thing for a Victorian ghost story. I wanted all that stuff to be in there. Even from the very beginning, it's a record of all the stuff I like. Yes, it's kind of an H. P. Lovecraft pulp magazine, but I needed quiet stuff, ghosts, I needed to have all that stuff. I can't put everything I do into one story, but over the course of twenty-two years I was able to put almost everything I like into that thing. It's creating a body of work that was uniquely me. And after ten years of doing stuff for Marvel and DC Comics, there was no work I had done there that really said anything about who I was and my ability to draw certain things.

The series was meant to go on longer than it did. And at some point, I just felt like it was done. At the end of issue eight, he sits under a tree smoking a cigarette, and

I said, "That looks like the end, it feels like the end, I'm done." But I needed two more issues, I needed to resolve these things, and we needed ten issues to round out a collection. I wanted to deal with his ex-wife, and I took a lot of material I had planned to do, scrapped most of it, reworked an idea I had about him having an ex-wife. But the ending of the last issue is something I'd had in mind for a really long time. Not since the beginning, certainly, but since I started Hellboy in Hell, I kind of knew where that ending was going to go, and it does reference my favorite story I have ever done, a story that my daughter made up when she was little, this thing with floating objects. And I thought, "That is the most personal story I've ever done. If I'm reclaiming Hellboy and putting it away, let me reference the most personal thing I've ever done."

At the end, when it came down to drawing those last couple pages, I started losing my nerve, because I thought, "This is such a weird ending, this is so ambiguous. Are the people reading this book going to feel cheated?" And I thought, "This is my book. You said you were going to do it, you said you don't care what anyone thinks, let's stick to that and really do this thing that nobody but me would do." Maybe nobody but me understands what this thing means. We have to be true to that vision. And if nobody buys it, then that's fine. At this point, I was clearly doing this book just for myself, and after 22 years of doing this, it was important enough that I end on my terms.

Now that I'm working on my first comic I've drawn since I stopped Hellboy, and I'm as excited about this thing as I've been about anything I've ever done. The trick for me is to go further out on a limb, and say, "I got away with this, let's see if I can get away with this." I'm in a very fortunate position as the Hellboy machine is paying the bills. As a creator, I don't have to sit down and do a book

with any kind of commercial concerns. As long as I can find a publisher to publish my work, I'm free to do work that doesn't need to sell — so I'm really doing it for myself.

So the Hellboy in Hell stuff was really interesting. The stories I did in that collection — that's the stuff that's the purest me. If I can continue to work in that direction, if I can continue to do stuff that is graphically interesting, if it's a story most about the way colors work or the way certain sequences work. Plot is becoming less and less important and it's more an excuse to create these images, these odd things that roll up out of my head — I'm not trying to create another character that's going to be in movies. I hung up Hellboy at the right time. I didn't overstay my welcome. When I thought Hellboy was done, I said, "Now let's go and make the stranger things. There's no part of me that feels that I need to compete with Hellboy." I've made my peace with the fact that I will be the guy who created Hellboy: I don't need to try to top it or do anything else along those lines. From now on, I just think that I'll just play and do the weird shit that may be completely incomprehensible, but I'm really doing it for myself, and leaving a record of what the inside of my head looks like. The more I do it, now that I'm back to it, now that the machine is up and running, I say that "I made this very odd story, but now I want to do something that's — I hate to say it's strange, but let's do something more personal." I'm not telling the same story over and over again.

One of the questions that opened this book was whether a non-fundamentalist, welcoming approach to religion can still have a part to play in Western liberal civic discourse. The late journalist and critic Christopher Hitchens had a prophetic sense that pushed him to answer quite definitively in the negative. He reminded us that though we keep being told by its defenders

that religion, whatever its imperfections, at least instills a sense of morality in the believer, there is conclusive evidence to the contrary. Hitchens lamented that "faith causes people to be more mean, more selfish and, perhaps above all, more stupid. Violent, irrational, intolerant, allied to racism and tribalism and bigotry, invested in ignorance and hostile to free inquiry, contemptuous of women and coercive toward children: organized religion ought to have a great deal on its conscience."[10]

Reading Hellboy, however, gives one hope that it may be possible to still engage with religion, but on artistic terms. Christian imagery permeates Mike's work, but it is not given a privileged place amongst competing folklore. All of it melds together to give the world a sense of meaning. Can something similar ever happen in the Western liberal public discourse?

Mike: I did shy away from certain mythologies and religions that I'm not that familiar with. Ideally, I'd love to embrace everything and deal with everything. I just wasn't knowledgeable enough, and I didn't want to do anything that would be accidentally offensive. I did want to preserve as much as possible of what I find fascinating about all these religions and mythologies. When I began the series and I was coming up with some kind of H.P. Lovecraft inspired mythology that would be the big thing behind the series, the first thing I did was read different creation myths from different cultures so I could bring them together and find the common thread . . . I was looking at Egyptian creation myths and other old cultures that had things in common: this battle with the dragon at

10 Hitchens, C. (2008). *God is not great: How religion poisons everything.*
Toronto: McClelland & Stewart.

the beginning of the world, and the creation of the world from that dragon. In Egyptian mythology, there were eight creatures that rise up from the mud at the beginning of the world — I shaved that down to seven, so I hit that seven-headed dragon from Christian mythology. I was trying to touch on a bunch of different stuff and create this kind of neutral thing for my creation myth . . .

I've never wanted to explain that the Greek gods didn't exist, or that the Norse gods didn't exist, or that Christianity was created by aliens — I didn't want to explain away what was magic about all these different cultures. If I was pushed to it, I'd have some kind of rationale for how all these mythologies could coexist, but I would never want to explain. I guess that's why I've never really liked science fiction that much, because I've never liked something that explains the origin for all mythology. I want it all to exist — I think that's what makes this stuff fascinating. Which is why when I do folklore and fairy-tale stuff, one of the things I don't like that I've seen other people do is that they go in and graft on a logic and to me what's beautiful from these things is the weird shit that you can't explain. I would never explain why and how those things happen, but I can tell when it feels right. There's no real logic — Del Toro and I used to refer to it as "fairy-tale logic." If you've read a lot of folklore, you feel a rhythm to these kinds of stories. Certain things just happen the way things happen because it feels like that's the way things should happen. It's thinking with your gut and not thinking with your head.

Is there a place for unfettered free expression? Not as long as both the right and the left seek to censor and silence voices that make them uncomfortable. Is there a place for religion in civic discourse? Not as long as sacred texts are used as conversation

stoppers. These two outcomes are a product of identity politics replacing curiosity. The liberal conversation has been stifled by responding to curiosity with confrontation and argument. And so here is a unique opportunity for artistic expressions. As Lee asked, how can we bring more people to the party? How can we be more inclusive? And as Rorty phrased the question, what distinguishes an individual conscience we respect from the sort we condemn as fanatical? The answer has been provided by an artist who studies the mythologies of the world and decides "I want it all to exist."

There are deep points in Mike's work, and he doesn't need to make arguments to get them across.

Mike: I guess it's deliberate, I've just never really thought about it. Maybe I don't feel like I'm smart enough to argue . . . Certainly my politics, I don't think consciously comes into my comics at all. I just think with my gut and not the intellectual part of my brain — it's not the main driving force when I create my work. It's kind of like a happy place when I'm creating stuff. I don't do it when angry. I might be creating stuff when I'm sad, and I certainly have anger about some things these days, but the work is — it's trivial to say escapist, but it's just the work. It's just my outlet. The creative part of my head isn't the anger stuff. I remember being asked right after 9/11 to do a couple pages for one of those benefit books, and it really was a stretch for me to do stuff consciously about an important event. It's much more comfortable for me to do my fantasy work, and certain images are coming from where I am emotionally, but I don't force it into the work.

Maybe I just don't trust myself to be smart enough about certain things — but I find so many of these knee-jerk political things come across as silly or immature — they're big ideas, but not presented in a particularly

powerful way. If some of the concerns show up in your work, then it works a little better. Star Trek is a good way of dealing — and maybe it's science fiction in general, I've heard that argument. For me, science fiction is Star Trek. The idea of presenting so many political things in Star Trek, but it's been dressed up as dealing with aliens, so you can do a thing about racism because it's aliens. It's a more interesting and more compelling statement without hitting it on the nose.

Like almost all the artists we conversed with, Mike insists that interesting, experimental art necessarily needs to be indie. He can only do the work he does with Dark Horse, but never again with Marvel or DC. It's our first path to wisdom — the romantic instinct of the artist peeking out once again. Characteristics of classically defined romantic art include a rebellious streak, as well as a focused emphasis on the individual artist's emotions and unique imagination. For a romantic artist, the goal is to bring into the world a singular, uncompromised vision.

Mike: I don't think I'd ever go back. I don't know if it's possible. It'd be like being a filmmaker and going to a major studio to make your movie. The bigger the budget, the bigger the studio, the more people are going to be saying, "You can do this, you can't do this." If you do it independently, then no one tells you what you can and can't do. That's the thing with Dark Horse. From the very beginning, no one told me what I could and couldn't do. And I've been doing that now for twenty-some-odd years. The idea of doing something for somebody else . . . I would just feel like there's too many eyes on me.

I couldn't resist closing this conversation without his reflection on how truth is always stranger than fiction. In many ways,

the reality emerging is scarier than any of Mike's apocalyptic stories. In the world of Hellboy, there is a clear delineation of evil attacking the good. Writer David Frum observed that Trump will destroy American democracy not by attacking the innocent, but by protecting the guilty.[11] That's how you can get society to just give up. For some of us, the reality emerging is scarier than the apocalypse he portrays in his work.

Mike: Reality is a million times more frightening. Just in the last week and a half it's become more frightening than I fantasized. What I imagined [Trump] doing was one thing, but the reality is so much uglier and so much more complicated than the vague impression I had for what was going to go wrong. It's scary as shit. I think my work is an escape from that. It's simpler. The apocalypse that everything builds to in my work, there is a positive element to my version of it — it's the Norse mythology idea of one world runs its course so another can start. So even my bad guys had some kind of maybe deluded nobility to them. I don't understand the people I'm watching on TV. I cannot understand — it's not just that their idea is different, it's that their idea is so ugly. I don't understand people who have such an ugly prejudice that is groundless. Maybe that part of me that was raised Catholic is still in there. I don't understand if people are refugees, how you don't say, "We're a very rich country, we can make room for you." Especially if someone is saying that since we're a Christian nation, we're not going to let people in trouble into our country. It doesn't make sense. It's one thing to just be a monster and say, "I don't want them here." It's another to say, "We want everything to be great again, so

11 Frum, D. (2018). *Trumpocracy: The corruption of the American republic.* New York: HarperCollins.

we're going to do this horrible thing." It sets my teeth on edge, because it just doesn't make sense.

While music may have the power to shatter the soul, comic books use the sequencing of distinct visual images to tell a moral story. As words more often than not become cliché, the visual image takes on increasing importance. With Mike's art, the viewer is transported into the head of the artist. But don't worry, the world we are being invited into isn't some religious conception of Hell — it's "fairy-tale logic." Those curious enough to read Hellboy are rewarded with an artistic rendering that in many ways serves the same social purpose as early religious iconography, only to more inclusive ends. The art of Mike Mignola is meant to create a mood or an atmosphere where the viewer can reflect on the social conversation. The artist is immersed in a wisdom tradition, and offers the reader a path to wisdom.

The American philosopher William James felt that it was through art, and not philosophy, that his spirit was most stirred. Spending time with Hellboy can stir the soul in a number of ways. First, immersing oneself in this particular Hell transports an audience in the same way as the best mystical artwork. Mike has said that he draws the world he wants to be in, landscapes devoid of technology or people, part of a tradition that curator Katharine Lochnan has called "contemplative landscapes," where the viewer is invited to complete the art through an affective experience.[12] Emotions are stirred amid the text-free and somewhat barren frames that Mike drew to close the Hellboy narrative. Second, the narrative itself, driven by "fairy-tale logic" helps bring religion and mythology back into the social conversation from which it was expelled due to the unreliability of fundamentalists as participants. Lochnan writes that we turn to

12 Lochnan, K. (2016). *Mystical landscapes: From Vincent van Gogh to Emily Carr.* Munich: Prestel Publishing.

mystical landscapes when intellectual pursuits fail to answer the question of how we best should live. Art in this tradition does not strive to give us the answers, but facilitates expanding the conversation. Our dissonant era needs work that sketches a line from classic mythology to contemporary questions that is not shaded by identity politics, fear of cultural appropriation or fundamentalist proselytizing. Through the imaginative expressions of Mike Mignola, Hell can offer a welcoming respite.

CHAPTER 11

Play the Spaces

Malden Mills was a company located in Lawrence, Massachusetts. In 1995, days before Christmas, a fire broke out at the factory, destroying the facility and placing local jobs in jeopardy. Due to his religious beliefs and strong ties to the community, the CEO of the company, Aaron Feuerstein, ignored the strong economic rationale to take advantage of the situation and relocate the factory to a country with potentially less expensive labor.

Contrast that with Volkswagen's decision to install emission-cheating software in 11 million cars, enabling Volkswagen to sell their cars as offering better mileage and performance while saving the company money by negating the need for expensive pollution-control systems. Not only did they lie to their customers, but throughout the time leading up to and even during its early stages, Volkswagen represented themselves as having the highest ethical standards — one Super Bowl ad depicted their engineers with angel wings. Volkswagen recognized that to reach the top of their industry, they had to promise high-performance "green" cars without sacrificing the financial bottom line. Achieving that end, however, meant taking certain liberties.

The next path to wisdom is really an extension of the fourth (change the way you listen) and fifth (trade fairly). One way to rethink what it means to listen, to think, to create and to be democratically-engaged citizens is by choosing to temper parts of ourselves and only "play the spaces." This prescription emerged from my conversation with the legendary psychedelic musician popularly known as Sonic Boom. It is his term for how he improvises, and I like it a lot, especially in the context of metaphors that can apply a spiritual lens to rethinking politics and capitalism. Aaron Feuerstein sought to play the spaces, recognizing his responsibility to the town and its people who had welcomed his family's business into their space for over ninety years. Volkswagen, on the other hand, carved out the space that they wanted with no respect for any of the stakeholders. They wanted to be viewed as ethical, and they wanted to make money. They did not care about actually *being* ethical.

The legendary band Spacemen 3 were perhaps best known for *Taking Drugs to Make Music to Take Drugs To*. However, their sonic legacy and unabashed honesty continues to inspire twenty-five years after they disbanded. Peter Kember, a.k.a. Sonic Boom, brings a mystical perspective to the discussion of dissonance and social hope that is considerably different from any of the other musicians in this book. Historically, when musicians talked about "playing the spaces," they were referring to the importance of the silence between the notes. In this discussion, Peter will be talking about something different — about playing in the spaces that are left open for us by our partners.

It's a more proactive term than my own definition of modesty as withholding some of ourselves to create space for the other. My term is a negative action — withhold ourselves. Peter's term is positive — look to play in the spaces. See where the other members of our community are and play in the spaces that are left open. All community members are participants. All parties are important contributors to the world that is being created.

If we accept that, if we accept the importance of everyone as a potential contributor, then playing the spaces is the only moral path in social exchanges.

Playing the spaces suggests that the openness created by a population for political exchanges of power or economic exchanges of capital is transient and fluid. Community members choose to leave space for us to enter, and so long as that is the case, we can play there. Feuerstein was so grateful for the space afforded him by the local community that he wasn't going to leave it in times of crisis. Contrast this with the current business-speak of exploiting or filling a market gap. Volkswagen saw the opportunity to insert their brand into the burgeoning market for "green" companies. With the latter, the guiding philosophy of business is to aggressively and permanently entrench themselves wherever a market can be exploited. There is always more crap to be sold, always new customers to be reeled in.

"Playing the spaces" is a complementary notion to "free spaces" as explored by political theorists Sara Evans and Harry Boyte. They wanted to identify "the public spaces in which ordinary people become participants in the complex, ambiguous, engaging conversation about democracy."[1] Evans and Boyte saw the framing of politics as left versus right forcing people into paradigms of "resistance or reaction," instead of encouraging them to find a space that will allow for engagement in the political process. Boyte explains that free spaces have been "eroded by the rise of technocracy," and there is a need to "struggle against oppressive conditions," but the emphasis should be on finding the space beyond partisan politics where change can be enacted.[2] "Play the

1 Evans, S. M. & Boyte, H. C. (1992). *Free spaces: The sources of democratic change in America*. Chicago: University of Chicago Press.

2 Boyte, H.C. (2014, November 3). Higher education and the politics of free spaces. *Huffington Post*. https://www.huffingtonpost.com/harry-boyte/higher-education-and-the-_3_b_5747818.html

spaces" is directed at those in power to ensure that "free spaces" exist for citizens to take up.

Not only is this notion critical to more inclusive politics and economics, but it is found in spiritual narratives as well. In the Jewish mystical tradition, there is the idea that at the moment of creation, God constricted himself in order to create a space for life. Rabbi Adin Steinsaltz explains that the "attribute of contraction thus extends the essence of divine revelation by paradoxically concealing its power."[3] One of the moral lessons of this myth is that just as humanity exists on the cosmic plane because God withdrew himself for us, so too we should be mindful of not exploiting our power and limiting ourselves to the social spaces created for us by our fellow citizens. Scholar Arthur Green delineates what learning from the divine might involve in our contemporary age: withdraw from our "cavalier treatment of the biosphere . . . indifferent overconsumption and waste of resources . . . [and] disdain for nonhuman forms of life."[4]

Imagine if instead of greed and selfishness dominating the mindset of powerful business and political leaders, those leaders were to humbly play the spaces. It would mean checking in with the community and our own perceptive sense to make sure that the space is being left open for us and moving out when someone else needs a turn. I believe that thinking about playing the spaces can offer an important paradigm shift towards inclusivity amongst those who may not otherwise think very deeply about ethics when they engage in economic or political organizing. "Play the spaces" is a brilliant mantra, as interesting as the artist who coined it.

To understand Peter Kember and his band Spacemen 3, it is perhaps useful to reference Lydia Lunch's distinction between

3 Steinsaltz, A. (1989). *The sustaining utterance.* Northvale: Jason Aronson.

4 Green, A. (2010). *Radical Judaism: Rethinking God and tradition.* New Haven: Yale University Press.

U.K. punk as dealing with societal ills in contrast to American no wave dealing with personal insanity, which we will encounter shortly. Spacemen 3 may have been a British band, but they split the difference between contending with personal versus social insanity. The soul punk of Spacemen 3 is not the punk of the Sex Pistols. Spacemen 3 challenged privileged norms even within the underground. They weren't looking to fix society — they were on a mystical journey, sometimes hopeful, sometimes not, always escapist.

As always, if you're unfamiliar with the music of the band in question, I urge you to go and listen. To get a sense of soul punk refers to, take for example the Sonic Boom–penned "I Believe It":

> Oh Lord
> Ah, you know I believe it
> To my soul
> Ah, to my soul
> To my soul
> Oh Lord

The song begins with a droning organ, repetitive and ethereal. The listener is invited to join the band in what feels like a spiritual ascension. But just as we settle in, the music takes a darker turn, the church organs replaced by what is clearly a rock and roll guitar riff in the foreground of the soundscape, and a more menacing echo takes over the ambience, with even the organ becoming more dissonant. After a brief three-minute journey, Sonic Boom starts to fade out, singing

> Lord — Jesus
> Gotta help me
> Find my way
> Find my way

While Lee Ranaldo and Sonic Youth were taking dissonant sounds to new dimensions in New York City, Sonic Boom and Spacemen 3 were doing something similar in England. They, too, were sometimes regarded as "noise-icians" by the uninitiated, but they are held in reverential esteem by the myriad of bands they influenced. However, besides the obvious differences in sound, Spacemen 3 stand out for having a decidedly mystical motivation to their sonic explorations. The repetition and droning were meditative, whereas Sonic Youth's efforts were more art-school experimental. There are gospel influences in the music of Spacemen 3 and religious imagery in the lyrics, as displayed above. I asked Peter about the diverse musical influences layered into their soul punk sound.

Peter: There always was. People didn't used to see it. Particularly, elements of soul music — you know, like Memphis Soul from the '60s — rock and roll, really, a lot of 1950s stuff. It wasn't the format we were using, but it was definitely something that we felt. We felt that we were part of this continuum, starting maybe with African music, going into blues, going into different forms of what we can loosely call rock and roll, the stuff that came out from that. That was all the stuff we grew up on.

And then it cuts into what is essentially the punk and new wave stuff, whether it's MC5 or the Stooges, the sort of early pioneers of the '70s punk stuff. It all hit around the time we were early teens. Punk music is built for thirteen-year-old boys, really. It was kind of perfect. You know, *Never Mind the Bollocks*, that record stands up as well today as it did then. It's a stunning record, and it still sounds it — they took a lot of risks, and you have to admire them for that. It's a stunning, stunning thing.

We definitely felt kindred spirits with some of these people, even if our music wasn't entirely in that form. And

then over time, I came to realize some of the Krautrock. We were only really aware of Kraftwerk. Speaking for myself — and I think we can speak for everyone else — we were all Kraftwerk fans, but had no idea about Neu, or Harmonia, or any of this amazing stuff that I also feel real kindred feelings to. The only part that ever entered our music directly was Kraftwerk, who at the time hadn't quite yet become the legends that they are now. In the early '80s Kraftwerk were on the back end of two or three albums that no one really cared about. They hadn't quite come to the legend status that they deserve and have today.

Peter spends much of his time in Portugal now, and continues to explore sonic dissonance with projects like Spectrum and E.A.R. It was a real honor to be able to talk to him. Most of the conversations in this book have a North American bias, so including a voice from across the continent, especially one as influential as his, was important.

Peter: The first thing I should say is that I don't think — apart from a few E.A.R. tracks — I never really think of my music as being dissonant, particularly. I think there's a lot more dissonant music out there than I do. Usually, most of the things that I do, if I use different pitches, they're usually harmonically related in some way. I was interested in your thinking on this. It's just not the way I think of it, really. Or if it is, I take it for granted. If it is dissonant, I never really realized — I always thought it was quite tuneful. But perspective is everything.

Indeed, perspective is everything. To me, what made Spacemen 3 so magical was the combination of these beautiful harmonies and melodies, really tuneful as Peter notes, but beneath the concordance was always a distinctive noisy, droning sound.

Peter: I know what you mean. Some of those tracks, maybe "Suicide," I guess in some ways you can see it as symphonic with some sort of dissonance, but I don't know. I always thought that was more contrast and more of a tonal thing. That's interesting.

In past interviews, Peter talked extensively about how the band's drug use inspired the sounds they liked to explore. I was curious to know if decades later his thinking on the topic has changed. And I was ecstatic to discover that it had not.

Peter: I suppose that to most people, taking drugs is a dissonant thing to do. But I never really found it to be like that. I always found it concordant, really, and I felt that it improved my way of thinking, particularly psychedelic drugs. But people don't take drugs for no reason. There's a reason people take drugs. Maybe it's true that some people do it as a blocker or to forget — but in my experience, most people I know who take drugs or who have taken drugs didn't do it to try and block reality. They did it to enhance or experience a different reality.

I think that it is in human nature. Whether it be alcohol or nicotine, most people like to distort or take a break from regular reality. I don't know why it's taboo in these times. I think that it's changing. Particularly with psychedelics, there seems to be a lot of awareness at the moment. There's a lot more of the new generation exploring the shorter-acting psychedelics like DMT and I think a lot of interesting stuff comes out of that. It makes people think in a much more attuned way with the planet.

It's harder to throw plastic into the ocean once you have had that experience, and if that's the only benefit from it, then that's a massive benefit in my mind. The earth has some serious problems going on, and it's mostly done

by the people who claim to not take drugs, so make of that what you will. People just trying to get rich at the expense of the planet and fuck the consequences . . . those are always the people who say they don't take drugs. Donald Trump would be right up there at the top of the list.

Sonic Boom's argument for psychedelics is a spiritual one. He argues for their benefit as reality enhancers as opposed to tools of escapism. As we lamented earlier, there is considerable evidence that Western society has given a pass to corporations whose destruction of the earth is viewed as a by-product of profit-seeking. Donald Trump pulled the United States out of the Paris climate accord. BP and VW continue to thrive as businesses despite massive environmental scandals. Clearly, arguments for greater environmental awareness have failed. What is needed is for individuals who are in positions of power to have an internal aversion to polluting acts. Peter argues that in his experience, psychedelics open up a part of the imagination that solidifies the human connection to their natural ecosystem. In which case, there may be a social good in following him down the rabbit hole as we rethink spirituality.

Sonic Boom is emblematic of the artistic persona we have described throughout the work: a rebellious streak against the established social order, a focused and driven emphasis on imagination . . .

Peter: Ever since I was a kid, I always just really wanted to communicate. That element of wonder came out of it. I have moments, between two and five times a day, where I'm like, "Oh my god, this is so fucking awesome." But it will be clouds, or it will be lights, or something in nature — some weird animal or lizard comes by or something. It's one of the reasons why I spend time in Portugal. It's

a pretty cool, magical place. Anything or anyone that can make you feel like that is a fantastic thing in my mind.

I think that in some ways music for me is about encapsulating beautiful experiences, and it can be done in such a magical way that someone can instantly get to that place from the music. And then every time they hear it, once they formed a relationship with the music, it can transport you somewhere. I think it's really magical. That's always what I've tried to do — I've tried to take inspirations from whatever it is and try to encapsulate it in some way or in some part within a song. Music has a certain magical quality and it just always really appealed to me.

I also always really liked the idea of doing certain things — the type of songs I tend to write are incredibly simple in their structure, which is what I strive to do. There aren't many artists that I feel take that sort of line. I find songs written in that format by other artists, but usually it's a one-off, and whenever I search I can never find anything else like it by them.

I never really cared about where it fit in — of course with Spacemen 3 for many years, it didn't really fit in. Before the internet, it didn't find its natural audience as easily as it would in these times, I suspect. We were out of fashion, out of time, out of place. We weren't trying to be any of those things so it didn't matter to us.

I think that it's important and one of those things that defines us as artists is having some sort of faith in what you do and knowing when you are onto something and just trying to figure it out and put it out there in the best way that you can. I'm sure that a lot of artists are never entirely satisfied with their work, which is what drives them on to the next thing, usually — but occasionally, you get super lucky and things turn out much better than you thought they would. It's important to not be

too influenced by things like fashion and fads and stuff like that.

I wanted to go back to the soul punk label. Such a perfect framing for the band. I wondered if it still holds all these years later.

Peter: I don't know why we didn't use that more. We used that as a descriptor for the band on some posters for a club that we played when we were doing shows. Most of these things like punk, or grunge, they rarely come from the bands. I think they mostly come from the journalists. Or shoegaze is another one. They're usually kind of meant to be put-downs, in my experience. I guess we didn't want to label ourselves, even with that. I liked it.

The U.S. is in a bit of cultural turmoil — what does a European perspective have to offer about the current climate?

Peter: I mean, there are big problems in the U.K. with the whole Brexit state of bullshit. I don't know what to tell you. I try not to get too involved in politics and I try not to pay too much attention. Partly I feel disenfranchised from the whole process. Whilst I do vote, I know my vote never comes to anything — and I feel the same about most of my friends in the States as well — these are not people who were voting for Trump. But I knew he'd get in as soon as the primaries started. Just because I hated him so much. Like, this dude, there's no way he can't win, he's so horrible.

I asked Peter if he was ultimately hopeful of the liberal conversation getting back on track. Decades ago, he came up with the banner "For All the Fucked-Up Children" as Spacemen 3's

rallying call. Is he ready to once again address all the fucked-up children that need to hear the message of soul punk today?

Peter: I sort of agree with you, and my next record that I'm working on is all about and influenced by and dedicated to plants and everything they do and have done for us, including humanity even being able to exist. And everything they do for us on a daily basis, and the drugs and stuff that we get from them — most of the pharmaceutical drugs out there are based on either a synthesis or an organic material to start with, and then it's sent through labs and shit and a big price tag is put on it.

I agree with you that I do think that the right artists can have an impression in a way. I'm not sure that I have anything like the reach of the right sort of artist. But yeah, musicians can really make a difference — all art can really make a difference. Music seems to have some superpowers because you don't have to even look at it to hear it, if you know what I mean. It's pervasive. You only have to be within its range and you can ignore something or block it, but you can't technically shut your ears.

I always feel like music has something unique in those ways. A good idea combined with a great melody — there's nothing better. I know I'm not the only person who feels the way I do about the state of the planet, of politics, of things at the moment. Things get tough enough, people will react. We'll see. It's a challenge for me to make something about plants and trees that doesn't veer on the hippie-dippie kind of type. I'm enjoying the challenge and the discourse with plants.

Sonic Boom in live performances is an incredible impro-viser. And while we encountered many incredible improvisers

throughout these conversations, I was particularly taken by his unique thoughts on the virtues necessary to make improvisation work.

Peter: Humility — I refer to that as playing the spaces. I think a lot of interest in improvisation comes from the fact that I just really, really don't enjoy rehearsing. I would rather do shows in front of human beings. One show is worth ten rehearsals. Some rehearsal is necessary. There's no question you have to do it. But it's shows that sharpen up your playing and the way you have to react. You may hit something wrong, but something good happens — it's where you take it from there. That sort of rarely happens in rehearsal, because you stop and go, "Shit, I went wrong." Once you're in a show, you have to work with that. You've set that plate spinning, you'll have to come back to it in a bit and see what you can do. That keeps things interesting for me certainly.

I'm a believer that if I go and see a show, ever since I was a kid, I kind of like to hear how it was on the record. If they can do it better and more interesting, fantastic. Doing something that's totally different that isn't better than what they did on the record never appealed to me. I try to keep it fairly true, but changing arrangements around and stuff. They say sometimes you have lucky accidents — some idea comes to you ten years after you wrote the song, and you'll be like, "Oh, it should have a backwards horn in it," or I don't know. I can't think what. And you work it into the stuff. Playing the spaces and how you react to other people and what other people do. If you're playing with other people, you can't have four people improvising independently. It has to be an interacting thing or it's just horrible. It's important to listen and not just be thinking about what you want to do. It's about how you react and work with what other people do.

And there it is. "Play the spaces" is a compelling mantra for all the fucked-up children. It is a powerful call for modesty, with specific direction on how an individual can be more inclusive. It is an important follow-up to really listening and trading fairly on the path to wisdom.

We ended the conversation with a discussion of the community that has allowed Peter to thrive and keep making interesting art. His response was another warning about the perils of the music industry.

Peter: You say thrive, but I've had massive problems with the record industry in different ways. Most of the old-school labels are about older men taking advantage of younger girls and boys and making them sign away their rights for life. Which is something when you're twenty-one or twenty-three, whatever. You have no idea what life is. You can't imagine being thirty, let alone seventy. I feel the people who perpetuate it — of which the law does as well, I have to say, because whenever bands get into it with labels, the labels will usually settle with the band rather than go to court, because if they lose in court it sets precedent. I personally believe that you shouldn't be able to sell your copyright, and no one else should be able to register your copyright. Both things in many countries in the world — the U.K., the U.S. — are legal. But in many other countries, are not legal. I think you shouldn't be able to do that.

One thing that musicians and artists are rarely focused on is making money. If that's their main reason for getting up in the morning, it's not a good start to being a musician. People aren't looking at that, and they're not thinking about the implications of that. And nearly everyone I know in different bands, different ages — they'll all say the same thing. They nearly signed away everything, they did sign away everything, they signed

a super shitty deal, because they were like, "This might be the only deal that ever comes around." And all they wanted to do was get their music out . . . that was their focus. And someone else goes, "That's great, because I'll take all the money forever."

I just managed to thrive. The internet makes it look like that a little bit more — the internet makes it good for a lot of bands that are more niche, I think, and I definitely fall under that. Bands who never had any commercial success. And I stuck to it as well — it's been a few times around the block. There's been long periods not of inactivity, but of little interest. I think at different points in time it all looks magical. Kraftwerk would be a great example — they had some tough records, even their really awesome records weren't always recognized as that at the time. The model wasn't a hit single at the time. It practically became a standard when it was released some years later. And that's just the way it goes.

CHAPTER 12

Surprise Yourself — and Your God

Making our way down paths of wisdom requires mental fortitude. We can strengthen our minds for this journey by immersing ourselves in dissonance, soaking in the sensations that accompany unfamiliar words, sounds or images and trying to gain a clearer understanding of that particular discomfort's cognitive/emotional powers. As I have argued throughout this book, when the feelings of dissonance are mediated by art, the unbalancing perceptions can be integrated.

The prescription of this chapter is to surprise yourself, and your god, with a spiritual practice that can help you transcend the noise and find a new path to wisdom. Spiritual practices need not necessarily be associated with traditional organized religions or even New Age philosophies. As we have discussed, choosing to laugh at everything can be a spiritual practice, as can consciously eating at a table or playing the spaces. For our social conversation to thrive, we need everyone in our constellation to be a part of the exchange. Our society cannot wait for some messianic wave of stability. The discordance needs to be a call to action for the curious, the romantic, the rule-breakers, as well as those who want to become so.

While I have a tenuous relationship with my faith tradition, it would be dishonest to pretend that Jewish expressions spark my imagination any less than Sonic Youth. The icons of the Jewish tradition are around me at all times. Most notably, there is a table in my house that has been spiritually broken in. It was at this table that I learned the seventh path to wisdom. After my grandparents escaped the fires of Europe and got married, the first item of furniture my grandparents bought was a large wooden dining room table. At it, they nourished the hearts and stomachs of both their fellow European survivors and new Canadian neighbors. The table gave them access to a dignified civil routine that they and many of their contemporaries had feared would forever be lost to them, and which many of us take for granted. Much more than a slab of hewn wood on legs, the dinner table that now dominates the main floor of our home is a blessing in material form.

Another revered teacher of mine, the philosopher, theologian and survivor Emil Fackenheim argued that the Holocaust needs to be seen as a type of revelation. There is no way to grasp the Holocaust intellectually; no way to explain it or assign causality. Jewish survivors could not hope to understand what God was doing at Auschwitz, but they must hear Him command that Jews are forbidden to hand Hitler posthumous victories.[1] After the camps, Jews are under a sacred obligation to survive. Simple existence itself becomes a holy act. My grandfather never found the words to articulate this worldview as Fackenheim had, but he lived it. After the Holocaust, the simple dignity of hosting a festive meal, for survivors, became a holy act.

In chapter seven we offered the prescription to eat at a table as a path to wisdom. I would like to revisit that idea here, as eating at a table is an integral piece of my personal spiritual practice. In many cultures the dinner table has been historically

[1] Fackenheim, E. L. (1994). *To mend the world: Foundations of post-Holocaust Jewish thought.* Bloomington: Indiana University Press.

viewed as a sacrosanct space of familial gathering. It may also soon become a relic of the analogue past. Dutch scientist and writer Louise Fresco, whom I mentioned earlier, muses deeply on the topic.

> The table is a place of memory where we . . . become aware of who we are and with whom we are. Around the table, all previous meals come together in every meal, in an endless succession of memories and associations. The table is the place where the family gathers, the symbol of solidarity, or indeed the backdrop to family rows and childhood tragedies . . . Eating around a table means both eating and talking . . . The table is the center of a universe in which we seek our place, revolving like planets around the sun, drawn by the gravity of the regularity of eating and the longing for company . . . The table makes us human.[2]

In a world where the apps on every phone can bring any global dish, often in a matter of minutes, it is still the table that makes us human. The table helps mediate familial authority. Biological impulses compel us to eat, but the table turns the animalistic compulsion into something distinctly human by forcing those gathered to engage in conversation. The modern cyber explorer may find it natural to bring her digital tools with her wherever she goes, but this should be resisted. Bringing a smartphone to a dinner table subverts the social power of the table. Then again, smartphones, to their credit, are higher in the evolutionary order and seem to be doing an excellent job at accelerating the extinction of both dinner tables and the conversations which sitting at a dinner table would inspire.

2 Fresco, L. O. (2015). *Hamburgers in paradise: The stories behind the food we eat.* Princeton: Princeton University Press.

The table I'm seated at is fast becoming a relic of a bygone age. The word my grandparents would have used to describe this curio is *tisch*, a wonderful Yiddish term that not only refers to an actual, physical table, but is also the signifier for the Hasidic gatherings that would convene around the table on the Sabbath, holidays or often just because. The Hasidic *tisch* is the Jerusalemite heir to Dionysian revelry, for even as my forbearers might have rejected Olympus, they did embrace the Greek wisdom that through a combination of wine, revelry and religious ecstasy mortals could achieve a mystical oneness with the divine. At a *tisch*, acolytes of all ages would cram around their rabbinic master's dinner table for an excess of food, drink, songs, words of inspiration and, perhaps most importantly, solidarity.

The *tisch* was not just a safe space, but an energizing one, where intellectual curiosity was celebrated along with camaraderie and music. Even as a child, I loved that these electrifying events were simply named "table," that Yiddish speakers recognized the power that may lay dormant in ordinary totems of domestic life. I still feel the communing energy emanating from my zayde's *tisch*, which can at times unnerve a neurotic like me (although, really, what doesn't). Insecurity and self-loathing are as much my birthright as this table. What gives me the right to sit where my grandfather once sat?

Wanting to soothe this insecurity, my wife found a poignant piece of art to hang opposite the dining table. It is a cue to restore focus and help conduct familial life during moments of doubt. The picture, printed on a metallic surface, is an arresting image of a father and son. The child is represented as a miniature version of the dad, comfortably seated on his generous lap, thus capturing a moment where two generations bond by being deeply engrossed in an open book, with the father appearing to point out and explain certain words of the text as the child looks on. Ostensibly inspired by the words of King Solomon, the artist has printed around the perimeter two versions of a

proverb, an accurate Hebrew representation and a popular English mistranslation.

The English begins with the injunction to teach your child in *the* way he should go. But the Hebrew actually says to teach a youth in *his* way. It's an amazing bit of dissonance. I wonder which of the two messages inspired the artist — to teach children *the* way or *their* way. Is there an objective path to direct all children on, or are there only subjective paths? Whether intentional or a glorious unanticipated accident resulting from playing with foreign language phrases, the dissonance on display in the piece is both striking and comforting. It suggests that despite the fact that I would not have lasted a second in the concentration camps, it may nonetheless be okay for me to sit at his *tisch*. Yes, this table has borne witness to joy and pain beyond my experience, but there is a place for us in this history too. The table itself seems to be relaying a message to those that gather around it: come towards, and not away from, the dissonance.

Rabbi Tzvi Freeman, with over 500,000 subscribers to his daily email blasts, may be the most widely read rabbi in the world. I've had the privilege of ceding the head of my dining room table to him on a few occasions. He's an interesting thinker who wrestles with the dissonance in religion. I asked him for his thoughts on the notion of there being a place for religion in our civic discourse today. Given that he leads such a conversation, he's obviously someone who believes in it. But he's also faced the difficulties of being a public figure talking about religion today.

Tzvi: America is a country with a church for a soul, so you see people living in denial. There is religion, but people don't want to call it religion, because religion is a bad name. So in the religion of America, there are certain things you cannot stand up and say. You cannot go against the American religion, or maybe specific religions within America. Anybody who is committed to belief and has

built a lifestyle according to the beliefs that they have is following a religion. The conversation that should be happening is dampened by the loud debate of everybody trying to prove that they are right, to justify themselves. And as long as we're trying to justify ourselves, it results in apologetics, so we don't know who we really are.

Politics in the era of Trump manifests in deep partisan entrenchment. Journalist Thomas Edsall observes that "hostility to the opposition party and its candidates has now reached a level where loathing motivates voters more than loyalty."[3] Western capitalism has morphed into a religion that encourages greed, self-interest and callousness as innovations are more often than not construed in zero-sum terms instead of mutual wins. London Business School professor Sumantra Ghoshal was just beginning to find a prophetic voice when he suddenly passed. Ghoshal argued that business schools desperately needed to hit the pause button, breathe and reconsider where inertia is driving the field of management education. He reasoned that we in business academia do not need to create new courses so much as we need to stop teaching some old ones.[4] We teach that managers cannot be trusted to do their jobs unless managers' interests and incentives are aligned with those of the shareholders, we preach the need for tight monitoring and control of people to prevent opportunistic behavior, we indoctrinate the idea that companies must compete not only with their competitors but with their suppliers, customers, employees. And then we unleash narcissistic monsters out into

3 Edsall, T. B. (2018, March 1). What motivates voters more than loyalty? Loathing. *The New York Times.* https://www.nytimes.com/2018/03/01/opinion/negative-partisanship-democrats-republicans.html

4 Ghoshal, S. (2005). Bad management theories are destroying good management practice. *Academy of Management Learning and Education,* 4: 75–91.

the global economy, while we await yet another opportunity to pontificate about necessary fixes after one of our creations causes the next great financial scandal.

My own spiritual journey included resigning from a senior position of lay leadership in a large Toronto synagogue after our efforts at suffrage failed. That's right — in this decade, in the progressive digital age, an effort to alter the constitution of a congregation so women might vote on membership matters was rejected. I had to listen to aging beardos pontificate on their fears of a feminist takeover of their safe space should women be given a recognized voice. I had to listen as the supposed spiritual leader of the congregation (the antithesis of a prophet) gave a speech about resisting the urge to undermine tradition, and something about what happens when two large asses wish to cross a narrow path. (I'm as confused as you.) I saw how the religious arena is fast becoming the exclusive space of morons and cowards. I'm just not sure if it necessarily needs to be so. As David Hartman, the rabbi and philosopher who believed in a God that hates lies, explains, "I soon realized that the main religious issue facing Judaism in the modern world was not the authority of *halakha*. The role of the rabbi in America today is not to be an authority figure or a judge. What are missing are not answers but questions! The rabbi has to instill a desire to ask questions, to be bothered by Judaism, to feel that Judaism is important enough to want to ask about it."[5]

In this vein, racism, tribalism, sexism, homophobia, transphobia and classism, amongst other concerns, would need to be challenged, not nurtured. There is dissonance in bringing the teachings of an ancient tradition to the modern age, but it is not a valueless exercise. I have always found inspiration in Hasidic master Rabbi

5 Hartman, D. & Buckholtz, C. (2014). *The God who hates lies: Confronting & rethinking Jewish tradition.* Woodstock: Jewish Lights Publishing.

Menachem Mendel of Rimanov's reading of what transpired during the revelation at Mount Sinai. In his view, the Israelites did not hear God shout out the Ten Commandments — He only pronounced the first letter, the aleph, of the first commandment. The Hebrew aleph is nothing more than an exhalation, and thus what was received was the breath of inspiration. The Jewish moral imagination was stimulated by God, but left to evolve in the minds and surprising actions of the people.

Most rabbis don't push their congregants to ask questions. Throughout this conversation, I wonder if the voice I hear is more Tzvi Freeman the artist than Tzvi Freeman the rabbi.

Tzvi: My wife printed the invitations for our wedding and they said "rabbi," so I had to get the rabbinical ordination, what can I do? And then they give me this position — "Ask the Rabbi." And I said, this is kind of artificial. They ask the questions, and I'm supposed to give them the answers. Is that a Jewish discourse? Because in Jewish discourse, I'm supposed to be asking the questions! In Jewish discourse, you ask a question, I ask you a question back. But if I do that, of course, they'll say, "I asked the rabbi and he asked me a question back — no good! No fair!" But it's so artificial. But how do I deconstruct the whole thing? What am I supposed to do with it? The person ends off with more questions than answers.

When it comes to ideology . . . consider how the internet is so resilient, because it has very few rules. Its coding and basic principles are very minimal — that makes it very resilient. So it's the same thing when it comes to Jewish belief — you can really get it down to a few bare bones. That's the whole concern of Maimonides. How many principles are really essential principles to Judaism? Can we get it down to less?

I would argue that religion has lost its place in the public conversation because those who try to bring religion into it are generally not motivated by wonder, like the artists we have encountered. Instead, they are motivated by power or greed or a desire to control. It's not a wide-eyed explanation of beauty, but it's usually a very judgmental voice of why I'm better than you.

Tzvi: The same thing occurs in the world of science, especially in physics. David Kaiser, in his book *How the Hippies Saved Physics*, discusses how there was a shift in the first half of the century. The small group of physicists all knew each other and would talk and take the train to go see each other, and quantum physics was born from these deep social interactions. They were all philosophers. They were asking, "What does it mean?" And Bohrs had his way. And Einstein had his way, but they were philosophers because they wanted to know what it was all about. And then — what happened? In the 1950s and the 1960s if you started asking questions like this you were told to just shut up and do the math — because "We've explained it all — it works." And if you're a layperson and you ask a physicist to explain it to you to this day, they'll tell you that you don't understand calculus, so they can't explain it to you. And the sense of wonder got lost.

We're stuck in this paradigm today, and that's just how the paradigm works. You want to talk to people with a sense of wonder, you talk to mathematicians. Like Richard Hamming. So much of our computer science comes from Richard Hamming. And he talks about how when he was a student, he would ask his fellow students and his professor, "Why does $1 + 1 = 2$? Why is it that if I have five sheep and seven sheep, I have twelve sheep, and if I have five apples and seven apples, I also have twelve apples? Why is that? These are sheep, and these are apples. Why?

Or if I have one mile and another mile I have two miles, or if I have one cubic litre and another cubic litre I have two cubic litres? The same paradigm applies to all these different things. Why is that?" And he said that almost everyone he asked this question to just gave him a dumb stare, like, "How could it be otherwise?" But that is what makes a great mathematician. Alan Kay said this — that the great minds, especially the great mathematicians, are the people who never grew up. They ask questions that make perfect sense to a seven-year-old. But not to a ten-year-old.

I'm not a mathematician, but I wanted to be a mathematician. In high school, they streamed everybody: "No, you're going into arts." "But I like algebra!" "You are going into arts." That's what they did to people. Musicians are mathematicians. I remember when I was at UBC there was a concert at the music college. And even though we were right next to the architecture building and the physics building, it was the mathematicians who attended the concert. Music and mathematics are very similar. Maybe that has something to do with it.

The point to all this is that the sense of wonder that goes along with asking any questions, that is true intellect. Real thinking is to question all assumptions. To question all assumptions, you are left with asking, "Why?" You know Leibniz said that the only real question is "Why is there anything at all and not just nothing?" And that left him with a sense of wonder because there's something here.

What's truly amazing to me in the theology articulated by Tzvi Freeman is that this sense of wonder extends to God himself. We would often talk about the idea that at the heart of Jewish theology is the belief that God wants us to surprise Him. It's the essence of the Hasidic retelling of the Adam and

Eve story shared in chapter three. God gave rules to his human creations, but Eve broke them in her desire to cocreate a world that privileges love over judgment. In the end, God appreciated the surprise and altered the consequences. There is a famous story in the Talmud capturing a debate over the ritual fitness of an oven. Each sage raises certain rational points to defend their positions, and a majority opinion is formed. Unwilling to cede, a sage in the minority opinion calls out for a voice from heaven to attest that he is right. The voice materializes, but his fellow sages reject the divine intervention on the grounds that legal matters need to remain in jurisdiction of earthly judges. The postscript to the story involves a prophetic inquiry into God's reaction to the rejection: He enjoyed the surprise turn of events, laughing and exclaiming "my children have bested me!" That's a very punk-rock explanation of Judaism, and I think it's a very interesting one.

Tzvi: It's not my idea. I heard it and it hit me hard — I heard it from the rebbe. He was saying to make a calendar based on the cycles of both the sun and the moon. The sun is constant, and the moon is constantly renewing itself. In Hebrew, we call the lunar month *chodesh*, which comes from the root "*chadas*," meaning "new." The rebbe identified these as two fundamental elements within Torah. There's that which is constant, and that which is constantly new. There is "*mesorah*," which means "tradition," and "*chidush*," which means "innovation" or "novelty."

In the Babylonian Talmud it is told that when they had to decide who was going to be the next head of the academy they sent a message to Israel asking which is better: one who stores wheat or one who uproots mountains? And the answer they got back is that everyone needs the one who stores wheat. I would interpret that message as stating that there is a battle between the *chidush* and tradition,

and the answer from the sages in Israel was that tradition is more important.

The rebbe said, "No. That is not the way to understand the answer." Everyone needs to be rooted in a tradition to innovate. You can't uproot mountains and make *chidushim* unless you have tradition. So what is tradition there for? Tradition is there to serve for the sake of *chidush*. You're not going to be able to advance or make progress unless you know the background. It's the same thing in our calendar. The main thing in the Jewish calendar is the moon — it's basically a lunar calendar. But we take into account the sun as well so that, for example, Passover always falls in the spring.

When a kid comes home from school, what do the parents ask her? They ask her what new things she learned that day. The whole point is what's new. So tradition is there for the sake of novelty. You can't come up with something new unless you knew what was there before, and with that power you can create something novel. That was a *chidush* to me.

If you could imagine God having a subconscious, and he's lying on the couch and we're the psychoanalyst, we're bringing out his subconscious desires. I'm putting it in those words . . . it's like a Midrashic kind of thing, but I see it deeper than that. But there are certain things that leave us in a moment of doubt. Like what's in the heart can't tell what it wants to the mouth. So there are certain things that the only way they can come out is if they're pulled out of you. So we do that.

It's like, I had this happen to me, I'm giving a class, and I'm explaining something, and there's a student there who doesn't get it and doesn't get it, keeps on asking questions, and finally said to me, "You mean this, don't you?" Yeah, I mean that. "So why didn't you say

that?" Because I didn't know that's what I meant. And I'm so glad I taught that class because I didn't know what I meant at the time — now I see everything in a whole new light.

Teshuvah — repentance — is also a *chidush*. With the Torah, God presents humanity with a script of how to be good. Everybody should be good. So we've got a nice task to do — we follow the script and we're good. It's kind of boring to God, but it's sort of what He said that He wanted. And then somebody goes and messes up. What is He going to do now? God says, "Well, it's not in the script. So I guess you're going to have to write your own script. You wrote yourself out of the script, write yourself back into the script." The penitent has to do that. And when he does that, God says, "It's amazing! Deep down inside my vision, that's what was really there. And I didn't even know it."

When Cain was coming back from negotiating with God, he meets his father. And his father says, "So, what did He give you?" Cain answers, "I got him down by half! I was supposed to be a wanderer in a foreign land, and now He says I can just be in a foreign land, I don't have to wander!" Adam is perplexed. "How did you get Him down by half?!" Cain explains, "I told Him that my sin is too heavy to bear. I sinned, and that's that. Basically, that's a type of repentance. I admitted that I was the one who did it." Adam's whole world is rocked at this point: "If I had known, we could still be in the Garden of Eden!"

So the idea that you can negotiate with God and do *teshuva* (repentance) and it works great is a *chidush*. Adam was just following the rules: "I don't know how to work in this world. So what am I supposed to say? Okay, so I ate it. You put her here. She's supposed to be the helper who challenges me. And she did!"

Modesty. There's almost a distaste to talk about modesty in the public discourse because it's been so tainted by the religious right and controlling female sexuality. The notion of modesty is truly beautiful — in my research, I wrote about this Jewish notion of modesty as withholding some of yourself to make space for the other, and I related it to greed. Tzvi talks about greed, too, when he discusses finance and Jewish ethics. Greed is when you start claiming so much that other people cannot get what is theirs. Modesty is about giving space to someone else and not trying to control other people — playing the spaces.

Tzvi: What I think is interesting about modesty in Jewish law is that when you're walking down the street and your neighbors have left their windows open, you don't look inside. Because that's their business — it's their space. Even if you say they're not protecting their space, it doesn't matter. It's immodest of you to look inside and see what they are doing. So modesty sounds like something so essential to the human being, which is the discovery that there is someone other than myself. Once you realize that, the role of modesty is a discovery. Wow, there's someone other than me! So many people never get it. So part of it is not intruding on other people's space, and part of it is that I shouldn't leave the windows to my house open.

Our liberal institutions are not as strong as we hoped. I asked Tzvi for his final thought on what we can learn on the topic from religion.

Tzvi: There's a general principle in the Jewish world. It is totally miraculous to me to see how vibrant Jewish life is here in Los Angeles. I wrote about this when I wrote on capitalism and socialism — that the whole paradigm is a top-down

paradigm. All of society is built on governance. But no, society is built on education. Jewish society is built on education. And governance is when there's not enough education, you have to come in and use it to handle things. But really the beginning is a bottom-up dynamic of education. And the classic example of that was the civil war between Benyamin and the other tribes. They said it was the fault of the elders at the time. Because there was immorality. They shouldn't have sat there in their court and judged cases, they should have gone and traveled to the villages and taught children to be moral. So because they relied on governance rather than education, that's why this happened.

The way Judaism works is that it's based on education. Once people have the same education and are speaking the same language and engage in dialogue, we know what we are talking about. We know what the vision is and what it isn't because we're talking about it, so there's a commonality to discuss. When you build everything on governance and the checks and balances for governance, you're still going to mess up if you don't build it on the values being taught in school, on what are we are teaching in preschool. And America is not teaching values in school! They're teaching kids about dinosaurs and blue whales and a big flood and then everything just sort of happened by accident, and now human beings are messing it up by accident. So if it started by accident, and it gets ruined by accident, and everything is by accident, how do we teach responsibility? We have to start with values. There are no values there.

Tzvi's closing comments offer a powerful callback to the sixth path to wisdom — educate for the future. With the right education, and the right motivation, we can break rules and begin to create a

new social order where the powerful plays in the spaces. We can surprises ourselves — and our god — by building the foundations of a more humane future. The real first commandment was the permission to be inspired by the divine and surprise the universe.

CHAPTER 13

Seek Out Elders

When I began mapping out this project, the feedback I got from a millennial colleague was "Great. Some privileged middle-aged professor wants to write about conversations he has with even older, more privileged people." I was taken aback. Privileged or not (and I do recognize the privilege), these explorations of wisdom are timely and necessary. It saddens me that, amongst other weaknesses, ours is a terribly ageist society. Seeking the wisdom of elders, what once might have been a natural societal inclination, even a rite of passage, is in some circles now derided, especially in professional settings.[1]

I reject that line of thinking and encourage everyone, of all ages, to seek out and learn from elders. This turns out to be controversial. Yes, there are innumerable younger artists out there that are making brilliant and inspiring art. My shelves are

[1] Gallucci, N. (2018, May 1). Ageism is becoming a major issue for corporations. *The Globe and Mail.* https://www.theglobeandmail.com/business/careers/leadership/article-ageism-is-becoming-a-major-issue-for-corporations/

stacked with their records and books, and they certainly have an important role to play in our social conversation. But for this project, I was looking for wisdom — and wisdom is the domain of our elders.[2]

I think there is a correlation between glorifying a culture of youth and our technology-obsessed age. In our day-to-day life, we don't look for wisdom but information: How do I use the latest features on my iPhone? What's the best app for finding the hottest restaurant? Which social media platform is the coolest? Sustained reflection is not as valued as the perspective of a techno-toy obsessed teenager, which has somehow become aspirational. When my research assistant turned twenty-five, she lamented that she knew she was now getting old because technology had begun to confuse her.

Throughout this work, we drew on Richard Rorty's definition of wisdom as the ability to sustain a conversation. That definition implies that wisdom must be carried forward. It cannot be created in isolation. There is a social skill involved. To find wisdom, you must enter a dialogue that started with those who came before you. And you must be prepared to listen. Not uncritically, but generously.

Unfortunately, in ageist societies our holders of wisdom are loath to be identified as elders. So we suffer the rantings of the naïve and inexperienced. But if we want to get our social conversation onto the path of wisdom, each of us needs to listen to older folks.

This was a lesson instilled in me by my mentor Rabbi Zalman Schachter-Shalomi, a towering figure who inspired this book but passed away before it came to fruition. Reb Zalman was a

2 Innes, E. (2013, September, 25). Wisdom really does come with age: Older people's knowledge and experience means they make better decisions. *Daily Mail.* http://www.dailymail.co.uk/sciencetech/article-2432221/wisdom-really-does-come-age-older-peoples-knowledge-experience-means-make-better-decisions.html?ito=feeds-newsxml

contemporary trickster, a man of uncontested brilliance who would challenge conventional norms around social expectations and religious boundaries. Ordained as a rabbi, he famously went on to spirit-expanding adventures that were considered taboo in the Hasidic world of his upbringing, including experimenting with LSD alongside Timothy Leary in the 1960s and counseling the fourteenth Dalai Lama in the 1990s on how a religious community can thrive in the diaspora. He advocated for a true melding of old and new thinking.

Reb Zalman would often lament that the contemporary cultural landscape privileged youth above all else. He offered an alternative perspective to the dominant idea that growing old is in opposition to the possibility of continued spiritual growth as, to many, aging signifies decline. He was disturbed that so few people own their advanced age as a badge of pride. Reb Zalman would often explain that the difference between being an elder and an old person is that an elder has gained wisdom.

Elders have distilled their life experience in such a way that their very presence becomes a possible source of inspiration, and they offer a valuable repository of awareness and knowledge that is still present and accessible to younger spiritual seekers. He talked about the idea that elders historically served as an outlet for wisdom testing. And indeed, for me and countless others, Reb Zalman made himself available for wisdom testing, always knowing what exactly the particular pilgrim needed for their unique spiritual journey.

The artists who partnered with me in this project all embrace the wisdom they have acquired through age, experience and hard work. They are all folks who themselves looked to mentors in their youth for guidance and humbly defer to their influences to this day. It is incredibly self-defeating to cut ourselves off from conversation with the people who can help us find the wisdom obscured by waves of information. By keeping a conversation going, you gain access to wisdom and, when

the time comes, you may then act with purpose and confidence. Listening to elders allows both them and you to access a valuable trove of social power.

Dany Lyne, who has spent her own life seeking the wisdom of elders from across the globe, was the person who helped me find hope in overwhelming dissonance, as you will read in the afterword. She also personifies the interconnectedness between listening, organizing in the physical world and exploring the metaphysical. She is an artist, author, teacher, therapist, trauma intuitive and body whisperer. Her writing, art and therapeutic practice are shaped by her continuing exploration of various Indigenous healing techniques, meditation and artistic sensibilities. I can only describe what she does as the most spectacular performance art. She is a punk shaman who intuited the fine details of my trauma and coached me to wellness, tapping into a world that I need to define as her imagination for my worldview to hold. Her work completely erases the line between artist and mystic.

Dany's awakening came over two decades ago. As such, she is a couple decades ahead of the rest of us in confronting a world where nothing makes sense. Her journey out of the dissonance began with claiming numerous horrifying repressed memories of abuse. She was abused first by her grandfather and then even more severely — to the point of sexual slavery — by her father. This level of betrayal is nearly unimaginable. And yet, she not only survived but found the strength to spend her life helping others.

Dany: I was involuntarily installed as the blond and blue-eyed princess in my mother's maligned nouveau-riche castle. My father's money bought everything my desperate mother wished for — including me. He was the dirty old john and my mother was my unscrupulous pimp. I suffered years of my grandfather's abuse and the mindfuck of systemic familial deception. My father too had abused

me sexually, violently raping me when I was nine in the hockey locker room of the arena where I trained, in his office on weekends and, between the ages of thirteen and fifteen, drugging me so he could brutalize me for hours. My mother not only turned a blind eye but took me to our "family doctor" with a stuffed brown envelope under her arm to pay for the illegal abortion that almost killed me.

Dany writes and talks freely about her healing journey from abuse, survival amnesia and dissociation. She believes there is a dangerous risk of further activating the cycle of violence when self-inquiry and self-healing are not embraced. She notes that violence, within and without, is the inexorable outcome of turning a blind eye on our inner truth. Compassionate self-inquiry and self-witnessing transforms "unlove" into love. I asked her to share her journey of awakenings.

Dany: The first one was the time I went to a chiropractor. The look in his eyes — I knew that he knew me more than I knew myself. I went home haunted by that look in his eyes and I thought, "Why is that outside of me? Why is that knowledge outside of me?" And I could see that in that knowledge there was power.

As the things associated with the first awakening happen, the "woo" factor comes in, and there's an eclipse . . . like the whole moon covered the sun that day. It went totally dark for me at three p.m. In that personal eclipse, in that darkness, when the moon was in front of the sun, I saw the pupil of his eyes again. And I thought, "What is that? What is that knowledge that I know he has but I don't have, and I feel like it's mine to have?"

A friend of mine who's an actor comes along at the right moment. The eclipse happens, which shifts the energy enough and makes it not an ordinary day, and

then every friend drops by my house that day. Every close friend. Nobody drops by my house. I'm a designer, I'm fully busy, they don't expect me to be there. They're dropping by the house or calling. So everyone I love — my chosen family — actually showed up that day. Pretty mysterious, don't you think? It's like they all thought, "Something's going on with Dany." And that night, that's when the whole first memory emerged. And the first memory is a really big moment.

That memory was that my mother knew. My mother caught them. So then I wasn't just losing my grandfather and all of that love for this grandfather, and I wasn't just losing my father, but also the whole family structure. It was a really big memory to have — to know that they've known this all along and have kept this from me. And if they know and I don't know, I can't heal.

And why weren't they more open about it? It's when you get into the thing of my mother was abused, my grandmother was abused, and all they know is silence. So I'm being taught to be like them — to stay silent, to stay disempowered and to stay with the lies. Rejecting that gave me strength. I remember my eyes being brighter than they'd ever been.

Then I go to the desert for the Moontribe festival. I'm still a designer. I've had years of reconstructing my truth, and at that point, I've reconstructed my truth of my grandfather and father abusing me. I've really processed that one. I go to the desert, it's a full moon, and I'm in a completely disorienting situation. I'm thrown into the back of a truck with people I don't know, driving, off-roading, through the desert to this crazy party . . . They don't announce the location until midnight of the full moon, and to only a few people, so you have to gather at all these houses. Suddenly it was said that all trucks had to be high

— we couldn't go in a low car, which is why I couldn't go with my friends. We had to all transfer to higher vehicles. And I'm completely disoriented from a lack of sleep, and I'm with people I don't know, and I get to the infamous party, and it's like I'm on the moon, having never been to an event like this. And I don't find my friends.

I'm stumbling through the dark, and I'm trying to find my friends and tell myself it's okay, and I have a whole experience here of disorientation. And then I'm given a mushroom. And I don't do a lot of drugs so I decide I'm going to be really cautious and I'm going to have this thing through many hours. And that's when I had the awakening of "I am not daughter." That is the first one that came. And it was so liberating! Instead of saying for years that I don't have parents, it turned around into "Well, if they're not parents then I'm not daughter." I let go of any sense of responsibility or accountability that is attached to being a daughter. I can make free choices that align with where I'm at, being free from any contracts or obligation that that title infers in our culture and in our family.

Then I get "I am not artist." And that was my whole identity. Daughter was just something I was stuck with. Artist is what I survived with, it's what I hung everything on. So to hear "I am not artist" and the world didn't fall apart — I actually then danced and did yoga and by then the sun was up, and I felt better and better. Like I felt liberated by that thought.

When I came back to Toronto, I announced that I was doing my last show. I came back, I stayed home for a day, I worked for a bit, and then I had a nervous breakdown at work and I couldn't see people's faces — everyone was just three holes and no features. I jumped in the car, drove home, sat in the dark. And it was my partner upstairs who said, "I think Dany's home" — she heard me, but she

thought I came home to pick up something. She came down to see me sitting fully clothed, the snow from my boots melting on the floor, and she said, "What is it?" and I said, "It's my last show." In my bones, I had left — I just left the theater. And I'm going to finish this show, but it's my last show.

I will resist the urge to editorialize here. Dany's story is so powerful, that I want her words to dominate. All I will say is that her insight of "not daughter" changed my world as well. It's a big piece of my thinking on choosing community over institutions. Because family of origin is an institution. Families of choice are community. The notion that we need to submit to institutional pressures around familial obligations regardless of whether or not family members respect their own roles in the relationship is the path to eternal dissonance. When fathers and grandfathers don't behave like fathers and grandfathers but become predators, they are no longer fathers or grandfathers and the victim need no longer be bound by the responsibilities of "daughter."

Dany situates herself within a tradition of reiki, clairvoyant intuition and Indigenous healing. But I call her my "punk shaman," and she's cool with it. I don't know how to rationally assimilate Dany's assertion of "talking to ancestors," but I know that finding hope in these dark and confusing times means wanting all of these mythologies to be true and finding a space for the richness of imaginative diversity. Welcoming Dany into my life meant embracing romantic tendencies, fairy-tale logic, curiosity and laughter during a period in my life where I didn't have much strength for any of it. And it brought me close to wisdom. So I'm going to give her back the mike and encourage you to read her words while embracing the traits we have pushed for throughout this book.

Dany: The grandmother piece comes in as my grandmother is dying, and I have my dead aunt tapping on my shoulder.

I keep turning around and I feel her presence and that's not how I see the world yet, in terms of ancestors and all that. I see someone who sees her, and she says, "Your grandmother's dying and you've been chosen to help her die." So my aunt and I were assigned to be the bridge so my grandmother could pass and not be alone at any point. We formed a bridge between the two worlds. And I spent a week talking to the dead aunt. It was my first time feeling love from the other side.

My grandmother was my "love-mother." I did not have an ounce of fear in my body. I was so focused on helping her die that all the normal thoughts or hesitations didn't come up. I was just an A-type personality on a mission. With that A-type personality, if you have a job to do, you do it well. You get on it. By the time she passed and I came down from that experience and I was in my bedroom with her ashes under my arm, I thought, "Life's going to change." And that is when I drew on the power of my ancestors. I found out that I wasn't daughter, but that didn't mean I was alone. I had a whole family. I had more of a family than I thought, and it's okay that they don't have bodies. In fact, there's a big advantage, because they have a lot more wisdom where they are. Though my little aunt and grandmother were four-foot-something, they ended up being twenty-foot-tall Amazons on my team. That gave me strength.

I want to build on that for a second. The reason this dissonance thesis is controversial is because in the world of psychology, they say that rational people try to reduce dissonance. Dany now spends her life immersed in it. And the theme that runs through her story from her practice as an artist to her practice now is that she is comfortable diving into the confusion. The sense-making only comes later.

Dany: Always, exactly. And I think that comes from knowing how to drop into the body. If you're in the body, and you learn how to be in presence, you're going to feel if it feels good and if it feels right, and that's what you're going to trust. You're going to run like an animal on instinct. You're going down to those levels — not just from fear, but your fur is going to tremble. You're going to get those sensations. And that becomes your guidance system. So what your head says, what other people say, what politicians say, you take that with a grain of salt, and you drop in a level deeper to say, "What's the truth? What am I not being told?"

What I think is even harder, though, is that she really immerses herself in trauma. There's a line in one of her writings about pain and creativity, and not being afraid of that. All I can ask when reading those words is "How?" How does she find the strength?

Dany: Truth is love. Pain is part of the truth. I hold this space from love and compassion. Compassion is the highest vibration. When you go into trauma, and you're just throwing yourself into that adventure — there's something about that. To hold that space, it's like a washing machine. With trust, it's like you're in the spin cycle. To get outside of your comfort zone, it's how you get to meet what's really inside. You let yourself get taken on the ride. With memories of sexual abuse in particular, I see it with clients. People think I see through walls. I don't. If the person has a wall, then it might take two years for me to see the memory behind it.

We have an internal part of us taking care of us — we have an internal healer that has that connection to pre-birth, has that connection to past lives, has a whole karmic understanding. And it is navigating through this whole scene that we call reality. Navigating us in a way

so that ultimately, we reach enlightenment. The force that we're collaborating with is a benevolent force. If we use the language of karma, our job is to keep producing wholesome karma. A lot of the time in past lives and in this life, we haven't done that. We've produced seeds of unwholesome karma. And the life force doesn't have the capacity to take some laser gun to it and blast it to smithereens. The energy is in the world, and it exists now. The seeds are there and they're real. However, they get put into a form of seed bank somewhere. And what happens is that there is a time in this lifetime or in future lifetimes when the conditions are going to be right for the seeds to blossom. So in other words, that unwholesome karma — which could be a car accident, could be an illness, all sorts of things — will come in, but it will come in at a time where you can take that energy and you can transform it into enlightenment.

The timing of everything — that's done with love. It doesn't come when it would fuck you up. It might be hard, but it will come at a time where you actually have the resources to transform this unwholesome karma into love, and plant seeds of wholesome karma moving forward. In other words, to be the victim, you're in the choice position of taking negative karma and transforming it. The perpetrator is in trouble. More trouble than you are. They're planting seeds of unwholesome karma that are going to nip them in the butt at some point.

For years, I could feel this energy. And in my first book, I refer to it as divine justice. Divine justice is actually karma. That was my experience of it. I kept saying that there's divine justice, because it works out. I could feel that my father's dealing with more than what I am. I could feel his inner turmoil and what he has to go through. And of course because I talk to and connect

with people, I see what he's going through. He's dead now. I see what he's going through, and it's not pretty. My mother, I witnessed her whole process. That is a kind of an advantage — I get to have the ability to see — but that's divine justice.

I don't have to carry the notion that something wrong's been done to me. The karmic energy does that for you. So once you're liberated from having to prove that they've done something wrong, then you can just heal and move through what you need to move through to achieve your goal. In that place, you've alchemically transformed pain into love — that's what your job is. Karmic law, which is how they often talk about it, karmic law says that my father is going to go through his thing. It's not forgotten, it's all there, and it's being handled. And it's being handled with love. No one's in prison.

Wisdom is the ability to sustain a conversation. The conversation Dany is trying to sustain I find utterly foreign but fascinating. It's a conversation with tribal, shamanic traditions, which are really at odds with the voices today. I needed to change the way I listen to fully receive her wisdom.

Dany: That's right. That's exactly it. Wisdom is something that the ancestors have. Our ancestors are our elders' elders. And you know what we're doing with elders, because we're in an ageist society. We're setting people up so that they fall apart instead of stepping to their power and their wisdom in time. Regardless of whether they manage it while they're here, once they pass over, there's all sorts of systems over there that they will gain that wisdom. But if we don't talk and listen to them, we're compulsively on a tragic and alarming level cutting ourselves off from the elders' elders. People we have a personal connection

to, who know everything we've been through, including past lives. We cut ourselves from that conversation with people who can help you see. Because to keep the conversation going is to allow yourself to see. And that's compassion too.

And listen! And then act. I act on things. That's what makes the difference too. I don't just hear and see, I actually act. Because that's how I show the universe that I commit — my action is my commitment. The life force and karma react to commitment. Accountability and responsibility are in action. And that's because the action — to use the karmic language again — the action is what's going to produce. You're not going to just dream seeds of wholesome karma — you have to act. And the action is what creates the seed. And then your garden keeps growing. And those seeds of wholesome karma come from wisdom. Wisdom in action.

As this book attests, I have completely lost my faith in arguments. What I like best about Dany Lyne's manifesto is that she did not put out an argument. There's a statement, and then there's her imaginative expressions: videos, stories, narratives that allow the listener or viewer to be persuaded without arguing to get there.

Dany: What I hold in my heart is the love, and what I hold in my art and all that is the humility. I'm in the shit with you. I'm not choosing a position. That's why in my first book I show the wreck that I am. Then I put myself in the seat of a therapist. So I deconstruct this whole notion that I've got my shit together. You can read how fucked-up I've been. There's no power in it.

Dany had a great line: When you lose the plot, you turn to art.

Dany: Exactly. Because then the art creates the window for the wisdom to come in. In my art, I knew how to follow inspiration. I knew how to turn right on a street instead of left and end up in front of something that's the color I'm looking for. I've learned as an artist how to navigate intuition, how to navigate messages and all of that. I think that is why creativity is spirituality.

With my experience of the art bike,[3] the plot very gradually came into focus. The more we rode the streets of downtown Toronto under our glittery eyeball, the more elusive the framework became. Every ride evolved into a ritual of sorts. It demanded endurance, as a ritual would; it was nothing less than an open-hearted celebration, as a ritual would be; and it was definitely an exercise in trust because the current always carried us away from the anticipated. No matter our strategy, our outings defied our goals and demanded nothing less than surrender.

Creativity is to know how to enter into that flow. I mean, I'm on the art bike. I didn't know what I was doing, I don't wear makeup. I found myself in a wig on a bike. I had no idea what I was doing. I put people in makeup. I've never been in makeup. I kept saying, "I don't know what I'm doing." And it cost thousands of dollars, and I knew I had to do it, but I didn't know what it was. And then I found out that when you're white and you're in the street, people look you straight in the eye. I had more real conversations with strangers than I've had with my friends. There's something about the whole white thing and the surreal aspect of it that some people would just let everything out. What I learned is that I was practicing radical presence. I thought I was in my body, but when I was on the art bike — and it was hard, the art bike kept

3 For more about this project, see http://danylyne.com/makingwaves/

breaking down — cycling that thing, it weighed so much, and physically it was really intense. And then the art bike wouldn't go past Kensington Market.

I realized I wasn't supposed to go anywhere but Kensington Market. And that's art. I'm lying there thinking, "Why can't I get past Kensington Market?" I think it's because the project is in Kensington Market. As an artist you start accepting that you're in a synchronicity: you're like a surfer in the ocean, and you're observing the waves. Instead of arguing with the waves, you listen to the waves, and you know they're serving you — they're not hindering you.

As a designer I learned that. For operas, I would conceive of the idea a year and a half before the actual opera. So for a year and a half, I'd navigate my vision through all of the hurdles. And to know when I had to fight for something, and to know when to accept that the reason a particular wood is not available and the carpenter's being a jackass and we're walking into walls is because I need to evolve in my vision. And to go home, drop my ego and say, "What am I being told doesn't work?" Because there's an opportunity to improve it.

We close our conversation with a discussion on experimentation. What most inspires me in Dany's work is the idea of the architect of survival. It's such an empowering concept — to allow for experimentation and to recognize that there are parts of you that you created in the past to respond to certain situations that you were facing at the time. But what happens when you don't need these architects of survival anymore? What happens if you are out of that situation?

Dany: It ties in with me being a set designer. I had seen so many documentaries on architects. And architects — the ones

that make it — their level of dedication and their passion for their vision — even once they have the fame and the recognition to get the contract — architects run into the mechanisms of politics. I see them as a quite militant. They embody that because they work with the machine. I had a small glimpse of that in theater.

In my own healing, everyone was concerned about the victim. And I kept saying that there's somebody else here, and she kicks ass. And she's the artist, and she's the fuck-you teenager that just wouldn't put up with anything. I kept saying that I know I was addicted to drugs, but that chick was really brave. And even for me, what was deconstructing was my notion of shame, and how much shame is attached to how we survive. Because survival is messy. So how you survive is not something that is up for discussion — in terms of looking at it with judgment or shame. It's like going past that and saying that despite all the odds you are doing what you can with the resources you had.

That's what started to click for me. And then I realized that was my knight in shining armor. And there were many of them. And in sessions, I started meeting them. The sessions evolve like I evolve. I'm like a live wire. Clients are going on the ride of wherever the energies are moving through me. The architects started meeting. And that's where I found that if you can love those architects of survival and recognize how beautiful they are, even if it's heroin, prostitution — you name it, I've seen it. People who are addicted to heroin, I mean, just think about the pain that they have experienced that it takes that kind of drug and resource to numb their pain. And even suicide. That was the clincher. I had clients that were suicidal, and I knew they didn't want to die, but they wanted the pain to end. So that means that even being suicidal is an architect

of survival. And I met people on the other side who have committed suicide, and they're still trying to survive. They didn't want to die. And nothing ends. It doesn't work, anyway. The pain doesn't go away, unfortunately. So even if you cross the barrier, it doesn't mean that everything's gone. Sometimes it does, but a lot of the time it doesn't.

So I think in the architects of survival I found the parts of the human being that were in the doghouse. And meanwhile they're the knights in shining armor. The key is to honor their truth. When we compassionately recognize the agony engulfing us when we created them, the service they performed at the time and since, and witness their limitations without judgment, we unleash a powerful transformative energy. And they need to be celebrated and loved to bits. In other literature, you may have heard of these characters referred to as "coping" or "survival" mechanisms — but that description, in my opinion, belies how incredibly brilliant, beautiful and lovable they really are. For years, I collided with thorny and addicted architects of survival, my own and that of clients, without recognizing their determination, resourcefulness and creativity. Transformation on that level was a slow and arduous process yielding precarious harmony at best. When I acknowledged power and beauty or our architects of survival, unprompted love and compassion flowed and so did they.

I always felt that the institutions, and the energy that drives the corporations and drives that kind of recklessness or selfishness, were not the organizing principle of the world. And that comes from being in the body as well. If you're in your body, you damn well know that love feels good. And if you can access it — if, despite all my abuse, if I can tune in to love — then that can apply globally. Individually, we need to all find the love. Find our energy through creativity

and all those forms of activism and action — whatever form it takes in terms of your own life purpose and all of that. What we're doing is that we're finding our way to the love. And to me, all it takes for all wars to end, is for one person at a time to come to the point of accountability and presence and awareness, cultivate their body as a vessel for the vibration of love. And if we're all vessels for the energies of love, it will translate.

Dany Lyne connects to a wisdom tradition that exists outside of the rational norms of Western culture. Many of us might be unsettled by some of the statements she presents as facts, offering a great opportunity for self-reflection. Trying out fairy-tale logic allowed me to invite Dany into my life, and her wisdom changed me radically. As she notes, wisdom is something that the ancestors have, and so the path to wisdom involves seeking elders and those with connections to our ancestors. We need to engage with compassion and curiosity, and reject the ageist instinct to cut ourselves off from conversations with folks who can help us see life through a different lens.

CHAPTER 14

Re-create Yourself

The penultimate prescription of the book is this: we need to actively re-create ourselves. With the added caveat — before powerful institutions re-create us. The digital tools that we use to enhance our lives are changing us in profound ways. Technology critic Franklin Foer warns, "The tech companies are destroying something precious, which is the possibility of contemplation . . . Through their accumulation of data, they have constructed portraits of our minds, which they use to invisibly guide mass behavior (and increasingly individual behavior) to further their financial interests."[1]

Science historian Michael Bess worries that "we don't have enough time to adjust. What is all this doing to our habits, to our cultural sense of who we are? When these things happened slower in previous eras, we had more time to assess the impacts and adjust. That is simply not true anymore."[2] Since the early

1 Foer, F. (2017). *World without mind*. New York: Penguin.

2 Illing, S. (2018, February 23). Technology isn't just changing society — it's changing what it means to be human. A conversation with historian of science Michael Bess. *Vox*. https://www.vox.com/technology/2018/2/23/16992816/facebook-twitter-tech-artificial-intelligence-crispr

2000s, media theorist Douglas Rushkoff was offering similar warnings, and offering a path for resistance. His "commandments" include the need for us to stay on human time, even as we become more attached to the streams of information constantly being updated to our phones; to live in person, privileging physical interactions even as the tech monopolies try to force us into digital space; and to remember that we can always choose "none of the above" to the algorithms of Facebook and Amazon.[3]

I want to take this in a slightly different direction. What defines a community? Business philosopher R. Edward Freeman talks about community of place, community of interest, community as virtual advocacy group and community of practice. We may affiliate with communities based on our physical proximity even if there is minimal interaction between us and our neighbors. Or we may identify with a community based on regular interactions that may not be rooted in a physical place. Or we may privilege a community based on our shared beliefs or values.[4] Whatever the preference, there are many ways for us to define ourselves that will create the opportunity for us to strengthen and empower the communities we belong to.

One of the unique characteristics of living things is our ability to see patterns. But what might be a strength in some contexts is a weakness in others. We give too much weight to memorable events. We tend towards confirmation bias, privileging evidence that supports our existing worldview and ignoring evidence that disproves it. We rely on analogies from our experiences that are significantly less than appropriate. We need to be aware of this and work towards continuous self-creation. We need to try to see

3 Rushkoff, D. (2010). *Program or be programmed: Ten commands for a digital age.* New York: OR Books.

4 Dunham, L., Freeman, R.E., & Liedtka, J., 2006. Enhancing stakeholder practice: A particularized exploration of community. *Business Ethics Quarterly*, 16(1), 23–42.

situations through a different light. We need to try to test alternative hypotheses to explain facts we have accepted. We need to try to formulate alternative explanations for the evidence we are faced with. Maybe it's more of the same, but maybe this is our chance to break out of a pattern and change.

As we talk of re-creating ourselves, we must be mindful of what Dany terms our architects of survival — the parts that were created in response to certain traumatic situations. So long as there is recurrence of the same, those tools of survival are necessary. But when we forge a new path forward, when we re-create ourselves, we need to discard them with tribute and honor.

For us to reach our full potential we need to re-create ourselves in a manner that frees us, as much as possible, from the tyranny of institutional power. We need to develop all aspects of our selves and re-create our identities away from victimhood. Sociologists Bradley Campbell and Jason Manning talk about three distinct moral cultures: dignity cultures, where there is a low sensitivity to slight because all people are understood to have inalienable worth; honor cultures, where there is a much greater sensitivity to slight because worth is tied to status and the assessment of others; and victimhood cultures, which combine high sensitivity to slight and dependence on others, thus finding moral worth in victimhood and moral suspicion in privilege.[5]

We can escape our culture of victimhood and head down a path of wisdom by embracing the virtue of self-creation. We need to claim the freedom to explore our full potential and reject the oppressive strictures of dependence and hierarchy, choosing instead communities of identity and interest. Artist and icon

5 Lehmann, C. (2018, May 17). Understanding victimhood culture: An interview with Bradley Campbell and Jason Manning. *Quillette*. https://quillette.com/2018/05/17/understanding-victimhood-culture-interview-bradley-campbell-jason-manning/

Lydia Lunch can lead us in this direction. Her call for a plea-
sure rebellion is a manifesto of creativity and communication,
about growing communities through self-understanding and
re-creation. The goal of the pleasure rebellion is to strengthen
the social fabric and not passively accept the current balance of
institutional powers.

I started this book with a conversation with Lee Ranaldo on
how to rethink listening. I characterized the artist as prophet —
imaginative, romantic, committed and uncompromising — and
sketched out a path that may be a model for solving the crisis that
ails our contemporary society. The path has a well-defined begin-
ning — the psychological discomfort many are feeling due to the
lack of harmony between the principles we want to live by and
the socio-political reality we are confronted with. Furthermore,
the path has a well-defined end — a social order that strives for
wisdom through inclusive, expansive and empowering soci-
ety-wide conversation.

The last interview in this book is with another no wave
prophet, Lydia Lunch. Lydia is an artist who has used her art
and her identity to become a modern-day prophetess. The first
woman in the Hebrew Bible explicitly identified as a prophet-
ess was Miriam, sister to Moses and Aaron. The ancient biblical
text paints a very vivid and moving picture of Miriam's prophetic
moment: standing with her people at the foot of the Red Sea as
the waves that were briefly walls crash back together after part-
ing, Miriam grabs a tambourine and leads an ecstatic chorus of
women in raucous song. Though her name means "bitterness,"
Miriam draws the women to an erotic dance that awakens the
dazed Israelite nation, still stunned at having crossed the sea in
safety, and brings the Divine energy of life into her circle.

The second identified prophetess was the warrior and judge
Deborah, whom the text describes as a dual persona. In times of
peace, Deborah would serenely hold court under a bucolic palm
tree in the hill country of Ephraim. People would travel from

across the country to have Deborah settle their disputes. However, when under siege, Deborah left the serene hilltop on which she sat in judgment to actively lead an army in defense of her people.

Lydia Lunch channels all of these traits into a singularly unique persona: part poet and musician, part warrior and judge, using her distinctly feminine prophetic instincts to rail against the horror of war and pain of trauma and offer a hopeful message of why societal change must start with an inner confrontation with the psyche.

In the first chapter, I quoted Lydia's assessment of the music of Sonic Youth as "the aural equivalent of an interplanetary detonation," a very apt description of the art, but as the "aural" qualifier denotes, not the artists. Part of Sonic Youth's beauty was that they were regular NYC folks, considerably cooler than the rest of us, to be sure, but clearly rejecting the call to put their individual personalities before the collective. In contrast, Lydia's public persona, as much as her art, could also be described as an interplanetary detonation. On stage, record and film, she is a powerful, confrontational, larger-than-life energetic force. However, the character crafted for public consumption is really only a small part of the complex figure behind the art and wisdom. Lydia Lunch is very kind, generous and humble. There is much for us to learn from her, even for those whose artistic preferences may be more mainstream. But as a confrontationist, she won't make taking the lessons easy.

Lydia: What made you come to me originally as, I'd imagine, a teenage boy?

From the outset, Lydia took control of our conversation. There would be no mutually awkward exchange of mundane pleasantries — the awkwardness would be mine alone. She asserted her dominance, owning the exchange and planting herself solidly in my head before I had a chance to probe hers. Her

words triggered a flashback to my initial teenaged encounter with Lydia as artist. First, hearing her voice alongside Kim Gordon's on Sonic Youth's "Death Valley '69" and wondering who she was. Then, seeing her image, encountering her goth pin-up girl figure in Richard Kern's film and photography. Finally, finding her spoken word efforts and music after an extensive hunt through local independent record shops. It was the pre-internet era, so discovering the work of a fiercely independent NYC underground artist was often arduous but rewarding, as I was slowly able to discover varying pieces of Lydia's wide-ranging artistic output. But both the teenage boy and the middle-aged professor came to Lydia Lunch for the same reason — to get a window into a different kind of mind and draw inspiration from someone living a very different kind of life. I found it very easy to open up to her, sharing the details of the intellectual crisis that led to these wisdom tests. Lydia morphed into her counselor role:

Lydia: You chose two very extreme positions to go into! Rarely do we see an ad of "musicians wanted" in the kind we might be, and professors, even less so. Never saw an ad that said "genius wanted." Let's just face it — we're fucked.

I liked that she used the word genius to describe herself. On the day I sat down to turn our conversation into this chapter, the buzz of the moment came from an article revealing that the word "genius" had been blacklisted at Cambridge University.[6] Lucy Delap, who teaches British history at the school, tried to justify this backwards reaction by explaining that "genius" is historically associated with traditionally male qualities. As such, there is the

6 Pells, R. (2017, June 13). Cambridge University examiners told it is sexist to use the word 'genius' to describe students. *The Independent.* http://www.independent.co.uk/news/education/education-news/cambridge-university-sexism-row-genius-lecturers-students-a7787401.html

concern that the word genius may prove to be a trigger that alienates female students and should therefore be avoided.

Unsurprisingly, I am quite troubled by this type of oversensitivity and the knee-jerk reaction of some to censor instead of reframe. If there was ever a want ad posted for "genius," I could easily imagine an impatient Lydia — ignoring the fragile, triggered women of Cambridge — shoving and elbowing her way to the front of a lineup of self-absorbed men, who themselves cower when confronted by her strength, as she claims the job without serious challenge.

That, of course, would be the appropriate cultural response if indeed there existed a society-wide perception that "genius" referred to uniquely masculine traits. The instinct towards censorship is, to my mind, a fatal weakness in any viable intellectual movement. I asked Lydia about the liberal tendency to right historical wrongs against women through censorship, and she answers toughly, steering the conversation to an analysis of the type of figure that is to blame for female oppression and her diagnosis of the appropriate educational responses.

Lydia: Certain feminists, like Mary Daly, hated religion so much. She studied theology and then went back to the origins of words, which was very important work. My criticism is about the wave of feminism which became anti-sex, anti-pornography, not really understanding what pornography is. Most pornography is horrendous, we know this — but I don't even want to go into a discussion about pornography other than that I think it serves a purpose, and it can be done correctly, even though it hasn't always been done right. But to want to censor sex . . .

I've never been anti-male; I've always been anti-men-in-positions-of-power. That's a really big difference. I feel like most men have been bullied — any man that's been intelligent, sensitive, weird, queer, an outsider — they

have such an incredible burden to bear from the pressure
to conform to the traditional macho stereotypical bullshit
. . . These types of men have always been very strong
fans of mine. They realize that I'm not picking on them,
I'm picking on the assholes that ruin and rape everything.
I'm not picking on the male species, I'm picking on men
in positions of power. It's a very specific subgenre of men
that I'm going after. I really feel like I'm a humanist. I feel
like I am speaking for the human condition. Anybody that
is intelligent, non-commercial, non-mainstream, literate,
musical, weird or deviant is included in my coven. It's not
just women I'm specifically speaking for.

Lydia offers a lot to unpack here. When feelings of dissonance
are mediated by art, the unbalancing perceptions could be inte-
grated into a comforting sense of inclusivity. At least some of the
dissonance in the current political arena is borne of the fact that
the elected American head of state aspires for the worst aspects
of stereotypical masculinity: an anti-intellectual bully, indiffer-
ent to the poor or vulnerable, who celebrates rape culture and
the indiscriminate acquisition of personal wealth. Intelligent,
sensitive, weird or queer men — to say nothing of women —
are outsiders in this environment. But we need not be alone; by
experiencing her art, we can join Lydia's "coven." She becomes
our voice and thus creates a community where an alternate con-
versation takes place, where we can begin to think about how to
re-create ourselves.

Unfortunately, in many ways today's intellectual climate is as
vacuous as its political climate. For just as boors have risen to the
top of the political elite, fragile lightweights dominate the intel-
lectual elite. Contemporary "safe spaces" need to be completely
sanitized. Universities are afraid of exposing the next generation
of leaders to any sort of emotional trigger in deference to the
victimhood culture described earlier in this chapter. Lydia foresaw

the folly in this approach decades ago. She realized that for individuals to reach their full potential, for folks to re-create themselves authentically, they would first need to free themselves from the tyranny of their upbringing or childhood trauma. They would need to be taught to access the full spectrum of potential human emotions. And so she put herself out there as a model, exposing all of her psychic pain, in the hopes of empowering others.

Lydia: The predator didn't wake up one day and decide to become a predator — they were taught to be predators. And this is what we have to understand about "the family war" — how is a predator or a serial killer or a rapist created? I've examined that in my work. Sexual segregation as children is one of the big problems with humanity. Boys: act tough, don't cry and do not show your emotion. Girls: smile, act nice, be pretty and do not be aggressive. This is a problem. All of us need to embrace all of our emotions.

Second thing: Young children need to be taught from a very early age to deflect and defend against invasion of their personal being. I saw something very interesting recently about a woman who had to go to the emergency room and she told her children to wait outside with a specific instruction: Not about don't talk to strangers — everyone's a stranger — but don't talk to tricky people . . . Children as young as five need to have screech alarms, they need to be taught that nobody touches you if you don't want them to, and they need to be made aware of their own value. And that would change a lot of things right off the bat. Screaming, "No, fuck you" would change a lot of things.

Lydia can still achieve through her art something that present-day arguments simply cannot. Richard Rorty, being something of a prophet himself (as the book nears its end, you've

probably noticed that he is mentioned in every chapter — I'm a little obsessed) described how liberal arguments could actually set the social conversation off course and predicted the Trump era two decades before it materialized:

> At that point, something will crack. The nonsuburban electorate will decide that the system has failed and start looking around for a strongman to vote for — someone willing to assure them that, once he is elected, the smug bureaucrats, tricky lawyers, overpaid bond salesmen, and postmodernist professors will no longer be calling the shots . . . One thing that is very likely to happen is that the gains made in the past forty years by Black and brown Americans, and by homosexuals, will be wiped out. Jocular contempt for women will come back into fashion . . . All the resentment which badly educated Americans feel about having their manners dictated to them by college graduates will find an outlet.[7]

Rorty recognized that liberalizing arguments will fail. Poorly educated Americans will resent having their manners dictated to them by professors. The social conversation will come to a standstill, as the masses offer a big "Fuck You!" to the establishment. But what might happen when these same folks encounter an artist screaming "No! Fuck you!" right back at them? What happens when timid girls and macho boys watch Lydia as she thrusts herself into the ongoing conversation? In these times, we need a prophetess whose words are not governed by social convention, who is not part of the political class. In Lydia's art, we see girls that are tough and boys that cry. As such, in this era especially, her type of art is well-positioned to offer greater inclusivity and to resist the pushback on progress.

7 Rorty, R. (1998). *Achieving our country*. Boston: Harvard.

What inspired Lydia to devote her life to reaching out to the outsiders, to help them confidently re-create themselves in a manner that was right for them despite social pressures to conform?

Lydia: Literature inspired me. I've said this over and over again, but I was first inspired by the writings of Hubert Selby, Henry Miller, Jean Genet, Michel Foucault, Jean-Paul Sartre — all either philosophers or life-stylists. Although I was not that interested in the Beats, or at least their writing, I was interested in the way they lived — to tell their reality according to how they saw it. I've basically always used music just as the machine gun to fire the bullets that are my words.

What first inspired me, even before literature, was where I grew up. Twice, my house was the epicenter of the race riots — in 1964 when I was five and in 1967 when I was eight — which happened all across the Rust Belt of America. Even though I might not have been that aware of what was going on — coupled with the music of that period, the music in the late '60s was very rebellious and very political — I think it really set me on a path. By the time I was nine I knew I had to write, so I started writing, and at the age of twelve, I started reading the books and listening to the music that would influence me and set me on my path. I have always felt outside of everything, even though I've been connected to or instigated many different collectives.

I have always felt, even from a very early age, like a woman on a mountaintop with a shotgun and a bullhorn. Perhaps a dog — I don't even like dogs — but just in case. I have always felt like my job was to be the town crier. I felt called to protest the arrogant, belligerent, homicidal patriarchy which started, of course, in the nuclear family — which is just a microcosm of the larger picture and

then expanded on. I think that my generation specifically became truth-seeking and nihilistic in a sense, because we just felt that the situation is as it is. It may get worse and it may get better, but the lie is always the same. It is always, and always has been, the same as it ever was. It is always a feudal patriarchy. It is always the king rules. It is always against the individual. It is always against nature and a female planet. With that information in hand, there was nothing that I could be other than myself.

Those last five lines are critical to understanding Lydia's philosophy and why her art is so necessary in the current political climate and needs to be considered seriously. Lydia's experiences have allowed her to gather critical data on the world outside her psyche. She has lived broadly enough to come to a particular conclusion: it is what it is. And while that line of thinking might be cliché in the hands of a lesser artist, she identifies a consequence that is anything but. Her realizing that the world is what it is, that there are certain institutional truths that, painful as they may be, are unlikely to change, does not necessarily lead to individual despair and withdrawal. On the contrary — this identification of this truth forms the rationale for a liberating call to action. In the face of immovable power structures, the alternative to complete submission of the individual self is to embrace the opportunity for unreserved self-creation. This means that you could be a boy who cries or a girl who screams "Fuck you!" because you might as well become what your thoughts and emotions tell you to be.

It's a fascinating response to dissonance. The world outside your mind is what it is, whether you like it or not. And yes, as a consequence, navigating this dissonant world will be a difficult task. Instinctively, we seek harmony between our internal sense of what should be and the external world. But when "what is" turns out to be a repressive regime that is against the individual,

when the "is" of your observations and the "ought" of your imagination can no longer comfortably coalesce, then the revolution starts within the psyche — a decidedly spiritual path of looking within to connect with the universal. In this spiritual perspective, there is nothing to be other than yourself.

With this type of thinking, Lydia explicitly situates herself within a contemporary philosophical movement. While classical philosophical approaches to social morality often sought to guide individual behavior through the introduction of widely adopted universal rules and principles, the more modern philosophical schools of deconstruction, postmodernism and pragmatism moved ethics away from the realm of universal rules and into a focus on the more interesting questions of context and specificity in the individual decision-making process. The shared origin of these diverse philosophical movements, linked by their rejection of normative theory, can be traced back to the influential work of Friedrich Nietzsche.

Nietzsche left behind a complicated and controversial intellectual legacy. He questioned privileging Apollonian order (what we might call rationality) over Dionysian chaos (creativity) and the value in seeking a universal ethics.[8] According to Nietzsche, individuals need to develop all aspects of their selves. Therefore, from his perspective, the only sensible way to ground a theory of ethics is in the individual decision-maker and the celebration of the self. Lydia's work is very much an outgrowth of this type of thinking. In fact, she has often talked about the idea that the no wave scene from involved artists dealing with personal insanity, while punks dealt with social insanity.

Lydia: Punk rock really came out of the U.K. situation, which was a tragic time and punks were more like, "We're all in this

8 Nietzsche, F. (1967). *The birth of tragedy and the case of Wagner* (W. Kaufman, Trans.). New York: Vintage.

together, this social situation sucks." No wave started in New York City. People migrated to what was the asshole of the country at that point — New York was bankrupt, really criminal, dangerous, filthy, but like moths to that eternal flame, people came because it was so cheap to come here. So no wave ends up focusing much more on personal dissatisfaction than social insanity.

I thought originally after I was influenced by literature and music that I would go to New York and become a spoken word artist. But spoken word didn't really exist at that point because it was post-Beats, post–Patti Smith, pre–poetry slams. But around the same time, myself, Exene Cervenka, Jello Biafra, Henry Rollins, we all started doing spoken word shows as well as music. I started curating a lot of shows and still do spoken word, because I just think it's the most direct and intimate form of communication. It's necessary.

My first spoken-word piece was called "Daddy Dearest," but I went from my father as the target of antagonism, to the father of our country, and then God —the fucker. Quite quickly, under the Reagan era of terror, I became more socially and politically aware as an artist. It began with my personal dissatisfaction, *Teenage Jesus and the Jerks* [her first group album, 1979] or even *Queen of Siam* [her first solo album, 1980] are basically teenage youths throwing temper tantrums for reasons beyond a young child's comprehension . . . And again, the father — whether it be the father of our country or God the father — remains my eternal target to this day because these "fathers" never go away! When we as white Americans think of God, we think of a guy who looks like Santa Claus without the red suit who is the most supreme sadist of all. He had his son nailed to a cross, one of the most sexual icons ever in the Western imagination, and then justifies every torture known to man

as defensible for misbehavior! That has always, and still remains, a target of my verbal attack.

While her language may shock some, Lydia's art is an important imaginative extension of Nietzsche's arguments. Through her confessional "temper tantrums," she intimately demonstrates how individuals subjected to trauma and oppression can re-create their identities away from victimhood. I believe that Lydia's target — the perpetual father — is also a critique of the hierarchical structures that those who wield power in our society willfully created to compensate for their personal weakness and laziness. Because even the powerful are ultimately human beings with flawed decision-making processes, incomplete information about the consequences of their choices, a limited understanding of the alternatives to their choices and the recognition that gaining better information is a time-consuming and costly process. So they create hierarchies that can corral the rest of us down a relatively socially efficient path.

This, in a nutshell, is why the West has seen the sudden and rapid growth in both the power and reach of corporate entities. Why do we have so many companies, hierarchical organizational mechanisms for our business transactions, when we already have free and open markets that can support more equitable and democratic exchanges? Why not have a series of contracts tendered to an open market instead of performing these activities in-house under the hierarchical umbrella of a firm? What has happened to lead to the dominance of corporations? Economist Oliver Williamson believes that the answer has to do with efficiency. Markets are inefficient because people are greedy, selfish and untrustworthy. Corporate hierarchies use power to efficiently control the people they interact with.[9] While there may be

9 Williamson, O. E. (1991). Strategizing, economizing, and economic organization. *Strategic Management Journal*, 12: 75-94.

very few people that naturally prefer an authoritarian hierarchical structure over a more egalitarian model of flat organizing based on cooperation for their daily economic activities, it has come to be viewed as the solution to the problem of exchange among self-interested individuals. In contrast, Nietzsche had little regard for hierarchies as a solution to the problem of efficiency maximization. He believed that societal progression came from individuals given the freedom to explore their intellectual potential and reject the oppressive strictures of hierarchy/patriarchy.

Furthermore, by identifying the father as her eternal target because "they never go away," Lydia links to what Nietzsche called the "eternal recurrence of the same."[10] Recurrence was central to Nietzsche's philosophy and is equally central to the conversation Lydia has led for decades as an artist. As she said earlier, "the lie is always the same. It is always, and always has been, the same as it ever was." Nietzsche believed that anybody who is able to affirm life, to engage in becoming and willing a future, in the light of the supposition of the eternal recurrence of the same, would be able to overcome and conquer anything.

Anyone able to adopt this frame of mind and move on will have what it takes to endure and flourish in the aftermath of all disillusionment. If we can accept the possibility of the eternal recurrence of the same as a political paradigm, nothing in this world will bring us down. If we are frustrated at the prospect of the eternal recurrence, then we have not succeeded in the necessary self-mastery. But if we can affirm life knowing that we will be facing the same challenges over and over again — relabeling old ways of thinking, changing values and attitudes, but ultimately facing the same substantive problems — then we have achieved the necessary state of mind to thrive.

What I have always loved about Lydia's spoken word is that

10 Nietzsche, F. (2010). *The gay science: With a prelude in rhymes and an appendix of songs* (W. Kaufmann, Trans.). New York: Vintage.

it takes this project to a Dionysian/chaotic extreme. Her spoken pieces tend to be more art than arguments, even though they are word-based.

Lydia: When I started doing spoken word, there was very little precedent for it. From the people I mentioned before, I was still the most aggressive one. There was very little precedent for aggressive passion in articulate females . . . I have to do what I do. There's no alternative. It boils in my blood. I'm not a solutionist. I'm not a politician. I'm not saying I have a solution — but I see very clearly and historically what the problem basically is. The problem is that war is a virus that infects mainly men, which travels around the globe in a different form of contagion forever, based upon usually one of three things: God, land or elements. Greed, basically. And I don't see it stopping. Even though men born of a different generation than our fathers and grandfathers are far more intelligent, diverse and aware, men in positions of power are still going to be in positions of power only because they abide by the kleptocratic rule, which allows them to become homicidal slumlords . . . If the best person for the job was in a position of power, the world would be very different, the world over. But they are not. And so we suffer.

I think it was very difficult for a lot of people when I first began doing really heavy and violent political spoken-word pieces because people don't have war in their backyards. I had riots in my backyard and in my front yard, which are not exactly wars, but to a five- and eight-year-old psyche, they are wars. And the people warring . . . the people rebelling . . . had every right to do so because of the unfair situation which we don't need to illustrate any further. The thing about America and why I left it for almost ten years under the second reign of Bush Jr. was that I knew it was

turning into a fascist state. I went to a country that was thirty years out of fascism.

But even when I was that far away, I couldn't help but feel on certain days that I am the liver of America. Why, all this time later, is it me that continuously has to bang the war drum? I can't stop doing it. Even my group Big Sexy Noise, which is basically the party band when the apocalypse hits, has songs about soldiers. And I feel that, especially as a woman, it's important to carry on doing exactly what I do. I'm not saying that what I speak is the ultimate truth . . . there's a lot of poetry in the work that people just don't see because they're so horrified by the aggression. Or they're so unused to it . . . although they're more used to it now after thirty-five years of pounding my mouth on the gutter . . . But it's not going to stop. And it can't stop. And until they decide — not if, but when — to drop a drone on my head, I shall carry on. Because someone — at least you! — is listening. And if you are the only one listening, it's reason for me to carry on . . . I always saw myself as a woman alone at the top of a hill with a bullhorn, and a shotgun, and a dog. And if there was one person down the valley that was listening, it validates what I do. And I know there's more than one person.

Nietzsche called his approach to theory building "philosophy with a hammer," situating himself as an heir to the first Hebrew prophet. He believed that the only way for humanity to progress, the only way enlightened people can happen upon new and better ways of living their lives, is through performing the Abrahamic task of smashing the idols of their ancestors. He noted that whoever seeks to be a creator always annihilates. Lydia, heir to Miriam and Deborah, continues the work through music and performance.

But what of the need to bring more people to the party? Can it be found in Lydia's efforts to re-create herself, and inspire us to do the same? If I had Lydia's voice, I would loudly answer yes. For underneath the abrasive language and the confrontational persona, there is an ethical core to Lydia's art that in many ways sets a high personal ethical standard. Lydia's central theme is that greedy, small-minded men have an unyielding impulse to enhance their power through war. And so in her artistic persona, she offers an alternative quest for power that is not the celebration of a simple-minded, selfish or greedy egoist. Instead, she celebrates the pleasure rebellion, a drive that allows exceptional individuals to separate themselves from oppressive social institutions and accomplish great things. In a great soul, the satisfaction of the self is to the benefit of a social good. And so Lydia advocates for the pleasure rebellion.

Lydia: I feel that there is so much fear and loathing to be had in everyday life, so I had to reduce and go back to finding pleasure in the simplest things. And insisting upon pleasure to counteract the time I spend consumed with the problems of the planet. I insist on pleasure, I insist on bringing other people pleasure. I insist on having a good time. Because pleasure is one of the first things that they try to steal from us by telling us that we're too weird, we're not beautiful enough, we're queer, we're outside of this — with all of this weirdness, I can't hear most of the motherfuckers. You can't even define me by a gender, I know how good I look baby. But my job is to relieve other people's panic and pain and from that, teach them how to enjoy themselves because that's the only way we win in the end.

To quote Kafka, there is infinite hope, but not for us. I just think the problem is so corporate and so . . . so police-ticized, so us vs. them, so anybody that isn't the rich elite, all we can do is bond together in our small

covens and lead a life with as much pleasure and friends and conversation, good books, good music as possible. I don't know if we can change the situation. I'm not sure I have the solution to the larger subject. I think if individuals come together in individual packs to try to find their community and it's not a utopia, but to create, to live, to communicate, that that's the best any of us can hope for. I just don't have such humongous dreams of my potential, but I know I can affect the individual, and I'm very happy for that. Because the individual is who matters. I'm not a solutionist. To me, the solution is to overthrow it all, get rid of it all, the bombs always drop in the wrong place, fear of a female planet, no doubt, so we have to just look to ourselves and to the community we create to not make every day such a struggle or such a challenge.

I would like to hope for something greater, but I'm too realistic. I can't solve three-quarters of the world's problems that are living in abject poverty due to the fact that the kleptocrats are stealing everything from them. I've got no fucking solution for that. But what I can do is reach out to weirdos, to outsiders, to people that feel alienated like they don't belong anywhere, that they have been traumatized, that they are in fear or panic, and say, a) you're not alone, b) it's not the worst and c) you can get over it. And however you find a method to do that. Sex and drugs and rock and roll — it's all good for a certain amount of time and there comes a point where actually getting back to your naked or real self before all of this shit fell upon your head is the most important thing. It's really about detoxing from everything. And then deciding what you're going to want to bring back into your life. I'm not against any type of sex, drugs or rock and roll. I love them and still do all of them, but they don't run me, I run them. I think the main point for the individual — because

I'm an individualist — is to get back to yourself, not be controlled, not fear your obsessions. There is no taboo, try to find people that consensually want to further any pleasure you can find, from creativity, communication — and that's what we do. And that's why we're talking now.

Lydia's ability to articulate this manifesto of a pleasure rebellion is especially surprising given the deep trauma she encountered throughout her life. Trauma theory suggests that sufferers experience a crisis of language, and that never seemed to be evident in Lydia's work. She was always so able to find the words.

Lydia: I'm cognizant of how rare that is . . . I guess that I never felt that my pain was so special. I always knew that trauma was a universal language. It was never narcissistic, the way I decided to talk about familial abuse and then further on into economic and other forms of abuse. My situation was certainly not the worst I know of, but I felt like I had to speak for other people. I had to express this. Also, as somebody who has been traumatized in their life through the riots, poverty, familial alcoholism, the nuclear family as a microcosm of fascism, a father who was charming but couldn't control himself — I just felt that it was my job to speak for others. I always thought that. I think of the Harlan Ellison short story "I Have No Mouth and I Must Scream" — for people that don't have a mouth, I am the scream for other people . . . The details of my pain may be unique, but the situation is not. And I really do believe that art has to be the salve to the universal wound. Hence why I feel it is my calling: because I just have no choice in the matter. I just don't.

I've dealt a lot with psychopathic or sociopathic personalities because trauma is a very greedy emotion.

Anybody who has been traumatized for whatever reason and however it manifested itself — whether it's through sex addiction, drugs, alcohol, bad behavior or they overcome it and bury it — it's still a very greedy emotion that has a way of coming back when it's been in the closet for too long. And the other side of that is with victimology and magnetism, people attract or can attract a certain kind of person because of their chemistry, their magnetism, etc. And I always felt that when I attracted men who were extreme that it was because I could always see how they were before they were battered and becoming that bruised person.

My own history, I can't remember before I was conscious of something being wrong in my family life because that hit me at six, but I can see in other people that possibility that existed before they were perverted or pained by a generational, hereditary, genetic, unending cycle that happens — and I've always extended myself and I think this is what my art does — to people who have been bruised or battered. And I offer hope as a survivor because I don't feel like I've been a victim, but situations happened to me that I couldn't control at an early age. But once I took control of them, I never turned the knife inward, I always turned it outward, and then I turned my voice outward to help other people see that there is a way over this, and eventually, out of it. It's not just about surviving, it's about thriving and striving to own and to know yourself before you were tainted. That really applies to my work completely.

Lydia's personal journey from dissonance to inclusivity and wisdom has allowed her to create art that can help individuals navigate through the societal dissonance and towards a path of self re-creation. Lydia is the contemporary prophetess called

upon to come down from the mountain with her bullhorn and speak truth to the patriarchal power that bullies the intelligent, the sensitive, the weird or the queer. Her art fosters a greater sense of inclusivity, excluding only those who want to touch and claim that which they have no right to. While Lydia's call for a pleasure rebellion can superficially be read as self-interested, it is ultimately about creativity and communication, about growing communities. The goal of the pleasure rebellion is not to passively accept the current balance of political forces, but to rebel, to break the rules out of respect and ultimately change ourselves in a way that creates more social good.

AFTERWORD

Don't Be a Detached Observer

This book compiles fifteen paths to wisdom. We have now arrived at the last one. Hopefully, by this stage, the ground is becoming more firm under our feet even as, culturally, wisdom is being demoted under identity, and identity is constructed from something other than the civic or communal ties that used to be so critical. As we begin to tune out the noise of the modern world and turn on our imagination, a clear, intuitive sense of how the fifteen paths can open us up to more meaningful living and transformative social engagement.

I understand the nostalgia in stating a fondness for what "used to be," but as I discussed with Tzvi, the old is there for the sake of the new. Being rooted in tradition is what allows for novelty. And I agree with writer Mark Lilla's observation: when it comes to inspiring future democratic citizens, "the old model, with a few tweaks, is worth following." Lilla criticizes contemporary liberal, identity-based pedagogy in particular, calling it a depoliticizing force that undermines the "democratic we on which solidarity

can be built, duty instilled and action inspired."[1] The transcendence we have been chasing means going beyond politics and economics into the realm of the spiritual, through the opening to holiness identified by French philosopher Emmanuel Levinas: a sense of responsibility for others. It's what links the otherwise distinct realms of our existence together, through a shared conception of moral purpose.

I've proposed a number of paths to achieve transcendent wisdom. Embrace the romantic tendencies that best typify our shared vulnerabilities to foster deeper connections. Seek a wordless consensus to build bridges across political silos and reject polemics. Break rules to test boundaries and reaffirm what may already be good. Listen differently to better hear those who are so different from ourselves. Trade fairly, because capitalism is a superior equalizing force to old systems of barter, but it's in danger of becoming a destabilizing institution. Educate for the future without giving up on what worked in the past. Eat at a table, because it was never about simple convenience but always something more. Laugh at ourselves before we forget how. Be curious about everything. Try fairy-tale logic: it can make embracing beauty, if not spirituality, possible. Play the spaces to rediscover modesty. Surprise God because that is His greatest delight. Seek out elders when seeking wisdom.

And if we take the exploration of these paths seriously, we will find that we will have already re-created ourselves.

My journey down these paths has made me question my most deeply held beliefs. I have been forced to rethink how I have been listening and my own views on art, politics, economics, spirituality, psychology and philosophy. I was a disillusioned business professor who no longer believed in the arguments my peers were making. I couldn't keep making excuses for a system that was not leading to social progress: we had become part of the noise.

1 Lilla, M. (2017). *The once and future liberal*. New York: Harper.

As ethics and corporate social responsibility grew popular in capitalist discourse, they became corrupted beyond recognition. Many of the institutions with the most active corporate social responsibility marketing campaigns were still covering up shockingly immoral behavior. And so, I spent a year talking to some of the most imaginative and inspiring people on the planet. I knew that art offered a path of transcendence, but I wanted to *feel* it.

The conversations I've had changed me in ways I would not have predicted. They gave me the strength to find hope. They made me blow up the life I'd known for the last fifteen years. Each path I talk about in this book is penance for a year misspent.

I have spent my career trying to work from the inside to improve approaches to business and economic organizing. I told myself that change would come in increments. I told myself that I could make a difference. I told myself that what I saw in business school wasn't that bad, that the folks graduating into the world of commerce would not cause much harm, that the bad behaviors I'd helped cover up as a teacher served a higher social purpose: we were training the future leaders of a new and "enlightened" form of capitalism.

When this proved to be a lie, I thought my professional identity could still be fulfilling because my research was a critique of capitalist excess, that I could write what I wanted to despite the behavior of those within the institution in which I worked. But this, too, proved to be a lie.

My personal contributions to the canon of capitalist thinking include a compelling argument on why moral failures precede financial crises and why business leaders need to consider powerlessness as an important stakeholder attribute. Deep in my heart, I believed that my intellectual pursuits were on the right side of things. But I also couldn't help feeling that the business school that I was a part of for the majority of my adult life was not. Corrupt institutions have the power to destroy the soul of the people under their control, and I was being destroyed.

For fifteen years I have lectured students on what I believe to be the two truths about whistleblowers: 1) Western democracies cannot survive without whistleblowers. They are the moral core of our economic engines. Without them, institutions succumb to destructive greed. 2) It sucks to be a whistleblower. Without exception, they are repaid for their moral integrity with social isolation and professional shunning.

The business school I worked at has been ranked at the top of the *Corporate Knights* list of ethical institutions. They are, to the outside world, a beacon of hope amid the morass of capitalist greed. Or at least that's the way they used to be perceived. There is hopeful evidence that the outside world may be getting wiser about the industry-wide ethical hustle management theorists engage in. In a recent *New York Times* review of Anand Giridharadas's new book, no less an authority than Nobel–prize winning economist Joseph E. Stiglitz, the ultimate insider, chastises "thought leaders" in the management field for pushing buzzy but ineffectual concepts such as social entrepreneurship, social impact investing and sustainable capitalism. CEOs prefer these strategies because truly "doing the right thing — and moving away from their win-win mentality — would involve real sacrifice; instead, it's easier to focus on their pet projects and initiatives."[2]

I feel that if my colleagues believed in "real sacrifice," they would have stood alongside me and pushed for ethical behavior at home before preaching it to other institutions. I believe that if the leaders of our business school believed in "real sacrifice," they wouldn't be invited to Davos because their message would be too challenging for business leaders to hear. But, of course, they did go to Davos, basking in the company of the global elite and sharing insights into the future of a more "ethical" capitalism.

2 Stiglitz, J. E. (2018, August 20). Meet the "change agents" who are enabling inequality. *The New York Times*. https://www.nytimes.com/2018/08/20/books/review/winners-take-all-anand-giridharadas.html

Unfortunately, it seems to me that it is an orientation they write about but do not practice. Because predatory and crony capitalism can never be ethical. What we need to imagine is a different way to organize our economic exchanges. As Douglas Rushkoff makes clear in his tweet, "Companies have managed to hack and leverage the social good effect — but without doing anything so truly good as to change the underlying power structure between the wealthy and the poor."[3]

"Hacking" and "leveraging" the social good effect is an apt description of what I felt I had become a part of. I had stayed silent in the face of what to me seemed a cover up of systemic racism, sexism and homophobia in our *school*. I had watched as threatening, cheating, abusive, narcissistic managers-in-training were sent into the marketplace to engage in what I feared could turn into further efforts to destroy our planet, our people and our future. What was worse, in my mind, was that it felt as though they were being sent off with a nod, wink and our prestigious stamp of approval.

I couldn't help but feel like we were contributing to the social ills associated with the selfish and exploitive type of capitalism that many in the West assume to be the only type of capitalism. It is not. But even so, I was overwhelmed by a sense of powerlessness, watching with detachment as the leadership of the business school seemed to ignore the behavior of professionals getting our institutional stamp of approval as not only a leader in business, but in *ethical* business. In my subjective frame, the leaders around me began to appear as immoral as the worst of our students. They seemed to be knowingly empowering dangerous individuals — people whose greatest success was essentially playing the system without consequence.

The leadership justified their lax attitude to my concerns in the same way each time: separating so-called "academic" behavior

3 https://twitter.com/rushkoff/status/1042420447025999873

from the "immature" or "unprofessional" behavior I needed to learn to ignore. We, like many successful firms, had a customer focus. Trauma was silenced to assure that our in-house academic system did not stop anyone from getting a degree, no matter how awful their behavior.

The brand must be protected. Deals had to be closed.

Let me share one specific incident. I caught a student cheating. That student would later show up, uninvited and without notice, at my home hoping that I would end the academic dishonesty process (a process that was entirely out of my hands). The stalking took a tremendous toll on both my and my wife's health. I reported the issue and was assured that the university took "this sort of incident seriously" and would "be in touch" with me in a timely manner to help navigate the situation.

Unfortunately, nobody from the senior administration ever did get back to me. Nobody followed the policy for dealing with these sorts of very troubling situations. Nobody wanted to talk about it, not even my colleagues whose research interests were in ethics or justice, because it would force a very difficult conversation about who we really were as an organization and what sorts of values we were promoting.

The student was allowed to remain in my class, despite my misgivings, after signing a "memorandum of understanding." The memorandum prevented him from approaching me outside of the classroom or my office. The next thing I knew, his father appeared at a neighborhood synagogue on a Jewish holiday, and then knocked on the door of a friend, who was a stranger to him, looking for me. Our holiday was spent in terror. The administration concluded that this was NOT a breach of the memorandum because it wasn't the student himself that was now engaging in the predatory behavior.

If you are still with me, buckle down for the truly eye-opening part of the story. After all of this transpired, I met with the dean to discuss my future. I raised the severe emotional toll

of the hostile and toxic work environment (the story just shared was only one incident of many), and I admitted I was struggling to feel safe in the classroom. I made myself completely vulnerable in the hope that I would reach this man, an accomplished individual whom I had worked under for a decade and a half. I hoped for a transformative moment in my relationship to my employer and their stated commitment to a more ethical capitalism, an encounter rooted in honesty, where this dean would reveal himself to be the ally that true leadership demanded. Here is how he responded, as transcribed from a recording I made of the meeting: "Okay. So number one, the student problem is not unique. They threaten your life . . . There was one time when there was a threat. We've all had threats, including me, including the prime minster."

The dean of the Business School, who just a few months earlier had published a book on how to make capitalism better, told a vulnerable employee to get over his trauma, because, hey, both the tenured dean of a business school and the prime minister of Canada have received death threats while doing their job. So, you know, *occupational hazard*. But at least he was honest. Even better? The senior administrative health and safety officer was present for the meeting. While initially she signaled regret for what I had suffered, her response to the dean's comments regarding the receipt of death threats was to laugh. I filed a grievance with the faculty union and got a meeting with the university's provost. Her response to this information was to share the platitude of "two sides to every story," deny any wrong-doing on the part of her fellow administrators (because, as the dean stated, the student problem is not unique) and subsequently oversee a process that reappointed the dean for a few more years.

What I just described is what happens when people choose information over wisdom, institutions over community, anxiety over innovation, self-indulgence over modesty and arguments over imagination. It's how we got Trump. And it's why I now

believe that business schools are dangerous institutions. I broke down. And I spent a year looking for transcendence.

After the conversations with my heroes of the artistic world, wisdom emerged. I could no longer be part of the problem. I blew the whistle. And I was able to take action only because of the year I spent with these artists. My academic career is in jeopardy. I am out of the business school. But the thesis of this book has been proven true. Which leads to the final prescription: Don't be a detached observer — whether the revolution is coming or not, change is. If artists have one key message, it is this: audience members are not simply observers but participants. There is no such thing as a detached observer who does not impact the social environment through her observations.

Audience members are improvisational partners, as we saw in stories from Lee, Nels, Slava, Sunshine and Sonic Boom. With this knowledge, these artists create performance spaces that are not only designed to enhance their own creative potential, but the creativity of the audience as well. Knowing that there is no such thing as a detached observer, we need to take on the responsibility of participation.

The post-capitalist social conversation will be successful when we find new partners in places that the current elites would have never even thought to look. In an increasingly uncertain social environment, it is unreasonable to expect that the establishment — political, economic, cultural or spiritual — will predict what is needed for society to get on track. Institutions cannot harness social resources in the same way as communities. Society's success depends on communities growing by continuously reaching out and attracting new community members. It depends on turning strangers into friends. It depends on more folks reaching a wordless consensus.

Everybody has a stake in the success of the social conversation. While non-participation in the institutions of a corrupt society can be understood, the same cannot be said for community-based

participation. One of the most heartbreaking truths about the 2016 election was the huge number of citizens who were so disenfranchised that they chose to not even participate in the democratic process. Many of us are members of many different communities at the same time. That is a sign of a healthy society. Individual action focused on the common good will ultimately support that community's ability to innovate and strengthen relationships within the broader social ecosystem.

In the aftermath of the election, many folks in power went on listening tours to try to understand what was missed. But before they started these tours, did they change the way they listened? Were they ready to laugh at themselves? What they encountered was a tendency towards isolationism and a distrust of political and corporate institutions. Because our identities are not one-dimensional, we can create bridges between communities and empower people who may not yet see or understand the path to power.

My lived experience proves that art can help us find hope in the dissonance. The social conversation matters. There are no passive observers. We all have a part to play. Social psychologist Erich Fromm wrote that for a sane society "progress can only occur when changes are made simultaneously in the economic, socio-political and cultural spheres; that any progress restricted to one sphere is destructive to progress in all spheres."[4] We need to rethink how we listen to each other in the political realm. We need to rethink how we trade and exchange with each other in the economic realm. We need to rethink how we create, how we share and how we express our hopes and fears in the spiritual realm. We need to tune out the noise, turn on our imagination and work together to find the heart of wisdom.

4 Fromm, E. (1955). *The Sane Society.* Greenwich: Fawcett.

ACKNOWLEDGMENTS

This book was a collaborative effort between myself and the amazing artists that generously participated. Thank you Angelo Moore, Dany Lyne, Jeff Coffin, Jill Cunniff, Lee Ranaldo, Lydia Lunch, Mike Doughty, Mike Mignola, Nels Cline, Peter Kember, Slava Polunin, Sunshine Jones, Teren Jones and Tzvi Freeman for your open minds and generous spirits.

There were also a number of folks working behind the scenes with these artists that helped to coordinate our meetings. Thanks to Amee Jana, Anna Mouraviova, David Hyde, Deb Bernardini, Ekaterina, Eric Dimenstein, Etienne Tippex, G, Gwenael Allan, Julia Meredith, Maria Lentsman, Sam Kember, Shawn London and Susan Martin.

The good folks at ECW Press have been amazing partners. Special thanks to Michael Holmes, my editor, who has been supportive from the earliest stages and has diligently guided this project into maturation. Thanks to Jen Knoch for her edits and suggestions, Amy Smith for marketing guidance, Jen Albert for

her diligent work in bringing this book to production and Jessica Albert for her supportive patience in finding the cover design.

Wisdom is born in conversation, and there were many folks who engaged with me in critical conversation over the course of creating this work. Thanks to Roisin Davis for her comments on an early draft, Beverley Slopen for advice on navigating the publishing world, my reading course students, Jennifer Ralston, Heidi Noble, DJ Schneeweiss, Jonathan Shields, Mordy Bobrowsky, Mark Ross, Ora Shulman, Gary Miskin and Sruli Weiss.

I do not have the words to adequately express gratitude to my research assistant, Kelly Whitehead, whose diligence, commitment and brilliance positively impacted every page.

Writing this book meant going on a journey. Without a beacon to guide me back home, I would not have had the fortitude. To my wife, Alana, and children, Moishe, Shaindy and Leah, thank you for being the lights of inspiration and the promises of stability amid the dissonance.

David Weitzner (PhD, MBA) is at heart a philosopher who briefly became a music industry executive and has now spent over a decade as a professor of strategy. David's research takes a critical stance on decision making in capitalist environments, leading to publication in top academic journals like the *Academy of Management Review, Organization Studies* and the *Journal of Business Ethics*. David has presented at a host of international conferences, including Business as an Agent of World Benefit co-sponsored by the U.N. Global Compact. His work has appeared in popular media outlets as diverse as *Tablet Magazine, The Forward* and *Quillette*. David lives in Toronto, Ontario, with his wife and three kids.

At ECW Press, we want you to enjoy this book in whatever format you like, whenever you like. Leave your print book at home and take the eBook to go! Purchase the print edition and receive the eBook free. Just send an email to ebook@ecwpress.com and include:

- the book title
- the name of the store where you purchased it
- your receipt number
- your preference of file type: PDF or ePub?

A real person will respond to your email with your eBook attached. And thanks for supporting an independently owned Canadian publisher with your purchase!